Entering Heaven on Earth

Entering Heaven on Earth

THE SIGNS, SYMBOLS, AND SAINTS OF CATHOLIC CHURCHES

Fr. Lawrence Lew, OP

Our Sunday Visitor
Huntington, Indiana

Nihil Obstat
P. Robertus Ombres, O.P., STL, JCD (PUST)
Censor deputatus

Imprimi Potest
R. P. Martinus Ganeri, O.P., M.A., MPhil, DPhil
Prior Provincialis
Die XX Martius MMXXIV
In festo S. Cuthberti episcopi.

Imprimatur
✠ Kevin C. Rhoades
Bishop of Fort Wayne-South Bend
April 23, 2023

The *Nihil Obstat* and *Imprimatur* are official declarations that a book is free from doctrinal or moral error. It is not implied that those who have granted the *Nihil Obstat* and *Imprimatur* agree with the contents, opinions, or statements expressed.

Unless otherwise indicated, biblical excerpts are from the *Revised Standard Version of the Bible*—Second Catholic Edition (Ignatius Edition) Copyright © 2006 National Council of the Churches of Christ in the United States of America. Used by permission. All rights reserved worldwide.

Excerpts from the English translation of the *Catechism of the Catholic Church* for use in the United States of America Copyright © 1994, United States Catholic Conference, Inc.—Libreria Editrice Vaticana. Used with Permission. English translation of the *Catechism of the Catholic Church: Modifications from the Editio Typica* copyright © 1997, United States Conference of Catholic Bishops—Libreria Editrice Vaticana.

Every reasonable effort has been made to determine copyright holders of excerpted materials and to secure permissions as needed. If any copyrighted materials have been inadvertently used in this work without proper credit being given in one form or another, please notify Our Sunday Visitor in writing so that future printings of this work may be corrected accordingly.

Our Sunday Visitor Publishing Division
Our Sunday Visitor, Inc.
200 Noll Plaza
Huntington, IN 46750
www.osv.com
1-800-348-2440

ISBN: 978-1-63966-085-8 (Inventory No. T2824)
1. ART—Subjects & Themes—Religious.
2. RELIGION—Christianity—Literature & the Arts.
3. RELIGION—Christianity—Catholic.
eISBN: 978-1-63966-086-5

Cover design and interior design: Amanda Falk
Cover art: Fr. Lawrence Lew, OP
Interior art: Fr. Lawrence Lew, OP

PRINTED IN THE UNITED STATES OF AMERICA

To the memory of 婆婆, my late maternal grandmother,

Esther Marian Sui Ha Lam Chan,

who first opened my eyes to beauty in this world

and taught me to love and worship him who is Beauty's Self and Beauty's Giver

Contents

PART I

PART II

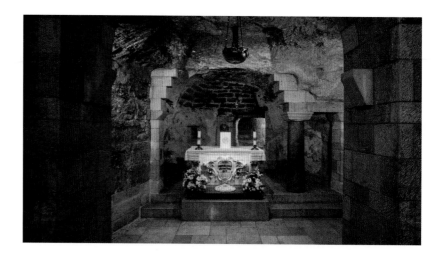

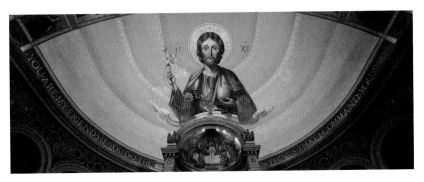

Part III

Part IV

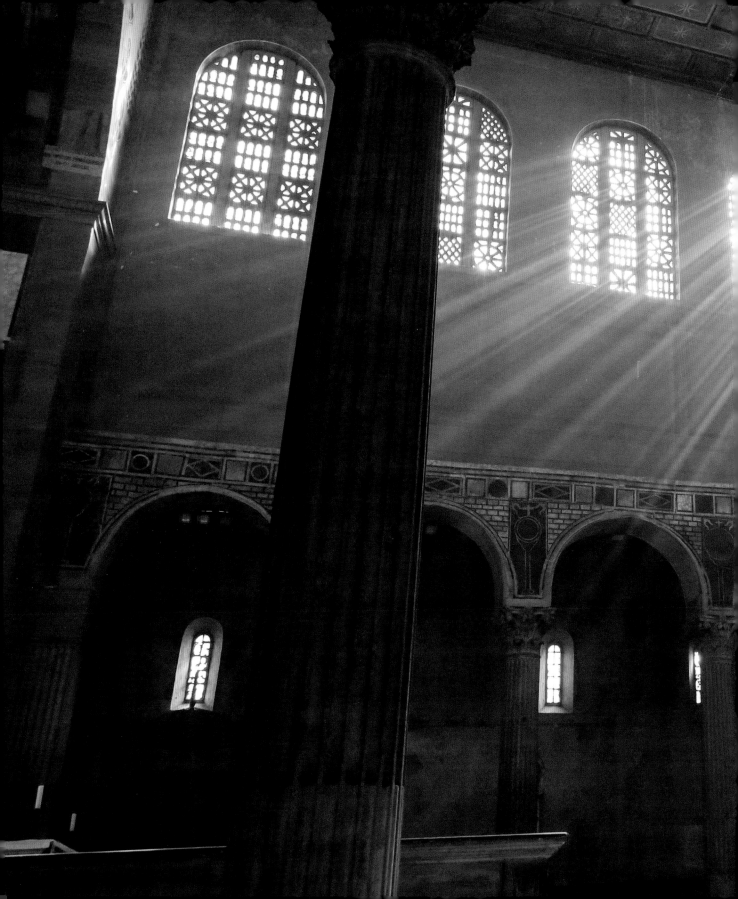

Part 1

1

The Teleology of Sacred Architecture and Art

O sacred banquet, in which Christ is received, the memory of his passion is renewed, the mind is filled with grace, and a pledge of future glory is given us.

With the words above, written in 1264 for the liturgy of Corpus Christi, St. Thomas Aquinas succinctly expressed our Catholic belief in the mystery of the Eucharist, in what is being done whenever we Catholics gather for holy Mass: We come together for a sacred banquet, instituted as a sacred meal by Christ when he brought his disciples together for the Last Supper. He commanded us, as his disciples, to "do this in memory of me" (see CCC 1340). Indeed, Saint Paul teaches that whenever we remember the Lord Jesus in this sacred feast, in the sacred action of the holy Mass, we are keeping a solemn memorial of his death on the cross and his resurrection from the dead. Thus the memory of the Lord's single and unique passion on Calvary is renewed, or made present, in every Mass. The Mass makes present the power and grace of Christ's loving sacrifice of himself, by which we have been redeemed and saved from sin and death.

By this single and unique act of sacrificial love on the Cross, Christ has reconciled God and man, and so heaven and earth are united in Christ and through Christ. As St. Catherine of Siena says, Christ is the Bridge that spans the chasm of sin. By his Incarnation he unites heaven to earth in his person, and by his saving death on the Cross, he is outstretched so as to bridge the separation from God that is caused by sin, thereby uniting us to God through his own person.

The Mass, therefore, unites earth to heaven because to be present

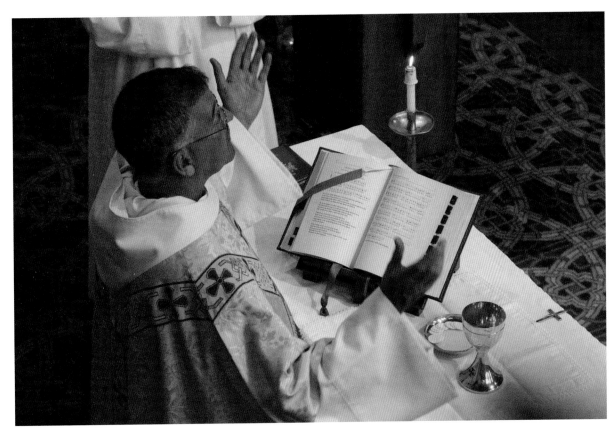

at the holy Mass is to stand at the foot of the Cross. For us to participate in the holy Mass as baptized members of the Body of Christ is for us "earthlings" to be united to heaven through Christ — through his sacrifice on Calvary, and through his own Body and Blood, made truly and substantially present for us in the holy Eucharist, the Most Blessed Sacrament. Contained within the Host is heaven, for heaven is where God is. Through holy Communion in the Mass, the mind and, indeed, the whole human person are filled with heavenly grace, which is the living presence and action of God the Blessed Trinity, who changes us. As Saint Augustine records, the Lord Jesus, present in the Eucharist,

told him, "You will not change me into yourself like bodily food; but you will be changed into me" (*Confessions* 7, 10, 18).

The Mass and the Blessed Sacrament itself unite earth to heaven, reconcile sinners to our loving Father in heaven, and increase grace and charity in the humble human soul so that, having a foretaste of heaven now, we are being prepared for heaven for all eternity. This is the promise Jesus gives to us Christians, and so he says he goes to prepare a place for us so that "where I am you may be also" (Jn 14:3). Jesus brings heaven to us through the holy Eucharist so that we might be with God eternally in heaven.

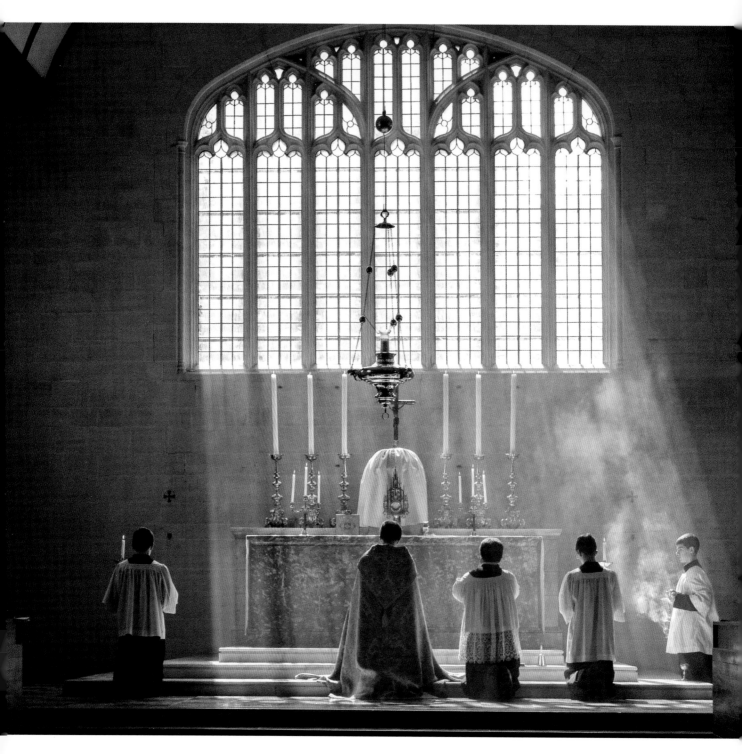

The Teleology of Sacred Architecture and Art

This is the "future glory" to which we have been called from the day of our baptism, and the Mass is an anticipation of that heavenly glory, an experience of the friendship or communion of the saints, and a glimpse of that heavenly beauty and goodness for which the soul has an innate longing. The Mass is heaven on earth, and the Eucharist, being the sacramental presence of Christ himself, is heaven among us. For Christ has pitched his tent and dwelt among us (see Jn 1:14), and he has promised to be with us until the end of all time.

The church building, and all the artifacts and symbols within it, are meant to point to the abiding presence of Emmanuel, God-with-us. Every element of beauty and delight and wonder in a church and in its architectural forms and artworks is celebration of the wonderful fact that Christ our God, who, in Gerard Manley Hopkins' phrase, is "beauty's self and beauty's giver," is with us in the Eucharist.

There have been many attempts to understand the church building and sacred art in merely mundane ways — as expressions of political power and influence, economic status and social dominance, or technical genius and human creativity. All these human and natural aspects are certainly present and evident in the history of church architecture and art; human history shows that our motives are always mixed, as the wheat and the weeds grow up simultaneously in this life (see Mt 13:24–30, 36–43). Nevertheless, merely to view our church buildings functionally and sociopolitically would be myopic. To focus principally on these worldly aspects would be to miss the forest for the trees, and we would fail to grasp the true meaning and significance of these monuments of faith if we did not first consider their Eucharist-centered purpose.

The church building — at least as we Catholics understand it — is always, first of all, a place for the Christian people to assemble for the Sacred Liturgy and thus to house the celebration of the most holy Eucharist. Moreover, every church building enshrines the reserved Blessed Sacrament, for both Communion for the sick and a focus for adoration and private prayer. As such, a church is built for the worship of God, for that human and divine action of the liturgy wherein heaven and earth meet. It is only fitting, therefore, that the church's very structure and form point to this reality. A church is a visible expression of heaven come down to earth in the person of Jesus Christ and of humanity's innate longing and striving for heaven. This is expressed through the enriching of a church with sacred art and skillfully wrought ornamentation, and particu-

My Personal "Invitation to Treat"

Therefore, my hope is that this book — richly illustrated with photographs that I have taken of churches and their furnishings from around the world — will help you to remember the purpose of a church building and to appreciate how the architecture and the art of our churches, at their best, serve this transcendent goal. My hope is that this book will help you see your churches with a fresh perspective and that it will inspire you to visit more churches, to seek out the images of the saints within them and to learn their stories, and above all to go to church and pray. For only in prayer and worship does the church building really come to life, and only through an actual and conscious participation in the sacred liturgy do we appreciate a church fully. As Pope Benedict XVI said on the occasion of his visit to New York City in 2008:

> Many writers — here in America we can think of Nathaniel Hawthorne — have used the image of stained glass to illustrate the mystery of the Church herself. It is only from the inside, from the experience of faith and ecclesial life, that we see the Church as she truly is: flooded with grace, resplendent in beauty, adorned by the manifold gifts of the Spirit. It follows that we, who live the life of grace within the Church's communion, are called to draw all people into this mystery of light.

So a book such as this is what I would call "an invitation to treat": It invites you to treat yourself and your loved ones to something beautiful by visiting a church; treat yourself to some quiet time with the Lord, present in the tabernacle, and bask in his

larly through the artistic depictions of the witness and lives of the saints and of scenes from Sacred Scripture. For the beauty of nature, the creativity and craft of mankind, and the good works of the virtuous and the just are all brought together in a church building in order to remind us of the graced activity of God among us. As Hopkins says: "The world is charged with the grandeur of God."

The great Gothic Revivalist architect Sir Ninian Comper wrote that "the purpose of a church is not to express the age in which it was built or the individuality of its designer. Its purpose is to move to worship, to bring a man to his knees, to refresh his soul in a weary land."

presence as you're surrounded by artistry; and treat yourself to a deeper understanding of the Catholic Faith that inspired and motivated men and women for two millennia to create some of the most beautiful buildings and works of art in the world for the glory of God.

As a young boy living in Malaysia, I recall being taken to see a newly built Buddhist temple in Kuala Lumpur. It was resplendent with color and gilding and finely carved wood and stone, and it was deeply impressive. I was then a Protestant, however, and my family worshiped in austere church halls that were completely devoid of any art, ornamentation, or color — just a whitewashed hall with a verse of Scripture at the front across the stage. I asked my uncle: "Why is it that we, who worship the true God, have such plain churches but they, who worship idols, have such beauty and grandeur?" I don't recall his answer, but the feeling stayed with me that God deserves the very best that we can muster.

Many of the churches I have since visited as a Catholic convert, and which I have photographed and which illustrate this book, satisfy that intuition I had as a child. Some are humble little wayside chapels with folksy medieval art, and some are grand basilicas and cathedrals with canvasses painted by great masters, but all embody the Catholic desire down through the ages to give the very best to God. Each makes evident to all visitors that the most important and beautiful thing that we as a Catholic community can ever do on earth takes place regularly in our church buildings. As an ancient antiphon sung during the Rite of Consecration of a church states: "This place was made by God, a priceless sacrament; it is without reproach."

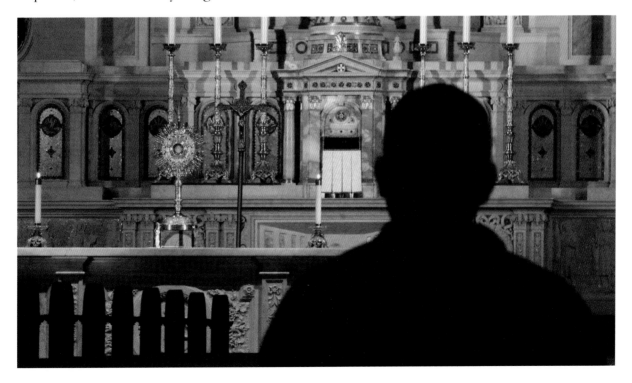

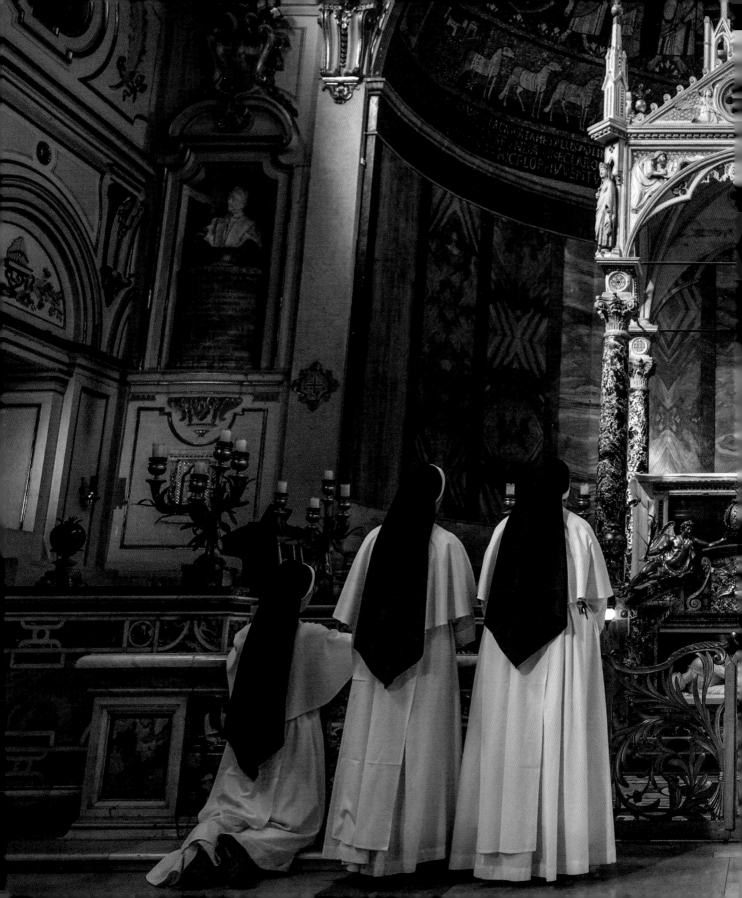

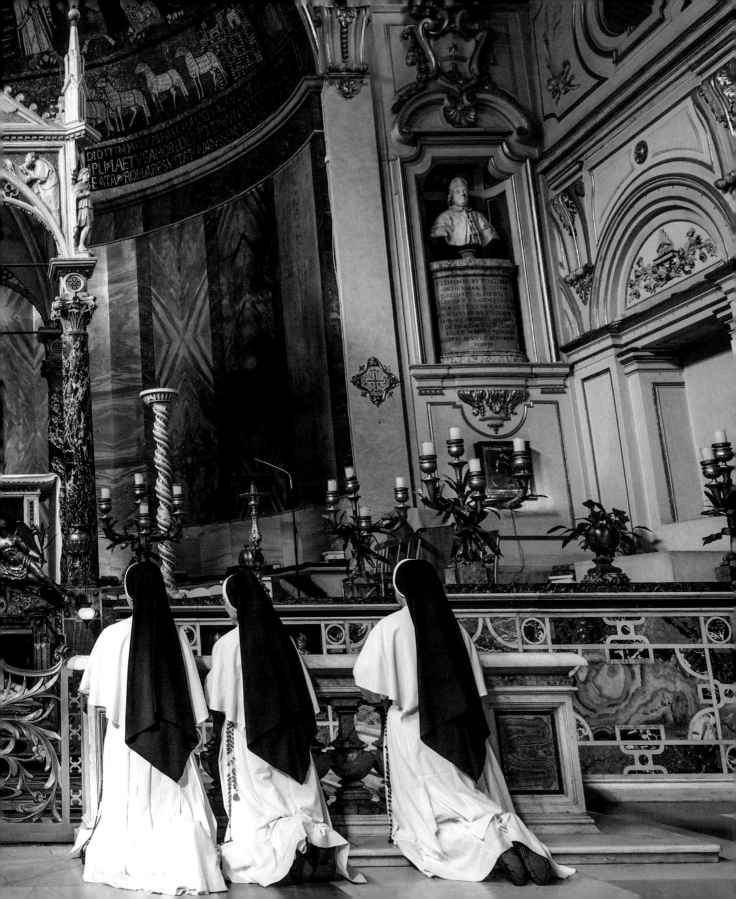

2

The External Form of the Church

A city set on a hill cannot be hidden.

— Matthew 5:14

A church building in a rural or an urban landscape is distinguished by its external form, setting it apart and pointing to the presence of God with us. The building may well fit into the architectural vernacular, perhaps by the use of the same stone or brick or building materials of the other structures around it, but it cannot be hidden and must, so to speak, be set on a hill. In many medieval villages in Europe, for example, church buildings are often on high ground. But even if this is not possible, churches are often raised by their height or through the construction of architectural elements that give the buildings verticality or thrust, as if they are reaching for the heavens.

Domes

The dome, a hemispherical enclosure of a space, is found in pre-Christian architecture and in non-Christian religious architecture. The Pantheon in Rome, for example, was built in the decades before the birth of Christ by the Roman general Marcus Agrippa as a pagan temple, and it was later converted into a church that houses the relics of the early Christian martyrs. A round building, often with a domed ceiling, became the favored architectural form for the burial places of illustrious personages in Roman architecture. A well-known example in Rome is the Mausoleum of Hadrian, which is now Castel Sant'Angelo, near the Vatican.

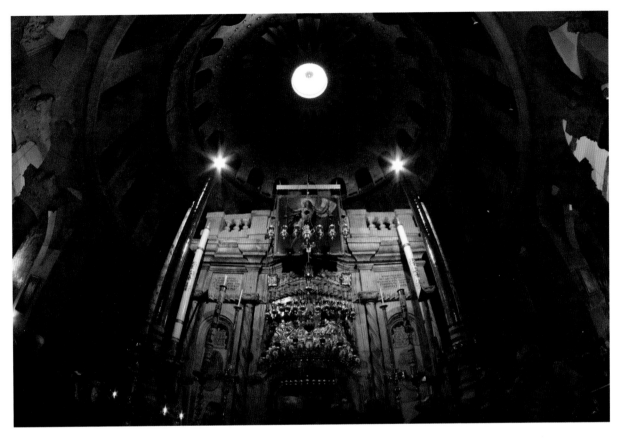

The most significant round church enclosed in a dome is the burial place of Our Lord Jesus Christ, which was built in the fourth century by the emperor Constantine. Following the Roman tradition of round mausolea, Constantine had commanded that a round church topped with a dome be built over the site of the empty tomb of the Savior. This was called the "Anastasis rotunda" — the Resurrection rotunda — which was surmounted with a dome; it has consistently been depicted this way in maps and drawings of Jerusalem. Consequently, round churches with domes are often called *marturia*, as they came to be built over the burial places of martyrs in honor of the rotunda in Jerusalem

housing the tomb of Christ, the King of Martyrs. A domed church is always a reminder of the empty tomb of Christ, a sign of the Resurrection that took place in Jerusalem, and it is thus a reminder that in every church where the holy Mass is celebrated we encounter not the corpse of Jesus but rather his living and risen Presence in the most holy Eucharist.

Domes, as such, stand for the heavens, the celestial sphere, and the heavenly life to which we are called. They signal the presence of heaven on earth, particularly when the rounded dome stands on top of a square building. The four corners of the square stand for the "four corners of the earth," so a dome on top of a square, which is probably the most com-

mon form that we see in most domed churches, is a sign of heaven and earth coming together. These domed churches, therefore, stand out on the landscape to signal that, within these buildings, heaven and earth meet in the holy Mass and through the presence of the Eucharist in the tabernacle.

Spires

Whereas the dome indicates heaven coming down to earth, the spire, which points upward, seems to do the opposite: it signifies earth reaching for the heavens. In French, the spire is called a *flèche*, an arrow, pointing upward to heaven.

The Curé of Ars, St. John Vianney, told a young boy who had shown him the way to the town of Ars that he would show him the way to heaven. Indeed, every church wherein the Sacred Liturgy and the sacraments are celebrated, and the word of God is heard, expounded, and preached, is a building in which we are shown the way to heaven. We receive in holy Communion the One who is the Way, and in the earliest days of Christianity, our faith was simply called "the Way" since we are led by Christ and follow in his way to heaven.

Unlike the dome, the spire is a uniquely Christian architectural development. From the twelfth century, as medieval Gothic architecture began to develop in France, a pyramidal roof was designed to cap square towers. Soon these became more elongated and elegant and ornamental. They served, principally, to give height to the church and to direct one's eyes toward the sky. In so doing, perhaps they teach us to look toward the heavens in expectation of the return of Christ in glory. For as the angel said at the Ascension: "This Jesus, who was taken up from you into heaven, will come in the same way as you saw him go into heaven" (Acts 1:11).

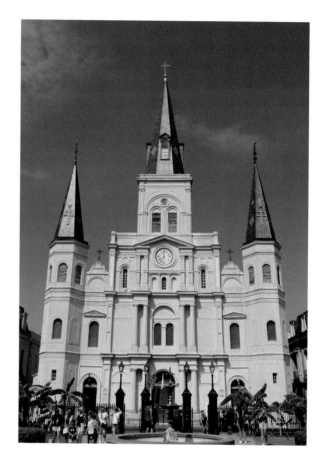

Even as our longing for Christ's return and our longing for heaven is stirred up by the verticality of church buildings pointing us upward, we should remember that within the church building, in every single Mass that takes place there, we experience a *parousia*, a coming of the Lord Jesus. As Joseph Cardinal Ratzinger said: "Liturgy *is* the act of this going forth to meet him who cometh. He always anticipates in the liturgy this his promised coming: liturgy is anticipated *parousia* or second coming; it is the entry of the 'already' into our 'not yet.'"

Towers

The third element that gives height or verticality to a church is a tower, and even if domes and spires might be unattainable for most ordinary churches, a tower of some kind is usually possible.

Often a tower will house a bell or some kind of device to draw attention to the presence of the church and what is happening within. Bells are rung to call people to services, or as an expression of festive celebration, or at the moment of Consecration to draw the attention of passersby to the presence of God among us. Likewise, when bells are rung for the Angelus prayer, they draw our attention to the Incarnation of Christ, to God's becoming man. A tower that houses a bell is called a *belfry* or a *campanile*, from the Italian word for "bell," *campana*.

Towers, like domes and spires, serve to distinguish the church building from its surroundings, so that those coming from afar can see it, like a city set on a hilltop, and people are thus drawn to the church. Usually a cross — the universal symbol of the Christian faith, since the cross is the instrument of our salvation — will surmount a tower. Occa-

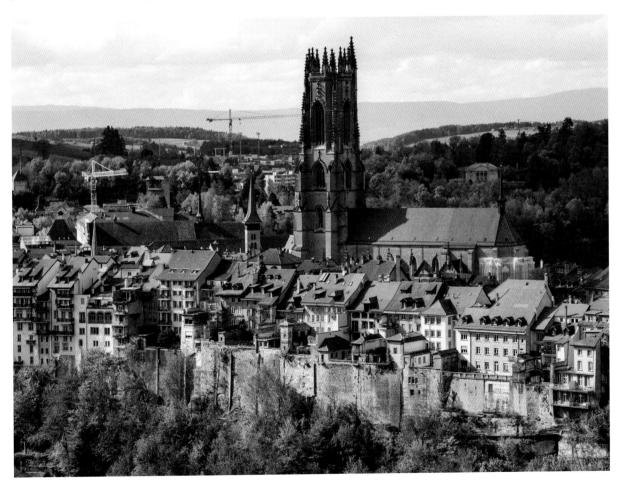

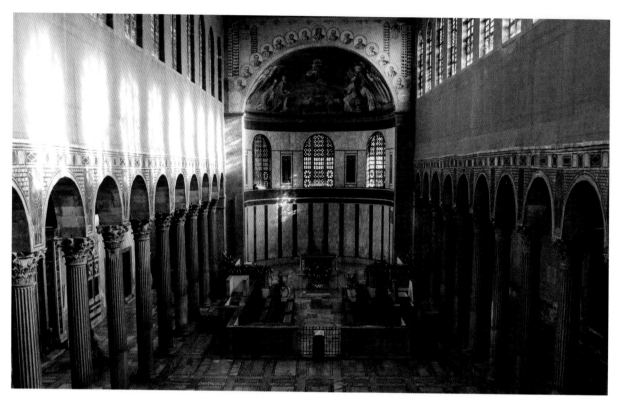

sionally, though, one might see instead a weather-vane with a rooster, which is a symbol of the Resurrection and of eternal life, since the rooster heralds the rising sun. These vertical elements, which seem to defy the laws of gravity, all serve to give glory to God, declaring his presence among us in our towns and cities and countrysides. At the top of the arches that support the central bell tower of Canterbury Cathedral, the opening words of Psalm 115 are inscribed in Latin: "Not to us, O LORD, not to us, / but to your name give glory."

The Shape of the Church

We have already noted the ancient significance of round churches, but the earliest purpose-built churches, from the time of Constantine in 313, came to adopt another existing Roman form — namely, the hall-like basilica. The word *basilica* is a Latinization of a Greek word meaning "royal hall," and this is what a Roman basilica was: a large covered space for official public assemblies used for a variety of public functions, including trade, legal trials, and even audiences with the emperor. The apse, which is the semicircular "stage" facing the length of the building toward the main entrance, was where a magistrate was seated or where an image of the Roman emperor might be set up. Constantine's architects adopted this kind of official public assembly hall — an aisleless rectangular covered space that was often supported by rows of columns — and erected the first churches in the Roman Empire in this basilican form.

This kind of open-plan hall would become increasingly subdivided with screens and smaller chapels in the Middle Ages, but the need for a large open space, particularly for preaching indoors, re-emerged during the Counter-Reformation period. Originally, though, a basilica-style church was conceived of as an audience hall with Christ, the true King, enthroned on the altar in the apse. Basilicas also provided ample space for indoor processions. In the Catholic Church, the term *basilica* has been retained as a papal honorific title that is given to certain churches, regardless of their building style, that have particular historical, architectural, or national significance.

Transepts developed after the sixth century. These are extensions along the sides of the basilica hall-shaped church, typically in front of the apse and on either side of the altar. They may have developed to allow more movement around the altar, especially if there was an opening to the shrine of a saint either in front of or behind the altar. The transept eventually gave rise to the cruciform-shape

church, which reminds us that within its walls the memorial of the Lord's passion is made present in the holy Mass. As St. Thomas Aquinas put it: "The Eucharist is the perfect sacrament of our Lord's Passion, as containing Christ crucified."

The Four Directions of a Church

If we think of the church as a cross, it is conventional to refer to the "top," where the altar and the apse are located, as the east end of the church, even if this does not correspond to the actual compass direction. The other side, across from the altar and where the main doors of a church are usually found, is hence called the west end.

The altar end is called the east end because, as far as possible, the first purpose-built churches were *orientated* (from the Latin *oriens*, "east"), which means that they were built facing east so that the sun would rise behind the altar. The priest stand-

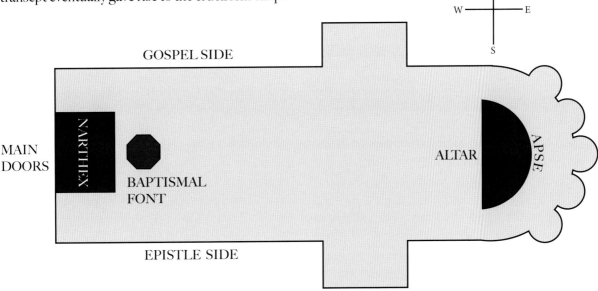

ing at the altar, with the congregation behind him in the nave (the main body of the church), would all be facing the rising sun in the east; this directional posture of prayer has been called *ad orientem*. Sometimes it was not possible to build the church eastward facing, maybe because of the location of the martyr's tomb or for topographical reasons. Over time, the orientation of church buildings became less of a concern. The priest continued to stand on the same side of the altar as the congregation, however, facing the nominal east end, or facing the apse, which is why this ancient element of liturgical prayer has also been termed *ad apsidem*.

One apparent exception to this, which might disorientate our understanding, is that in certain ancient shrines — such as the papal basilicas of Rome — the altar was built over an opening (called a *confessio*) that leads down into the burial place of a martyr. In these places, the priest stood facing the entrance doors in the so-called west end, but often the church was built "occidented," such that the sun at dawn would rise and shine through the open doors. Hence the priest was still facing east, facing the rising sun, which now shone through the doors onto the altar in the west, and it is thought that during the Eucharistic prayer, the people in the nave would also have turned to face the rising sun so that the Mass was still being offered by priest and people facing the east together.

Given that Jesus said that true worship is that which is offered "in spirit and truth" rather than in a particular holy place or in a particular direction (see Jn 4:20–24), why was the orientation of prayer and liturgical worship of such import? The practice seems to be of apostolic origin, and it is found across Western and Eastern rites of the Church from the earliest times, and the architecture of

the earliest church buildings provides physical evidence of this. Certainly Tertullian, writing in the early second century, takes it for granted that Christians prayed facing the east, whether in liturgical or private prayer.

The reason for eastward prayer for the whole Christian assembly is that we stand together awaiting the glorious return of Our Lord from the east. For Jesus says: "As the lightning comes from the east and shines as far as the west, so will be the coming of the Son of man" (Mt 24:27). There are other notable scriptural references to God's glory shining from the east, or coming from the east, and so the early Christians, in their desire for a sacred direction for their prayer, decided to face the rising sun in the east, just as the Jewish people had prayed facing the Temple in Jerusalem. St. John Damascene wrote: "Since, therefore, God is spiritual light, and Christ is called in the Scriptures Sun of Righteousness and Dayspring, the East is the direction that must be assigned to his worship. ... So, then, in expectation of his coming we worship towards the East. But this tradition of the apostles is unwritten. For much that has been handed down to us by tradition is unwritten."

Consequently, the altar end of the church came to be referred to as the east end regardless of the actual geographical direction of the building, and throughout this book I shall do likewise. So standing in the church and facing the altar, one would be facing (liturgical) east. The main doors of the church, therefore, are at the west end. Looking toward the altar, the left side is called the north, and the right side is called the south. Sometimes people refer to the left side as the "Gospel side" and the right side as the "Epistle side." This comes from the practice of the older forms of the Mass in which

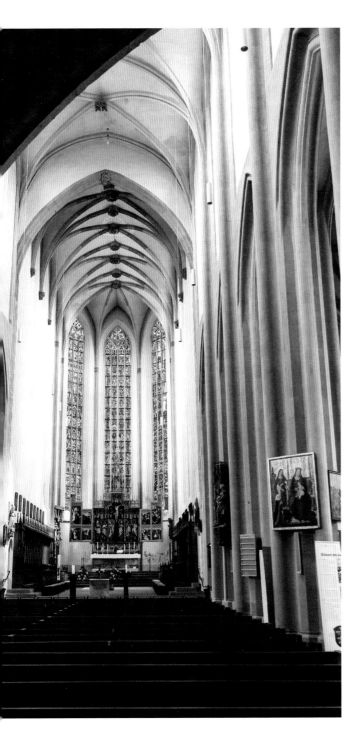

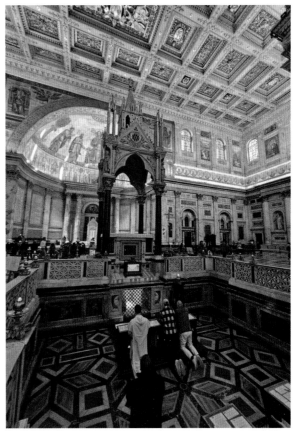

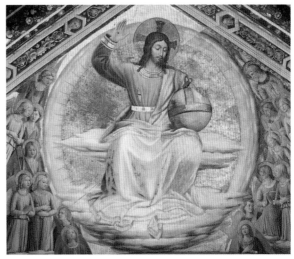

these Scripture readings are read from different sides of the altar or sanctuary. I think it is better, however, to follow the names of the compass directions, which is also a standard practice in architectural guides to churches. For example, you might read about the north rose window of Chartres Cathedral, which means the one in the left transept if you're facing the altar — one would never see this referred to as the "Gospel rose window."

The issue of liturgical orientation is unfortunately a controversial issue in our time and has even led to violent conflict in the Syro-Malabar Church in recent years. Although the apostolic tradition of the eastward direction of our prayer is important and should not be overlooked, nonetheless, the point is to orientate our hearts toward Christ, to be turned toward him, and so toward our neighbor in charity and compassion. As Saint Augustine said: "You turn your body around from one cardinal point to another; turn your heart around from one love to another." Whichever way we face, we should, as Pope Benedict XVI has suggested, be focused on the cross of Christ so that our prayer and worship will clearly move us toward this reorientation of our lives. In this way, when we're asked which direction we face in prayer, we can say we face our Lord Jesus Christ, "the true light that enlightens every man" (Jn 1:9).

Forecourts and Gardens

Churches are often surrounded by spaces that dis-

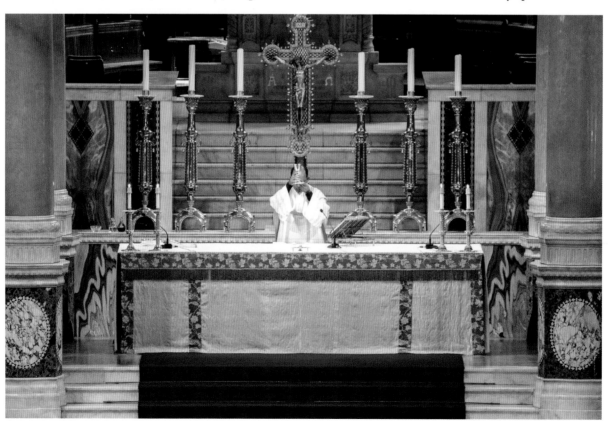

tinguish them and set them apart — and not simply functional parking lots! Whether public piazzas; gardens, occasionally with water features; enclosed walkways, such as a covered rectangular cloister; or forecourts with statues, such spaces enable us to behold a church like a city on a hilltop. They encourage us to prepare for and to anticipate our entrance into the holy place of worship where God is to be encountered. As such, they are liminal spaces between the mundane world, and its temporal and secular concerns, and the church building, wherein our minds and hearts, with their joys and fears, are to be lifted up to God. Similarly, the priest says as we "enter" into the Eucharistic prayer, "*Sursum corda!* Lift up your hearts!"

A garden surrounding a church, or even a small planted area outside the church, can evoke the garden wherein the Lord's empty tomb was found and in which the risen Lord was mistaken for a gardener by St. Mary Magdalene on that first Easter morning (see Jn 20:15). Gardens, especially with running water, are also evocative of Eden, that garden that the Lord God planted in the east and from which four rivers flowed. Now we, having been redeemed by the Second Adam, Jesus Christ, can return from our place of exile in the west; we can now go toward the east, back into that garden where the first man and woman walked in friendship with God. But Christ has not merely restored to us the friendship he had with Adam and Eve; he has also given us "grace upon grace" (Jn 1:16). And so the baptized Christian has been called into an even deeper relationship with God, to share in the divine Sonship of Jesus Christ. We go beyond the garden to enter into the church, for we have been called through baptism to go toward the east, that is, toward the altar and the apse. From there, through the Mass

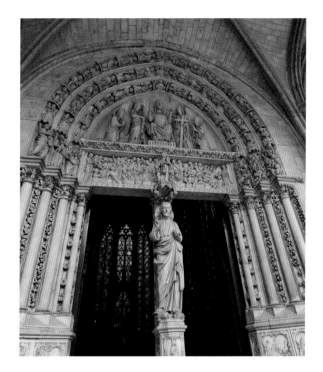

and the holy Eucharist, we shall receive the light of grace from Christ, who sanctifies us and makes us partakers in his divine nature (see 2 Pt 1:4).

Main Doors

Jesus says: "I am the door; if any one enters by me, he will be saved, and will go in and out and find pasture" (Jn 10:9). The main doors of a church, therefore, stand for Christ, through whom we enter into salvation, into safe pastures where we shall be nourished and fed. In some great churches, the entrance portals are dominated by a statue of Christ in the middle, or at least inscribed with a symbol of Christ, such as a cross or the Holy Name of Jesus. If the main portal has a rounded or pointed arch, the roughly semicircular or triangular space above the entrance in the space of the arch is called a *tympanum*.

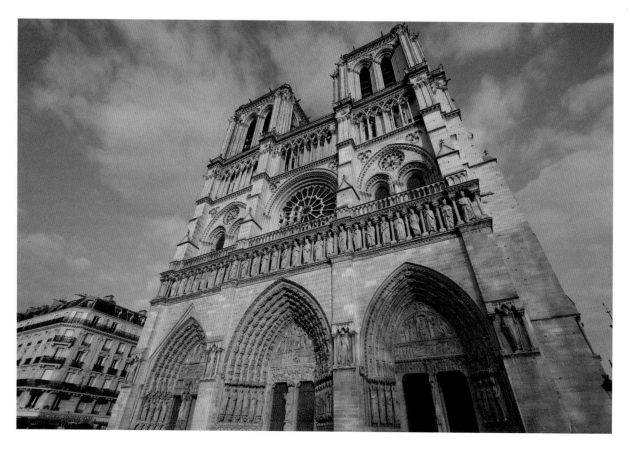

In the great churches of medieval Europe, the central tympanum at the entrance of the church is often decorated with carved images of the Last Judgment. In Saint Matthew's Gospel we read: "When the Son of man comes in his glory, and all the angels with him, then he will sit on his glorious throne. Before him will be gathered all the nations, and he will separate them one from another as a shepherd separates the sheep from the goats, and he will place the sheep at his right hand, but the goats at the left" (25:31–33). The idea is that one passes through judgment into the presence of God, and one hopes to be numbered among the sheep rather than the goats; the interior of the church is clearly a symbol of heaven, which we hope to attain by God's grace at the end of life's journey. Every time we pass through the main doors of the church, we are reminded of the Last Day, when we will be called to account for our deeds. But, looking upon this scene, we are also supposed to call to mind that within the church that we are entering, we shall find, through the Sacrament of Reconciliation, the mercy, forgiveness, and grace that we need if we have sinned. We shall also find in the Eucharist the spiritual food for life's journey, to keep us united to Christ and receptive to his graces and virtues. The twelfth-century doorway of a parish church in Dinton (Buckinghamshire, England)

carries a Latin inscription that says: "If any should despair of obtaining reward for what he deserves, let him listen to the teachings preached in here and keep them in mind!"

The entrances of cathedrals and other great shrines and churches often include three sets of doors. In many cases in medieval Europe, the central doors, as we have seen, are dedicated to the Lord our Savior. One set of doors, however, usually on the right, is dedicated to Our Lady with a large statue of the Mother of God; on the left, the doors may be dedicated to the patron saint of the church or of the region or the country, with another large statue to indicate this. The presence of the saints flanking these entry points (and also within the church building, as we will discuss later) is a reminder that, in life's journey, we are each a part of the communion of saints. The saints' images remind us that we are being helped in our journey of faith and in our desire for holiness by their example,

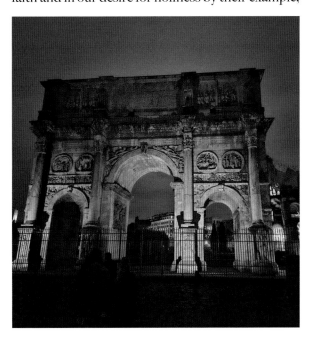

their inspiring histories, and their prayers.

An observation about this arrangement of three arched doorways: Though they do correspond to the central aisle and the two side aisles that are commonly found in a basilica-style church, they may well also be a reference to the heavenly Jerusalem, which has three gates facing in each direction of the compass (see Rv 21:13). I think, however, that they are also symbolic of the victory and kingship of Christ. The facade of St. John Lateran in Rome, for example — which is the cathedral church of Rome and which is called the "Mother of all the churches of the world" — has a large rounded central arch and two smaller arches on either side. This arrangement is seen in Rome all around the Imperial Forum in the form of monumental triumphal arches, ceremonial archways under which conquering heroes and emperors would ride into the city of Rome. When one enters into the cathedral of Rome, one enters in triumph, sharing in the victory of Christ, the true conquering Hero who has overcome sin and death. Inspired by the mother of all churches, even if subconsciously, I think that our church entrances — even on a humbler scale and somewhat evolved in their arrangement — are an evocation of the triumphal arches of Rome.

Side Doors and Porches

Unusually, the medieval parish churches of England do not always have central west doors. Instead, one commonly enters through a door on the south side of the nave, which is usually covered by a porch. A porch, like a forecourt, or like the narthex, which we will consider next, is yet another one of these liminal spaces, standing at the threshold of one's entry into the church. Porches offer the promise of shelter from inclement weather, a

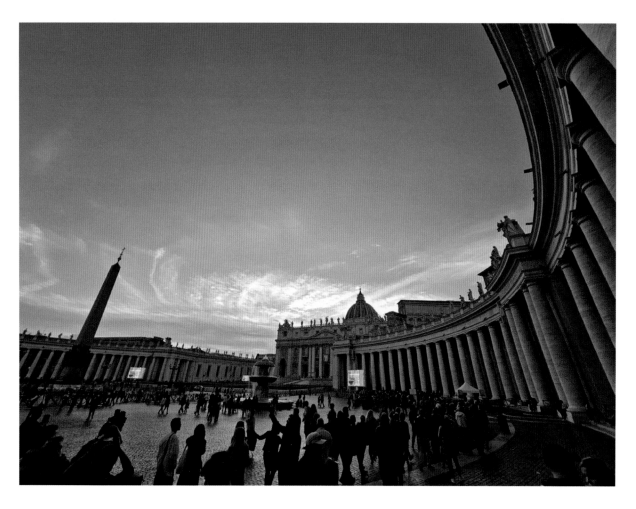

place to sit and rest. Because they do not have a door, they are always open, even when the church is locked, and so they are a place of permanent welcome for the passerby. Many people think of Bernini's great colonnade that encircles St. Peter's Square in Rome as a great architectural sign of the Church's embrace of all peoples, but the humble English parish church porch offers the same welcome, the same embrace of the Catholic Church, who, as Pope Francis says, "is a true mother who gives us life in Christ and, in the communion of the Holy Spirit, brings us into a common life with our brothers and sisters."

Apart from the south door in the main body of the church (the nave), there is often a north door. In larger churches, which may have transepts, these two side doors are in the north and south transepts, and people often exit through them, having entered through the central west doors. Since the 1100s, however, the church of the Holy Sepulchre in Jerusalem has been entered only through a set of side doors in the south transept,

so other churches that have this feature may be referencing this great church. Moreover, historically, as the Gospel was preached from the south, coming from Jerusalem, and went northward toward Europe, it was fitting to enter the church from the south and to exit through the north doors, as one is sent out from the Mass to evangelize the nations.

Narthex

Immediately as one enters the church from the west side, there is usually an area, a vestibule, where one congregates — an entrance space before one enters the main body of the church and usually separated by another set of doors. Here, church notices are pinned up, or we might pick up church bulletins, leaflets, magazines, and the like. This area is called the *narthex*, which comes from a Greek term for "casket," an ornamented box for holding precious objects. Saint Lawrence, the martyred deacon of Rome, rightly referred to the poor as the precious "treasures of the Church" who are often found congregating in the narthex. We can think of the narthex as a holding area, a place to wait before entry into the church — many people still wait there if a service is going on. In times past, catechumens would have to wait there until they were baptized and could then be admitted into the body of the church to join the Christian community in acts of worship and in the reception of the other sacraments. But if the altar is heaven on earth, perhaps we can think of the narthex as a reminder of purgatory, which St. John Henry Newman rightly called the "antechamber of heaven."

The narthex is yet another one of these anticipatory spaces in which we prepare to encounter the Lord in church, and even the chats and greet-

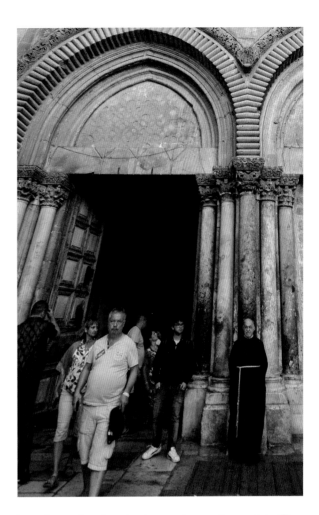

ings that take place in the narthex point to this. For, through our friendly conversation with one another, we grow in fellowship, in communion, as brothers and sisters in Christ, and this prepares us for holy Communion, which perfects our earthly relationships with one another by deepening our friendship with Christ. A beautiful eighth-century antiphon sung at the Evening Mass of the Lord's Supper on Maundy Thursday declares: "Where true charity is, God is there. The love of Christ has gathered us into one flock. ... Therefore, whensoever we are gathered

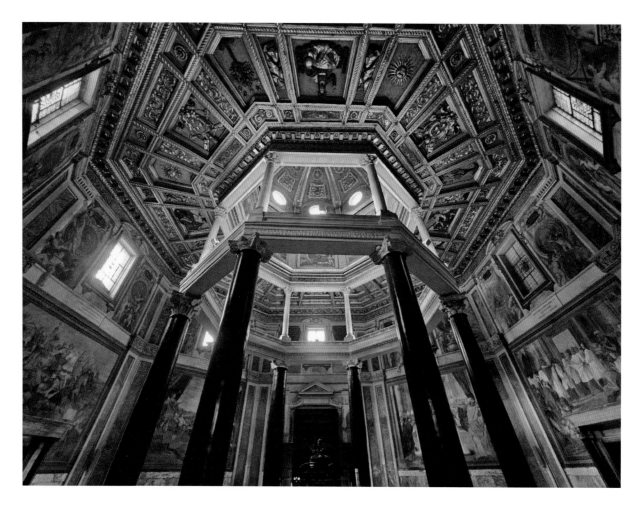

as one: Lest we in mind be divided, let us beware. Let cease malicious quarrels, let strife give way. And in the midst of us be Christ our God."

The narthex is also purgatorial insofar as it becomes a fitting place to lay to rest our quarrels and upsets, to be purged of our petty sins. As we come in from a perhaps fraught journey to church, or if we have been irritated by interactions in the parking lot, the narthex is the place to forgive our brothers and sisters in person or at least in our hearts and minds, or even, if necessary, by preparing first to go to confession. For many parents who have had to struggle with restless or crying children, the retreat into the narthex is perhaps an invitation to offer up our earthly trials and difficulties for the Holy Souls in purgatory and to heed their cries for our prayers! Jesus instructed us: "If you are offering your gift at the altar, and there remember that your brother has something against you, leave your gift there before the altar and go; first be reconciled to your brother, and then come and offer your gift" (Mt 5:23–24).

Baptistery and Fonts

It is an ancient tradition, preeminently seen in Rome at the Lateran Archbasilica, for the baptismal font to be housed in a building separate from the main church, usually near the west doors or near a source of flowing water. One of the finest examples is in Florence, directly opposite the west doors of the cathedral and famed for its bronze doors with scenes from salvation history executed by Ghiberti.

This building, called a *baptistery*, is typically a round or octagonal building. We have seen that round buildings were used for tombs and mausolea in Roman architecture, so the round baptistery also recalls the holy sepulcher of Christ. It points to the theological truth that, through the Sacrament of Baptism, we die with Christ, dying to sin and to old sinful habits. As the *Catechism of the Catholic Church* says: "According to the Apostle Paul, the believer enters through Baptism into communion with Christ's death, is buried with him, and rises with him" (1227).

The octagonal shape of the baptistery recalls the Resurrection and our rising with Christ. Just as the number seven recalls the seven days of creation, so the number eight and the octagon point to the new creation effected by Christ's resurrection. The day of the Resurrection is the octave day, the eighth day of a renewed and redeemed creation, and we Christians are reborn from the font to live in the new creation shaped by the grace of the risen Lord. Central to our celebration of our rebirth as Christians is the Sunday Mass, when we come together to celebrate the day of the Resurrection, and we look to the east, anticipating the coming of Christ in glory and the endless day that is eternal life in heaven. So Pope St. John Paul II said: "Sunday is

not only the first day, it is also 'the eighth day,' set within the sevenfold succession of days in a unique and transcendent position which evokes not only the beginning of time but also its end in 'the age to come.' So, 'in celebrating Sunday, both the "first"

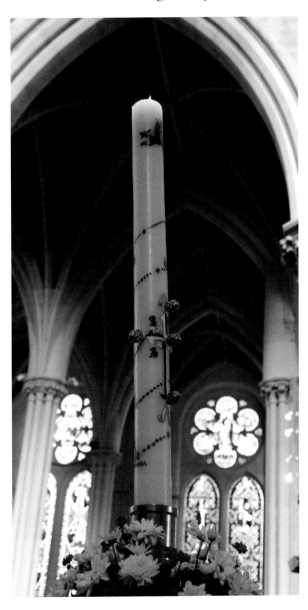

and the "eighth" day, the Christian is led towards the goal of eternal life.'" The eight-sided baptistery references the goal of eternal life, which is the reason for being baptized; the *Catechism* teaches that "Baptism is birth into the new life in Christ. In accordance with the Lord's will, it is necessary for salvation, as is the Church herself, which we enter by Baptism" (1277).

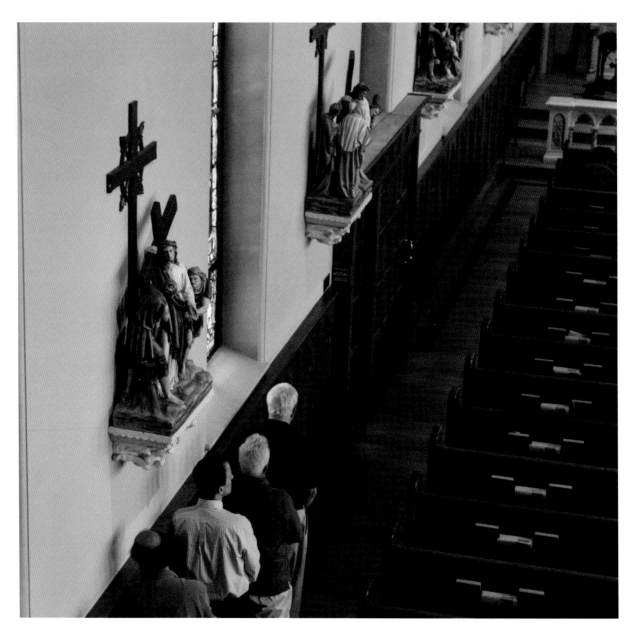

Even though baptisteries are no longer being built, there are still vestigial reminders. First, the shape of the baptismal font itself continues to be circular or octagonal. Second, the font is often situated in a baptismal chapel just inside the west door of the church, sometimes even in the narthex. Third, receptacles for holy water are usually found at the entrance of the church, and the Catholic custom is to dip one's fingers in this water and make the Sign of the Cross as one enters the church. This is a reminder that baptism is the means by which we enter the Church, and indeed, it opens the way to heaven. Thus the *Catechism* says: "The Church does not know of any means other than Baptism that assures entry into eternal beatitude" (1257).

Finally, within the baptistery or standing near the font itself, we can note a large candle, usually decorated and inscribed with the numerals of the current year. This is the paschal candle, blessed at the Easter Vigil. Throughout the Easter season, it stands next to the ambo in the sanctuary, and it is lit during Mass throughout the fifty days; then it is placed near the baptismal font and lit for baptisms and, for funerals, is placed near the coffin of the deceased. The paschal candle is a symbol of the Risen Christ, whose resurrection brings light to a world that had once known only the dark night of sin. Through baptism, we rise to new life with the Risen Christ, and through death, the Christian passes over in the power and grace of the risen Lord from death to eternal life. Thus the Church states that "in the celebration of funerals the paschal candle should be placed near the coffin to indicate that the death of a Christian is his own Passover."*

*Congregation for Divine Worship and the Discipline of the Sacraments, *Paschale Solemnitatis* (January 16, 1988), par. 99, Liturgy Office, England and Wales, https://www.liturgyoffice.org.uk/Calendar/Seasons/Documents/Paschale-Solemnitatis.pdf.

Confessionals

Another part of the church, usually situated near the main entrance, where the soul is revivified, where we can pass over from the death and estrangement of mortal sin to friendship and new life in Christ, is the confessional, or "reconciliation room." Sometimes confessionals line the nave of the church, which suggests to me that reconciliation and forgiveness, repentance and starting anew are an essential part of our Christian journey as we make our way from the font to the altar, from new life to life with God in heaven. In older churches, these places for the Sacrament of Reconciliation, or Penance, were sometimes called "confessional boxes" and were commonly wooden structures, often enclosed with just a small window in the door to ensure privacy. I have often thought that these wooden confessionals were reminiscent of coffins, and it is fitting that we enter into them as if we were dead because of sin. Confession is the sacrament of new life, however, "the second plank [of salvation] after the shipwreck which is the loss of grace" (CCC 1446), and so the penitent is raised by the grace of confession to a new life in Christ, the risen Lord. Thus we emerge from the confessional like one who rises from the grave, restored to the fullness of the Christian life and empowered by the Holy Spirit to perform acts of penitence and renewal of life that will "allow us to become co-heirs with the risen Christ, 'provided we suffer with him' (Rom 8:17; Rom 3:25; 1 Jn 2:1–2)" (1460).

3

Color and Ornamentation

Before we enter the church and explore further, we should pause and think about color. Many of us are accustomed to churches whose exteriors are beige or white or the color of natural stone or wood. In the Middle Ages, however, almost all churches were painted in an array of colors and patterns, both inside and out, including all the sculpture. Saint Paul spoke of our sight in this world as being darkened, like seeing "in a mirror dimly" (1 Cor 13:12), but he promised that in heaven we will see God with clarity and all things shall shine with God's brilliance. Therefore, a monochromatic color palette or, indeed, a lack of brilliant color reflects this transient world, still sunk in the darkness of sin. Polychrome surfaces and statuary, on the other hand, evoke the heavenly realms, in which we see the colorful beauty of creation restored by the grace of Christ so that, as the psalmist says to God, "in your light do we see light" (Ps 36:9).

A visit to an Orthodox or Eastern Catholic church in our time will give us a sense of how dazzling our churches used to look throughout the West as well: Every surface is covered with color, biblical images, and ornamentation. This visual richness and bold use of polychromy stood in contrast to the limewashed white walls of the other buildings around a church. Consequently, the church building, full of color from pigment-rich painted surfaces, stained-glass windows, and skillfully dyed fabrics, evoked the richness and brilliance of heaven — a vision of celestial splendor, a foretaste of the beatific vision, in which God is seen "face to face" (1 Cor 13:12).

Until the nineteenth century, when pigments could be chemically produced and color could be made synthetically, the pigments for paints and dyes were derived from natural elements in the earth, from ground minerals, or from crushed organic matter. Pliny the Elder said that initially there were only four paint colors, all derived from the earth or from soot: black, white, red, and yellow or ochre. Aristotle, however,

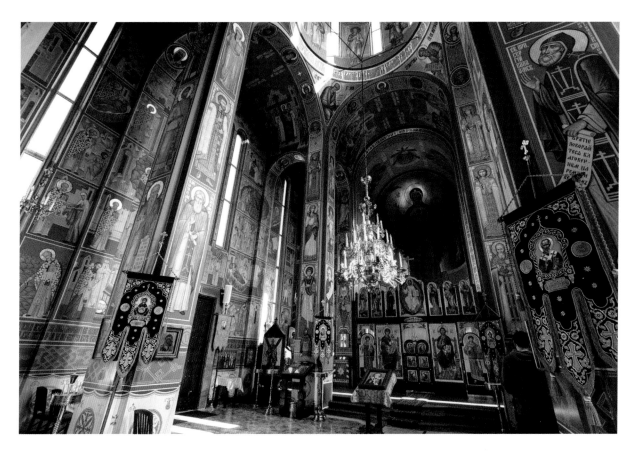

spoke of seven primary colors, which are those still used by the Church and her liturgy: black, red, yellow (or gold), blue, white, purple, and green.

Before considering the symbolism of each of these colors, I invite you to pause and marvel at the gift of color. We tend to take color for granted, just as (thanks to photography and digital imaging and print technology) we can now take the ubiquity of images for granted. Colored images and clothing are now relatively commonplace, but these were once rare and costly artifacts. Though color pigments were historically costly and difficult to obtain, our churches were nevertheless filled with color and patterns. This speaks eloquently of the

"liturgical instinct" of Christian artists and patrons down through the ages to give their very best to God, sparing no expense or effort to offer their all to God through the creation of beautiful, colorful, art-filled churches.

Through the color pigments derived from plants, minerals, and certain insects and mollusks, all of creation is brought together, made by human creativity into a work of art. These natural materials are transformed into something beautiful beyond the limits of their own nature, wrought into something supernaturally lovely and visually attractive — a thing of beauty — offered to God in thanksgiving. Artistry and the use of color, therefore, are

liturgical acts, just as all things in the natural world are found in some form in the church building and are lifted up to God in the divine liturgy that occurs in these places. Whether through carved and polychromed wood and stone, or mosaic and glass and metalwork, or paintings and sculpture, or through music and vesture, we use and fashion the diverse matter of the material world in worshiping God and giving him glory. Thus we give thanks to God for all that he has created and entrusted to us: "Blessed are you, Lord, God of all creation, for through your goodness we have received" all these good things that we now offer you in the liturgy. So Ninian Comper said: "In art man partakes in this purpose of his maker [to refresh the human soul through beauty] and objectively he brings the best of all that [God] has given him to create of beauty (in liturgy, poetry, music, ceremonial, architecture, sculpture and painting) to be the expression of his worship."

Gold

Of the Aristotelian primary colors, I have interpreted yellow as representing gold. Heraldic artists would argue that gold is a metal rather than a color, but as we are familiar in our times with yellow standing as a substitute for gold, I hope this interpretation will be forgiven.

Scripture tells us that the new Jerusalem, the heavenly city, is "pure gold, clear as glass" (Rv 21:18). Similarly, the Holy of Holies in the Temple in Jerusalem was covered in gold, inside and out (see 1 Kgs 6:20-22). The intrinsic value of gold as a metal is based on the fact that it does not tarnish, unlike other metals. Pure gold stands for permanence and durability and is a sign of fortitude (Jb 23:10). As a symbol, therefore, gold represents eternal things, the victory of the martyrs over earthly trials, and so it stands also for heaven, for the things of God, which endure forever, and for divinity itself.

This enduring quality of gold and its rarity as a resource, however, have made gold highly valuable,

so it is often linked to wealth, worldly power, and ostentation. This is unfortunate because the use of gold in Christian architecture and sacred art — adorning the altar, lining the chalice, in vestments, and as a background for icons and mosaic images — is not meant to express the wealth or power of the Church, as is commonly thought. Rather, gold is supposed to direct our thoughts to heavenly things. It should cause us to ponder the truly precious quality of the relics or the Blessed Sacrament that are carried in golden vessels. A golden background conveys the idea that a scene being depicted in art is suffused with a divine light, and a golden place is about a heavenly reality. Consider, then, the words of Saint Peter: "In this you rejoice, though now for a little while you may have to suffer various trials, so that the genuineness of your faith, more precious than gold which though perishable is tested by fire, may redound to praise and glory and honor at the revelation of Jesus Christ" (1 Pt 1:6–7).

Red

The earliest paintings of people, found in caves across the globe, all feature red hands, a color derived from the clay of the earth and mixed with blood. Red, therefore, is the color of man, who is formed from the earth; in Hebrew, *adam* means "red"; Adam is he who comes from the red clay, *adamah*.

The color red is found in images of Christ, the second Adam, as a symbol of his Incarnation and of his sacred humanity. Our Lady is also often shown in red because it is from her immaculate humanity that Christ takes his human nature, being formed in her virginal womb for nine months.

Liturgically, red vestments are worn to symbolize the blood of Christ's passion and of the martyrs, who share in his passion. Red is also worn to signify the fire of Pentecost, one of the symbols of the Holy Spirit (see Acts 2:3–4).

Black

The ancient Greeks called black *melas*, which means "darkness," and it was linked to the darkness of the grave. The ancient Romans subsequently wore black clothing as a sign of bereavement. It is from these Greco-Roman roots that black became a liturgical color for funeral Masses and Masses for the dead. Although Saint Paul rightly exhorts us not to "grieve as others do who have no hope" in the Resurrection (see 1 Thes 4:13), it doesn't follow that a Christian should not mourn or grieve at all. The use of the color black in funerals expresses the darkness and "shadow of death" (Ps 23:4) that befall our mortal nature. These black vestments are often suffused with gold or silver embroidery, which points to eternity, or with symbols of life and light, which express our Christian hope that the faithful departed will share in Christ's resurrection and final victory over death.

White

White reflects all the colors in the visual light spectrum, so it stands for brilliance and glory. It is used liturgically in the seasons of Easter and Christmas.

White is also associated with purity and is worn on feasts of Our Lord and Our Lady, who are both without sin. White, therefore, is the color in which a newly baptized Christian, freed from original sin by the grace of Christ in the Sacrament of Baptism, is robed.[†]

Pure white is a difficult color to achieve, however, requiring much processing, purifying, washing, and cleaning. As such, white linen, cotton, and silk were once costly materials to obtain and maintain. Considered in this way, white is fittingly worn on the feasts of all non-martyr saints, for it is only through much difficult struggle and costly sacrifice, by dying to sin and conforming themselves to Christ and cooperating with his grace, that the saints are purified of all sinful attachments and the effects of original sin. Scripture portrays the saints in heaven as being robed in white garments: "He

who conquers shall be clothed like them in white garments, and I will not blot his name out of the book of life; I will confess his name before my Father and before his angels" (Rv 3:5).

Blue

Scripture tells us that the woman in the book of Revelation was "clothed with the sun" (12:1), which suggests that Mary is clothed in light; this would be represented by gold, yellow, or white. Images of Our Lady of the Rosary when she appeared at Fátima frequently show her in white and gold because, in fact, Ven. Lúcia dos Santos reported that Our Lady was clothed in light.

Nevertheless, the association of blue with Mary is firmly lodged in the Catholic imagination, such that Bl. Pope Pius IX in 1864 permitted the Church in Spain (and in her former colonies) to use blue as a liturgical color on the feast of the Immaculate Conception. Some argue that blue, being the color of the sky, is fitting for Our Lady as Queen of Heaven; Saint Bernadette, in her vision of the Immaculate Conception at Lourdes in 1858, confirmed that Our Lady was dressed in white with a blue sash. Often white and blue are the colors associated with Mary.

The ancient Byzantine iconographical tradition, however, has been to depict Mary in a blue inner garment and a red outer garment. As with all genuine Mariological matters, the origin of this color combination comes from Christ and points toward him. As I have noted, icons of Christ show him in the red of humanity, and blue, being the color of the heavens, points to his true divinity; in many ancient icons, Christ's inner garment is red, and he is robed in a flowing outer garment of blue. This shows, according to Byzantine writers, that

[†] In the United States, an exceptional permission has been given for white to be used at funerals, as a sign of hope in the Resurrection and conceived as an option especially for those who die before reaching the age of reason.

Jesus is God (for it is the outer garment that we see first) who assumed our human nature (symbolized by the more hidden inner garment). With Mary, these colors are inverted to show, therefore, that Mary is, first of all, human and a mother — thus the red envelops her from head to foot — but she is full of grace and has had heaven dwelling within her in the person of Christ, and so her inner garment is a celestial blue.

At some point, the Western tradition began to show Mary with a red inner garment instead, and with her outer garment in blue. This seemed to be confirmed by the miraculous image of Our Lady of Guadalupe, which allows for this Christlike color combination, and even earlier than that, the fifteenth-century image of Our Lady of Perpetual Help also depicts Mary with a blue mantle over a red garment. What might account for this change, which dates to about the twelfth century? The combination of red and blue still comes from the ancient iconography of Christ and even follows it directly. But this shouldn't be thought of as a medieval Western desire to equate the Virgin Mother with her Savior Son. Rather, it seems that there was a desire to reflect the typographical significance of Mary and to relate her to the Old Testament.

In the Book of Numbers the Lord God gives a liturgical instruction to Moses: "Spread over [the ark] a cloth all of blue. ... And over the table of the bread of the Presence they shall spread a cloth of blue" (Nm 4:6–7). Our Lady had been likened by the Fathers of the Church to the Ark of the Covenant, and likewise she bore the Bread of Life, Jesus Christ, in her own body. It might have been thought that she is fittingly veiled in blue; thus Mary's outer garment became a blue veil and mantle.

From the ninth century onward, the blue pig-ment that was used for Our Lady's robes was also the most precious, even more costly than gold. The blue color used in most medieval and Renaissance art was derived from ground lapis lazuli, a semiprecious stone that had to be imported from a great distance, from the mountains of Afghanistan. The color, which is very stable and does not fade or darken with age, came to be known as *ultramarine*, which indicated its faraway source — *ultra* meaning "beyond," and *mare* meaning "the sea." This beautiful heavenly color, coming from a mythical realm far away, which was thought by medieval artists to be on the edge of paradise, came to be associated with Our Lady. Just as chivalrous knights offered their most precious

Artists relied on their patrons to buy them this precious material. In 1515, for example, Andrea del Sarto, who painted an image of Our Lady in Florence, required one ounce of lapis lazuli. This was reported to have cost five florins — equivalent to one year's wages for a minor civil servant or five years' rent for a laborer living out in the countryside. Of all the colors derived from mineral pigments, blue was the most expensive but also the most beautiful and enduring, the most "perfect," it was said, and therefore the most fitting for Mary, God's most perfect creature.

Purple

The veil of the Temple in Jerusalem was woven with red and blue linen threads (see 2 Chr 3:14). The color of the veil, therefore, was predominantly purple or violet, which was yet another precious color that came to be associated with the Roman ruling classes and then exclusively used by the Byzantine emperor.

Saint Luke mentions that an early Christian convert, Lydia, was a "seller of purple goods" (see Acts 16:13–15). This is a reference to Tyrian purple, the color prized highly in the Roman world because it was derived at great expense from the shells of mollusks. Some ten thousand mollusks were required to obtain just one gram of the purple dye, and the shellfish had to be harvested by an army of laborers. The price of Tyrian purple cloth was staggering: a typical fourth-century farm laborer would have had to work for twenty-four years (and save every denarius he earned) in order to purchase just a handful of purple silk.

Tyrian purple, though, was a dark color, which Pliny compared to the color of "clotted blood." This led William Durandus, the thirteenth-century writ-

gifts to their sovereign ladies, so the medieval Christians who could afford it wanted to clothe images of Our Lady in ultramarine as the ultimate sign of their loving devotion to the Queen of Heaven.

er of a famed treatise on liturgical symbolism called the *Rationale Divinorum Officiorum*, to comment that "purple is gloomy, as if drenched with blood."

Perhaps this is why purple is to be used liturgically as the color of repentance and penitence, and we should seek out dyes for this darker purple rather than the brighter and more glorious imperial tones that are often seen in our churches. Purple, as the Romans knew it, is "the hue of darkness," Pliny said, and so it evokes the gravity of sin, and the costliness of sin, which has to be paid for by the blood of Christ. As Saint Peter says: "You were ransomed from the futile ways inherited from your fathers, not with perishable things such as silver or gold, but with the precious blood of Christ" (1 Pt 1:18-19).

Green

The word *green* comes from the Proto-Indo-European root *ghre* meaning "to grow." The Romance languages derive their word for this color from the Latin verb *virere*, meaning "to be full of vigor" or "verdant and lively." Green, therefore, is the color of life, and abundance of life is to be found in Christ, who gives us life eternal (see Jn 10:10). It is also the color of youthful strength, and so Saint Joseph, protector of the Holy Family and of the Church, is often robed in green. The association of green with life has led some Eastern churches to wear green vestments on the feast of Pentecost because the Holy Spirit is the "Giver of Life."

In the Catholic Church, green is the predominant color of the liturgical year, which suggests that throughout the year and through the Sacred Liturgy, we are to grow in the grace of the Holy Spirit and in our knowledge and love of God and of one another.

4

Inside the Church

Now that we have considered in general the significance of color and ornamentation in a church building, we can proceed through the narthex into the main body of the church, which is called the nave. We have been called out of our homes and our comfortable places into the church building, which is filled with color and light. We have been constituted by the grace of God as a holy assembly. So Saint Peter says: "You are a chosen race, a royal priesthood, a holy nation, God's own people, that you may declare the wonderful deeds of him who called you out of darkness into his marvelous light" (1 Pt 2:9). In referring to us Christians as those who have been called out of darkness, Scripture thus refers to us as an *ekklesia*, a people who have been called out and gathered together, and it is this Greek word that gives rise to the Latin *ecclesia* and our English word *church*. The Church, therefore, is principally "God's own people" who have been assembled together into a certain place; they are within this building, and orientated toward the altar for worship. God has called us out of darkness into his light, to receive his grace, his gifts, his sanctifying Presence, which is why we gather for the divine liturgy.

The part of the church building where we, the Church, are gathered is called a nave because there is a sense that we have been called out of our houses and ordinary lives, and we are on a journey. The word *nave* is derived from the Latin *navis*, meaning "ship." It refers to the scriptural image of Noah's ark, in which Noah called together his family and all who would serve God, and on which they journeyed to a place of safety and rest from the destruction of the great Deluge. The Church has been called the "ark of salvation" in reference to this. Moreover, Christ often preached from a boat, and he gathered his disciples in a boat as they sailed on the Sea of Galilee. So the Church is often depicted as a boat with Christ (and the pope) at the helm.

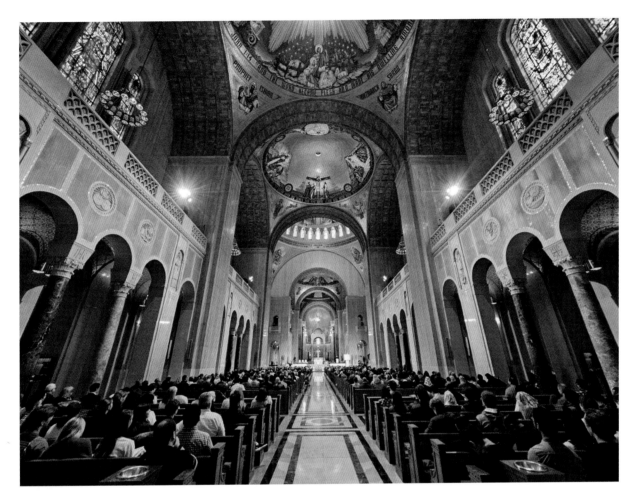

Gathered within the nave of the church, we are seated in the boat of Christ, with the pope, the Holy Father, at the helm. With trust in Christ and his Vicar on earth, we are journeying over the stormy seas of this life toward the safe harbor of heaven. If you find yourself in a church with a great curved wooden ceiling, you may look up to find that it does indeed resemble the overturned hull of a ship. The fourth-century bishop of Amasea (in modern-day Turkey), Saint Asterius, preached: "The sea is the world. The Church is a like a ship, buffeted by the waves but not swamped, for she has with her experienced pilot, Christ. Amidships she has the trophy of victory over death, for she carries Christ's cross with her. Her bow points east, her stern west, her keel is to the south. For her double rudder she has the two Testaments. Her rigging is stretched out like the charity of Christ, embracing the Church."

We have been embraced by the charity of Christ into his singular ark of salvation, sometimes called the Barque of Saint Peter, which is

the Church. Here we have been called to grow in charity, and here, as God's holy people, we are on a pilgrim journey toward heaven, facing the altar and the tabernacle, which is our focus. For it is here that "the dwelling of God is with men" (Rv 21:3).

Stations of the Cross

The nave is usually surrounded by images of the fourteen Stations of the Cross, which may even be simple crosses with numbers above them. The Via Crucis, or Way of the Cross, is a devotion fostered by the Franciscans, who have care of the holy places associated with the life of Our Lord in the Holy Land. Since the seventeenth century, when travel to the Holy Land became difficult or impossible, people have instead prayed the Way of the Cross in their own churches. When we pray the Stations today, perhaps we can pray for peace in the Holy Land and for the Christians who remain in the Middle East.

The Stations of the Cross are situated in the nave of the church to remind us, again, that our Christian life is a journey and, specifically, that we are called as disciples of Christ to follow him all the way to the Cross. Jesus told his disciples, "If any man would come after me, let him deny himself and

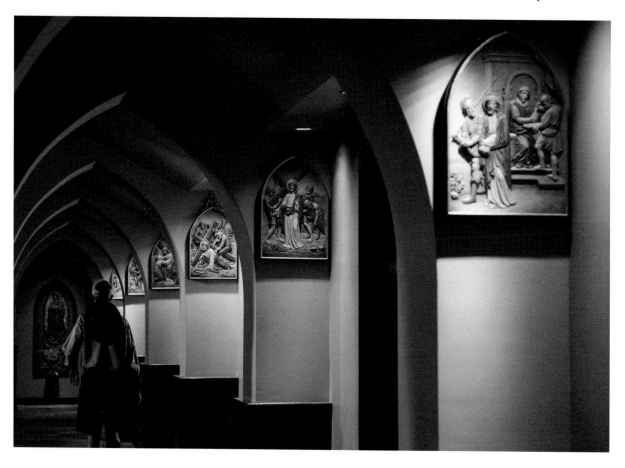

take up his cross and follow me" (Mt 16:24). Praying the Stations of the Cross is therefore a suitable preparation for the Mass, which is, as the *Catechism* says, "a sacrifice because it *re-presents* (makes present) the sacrifice of the cross" (1366). Seen in this light, the altar remains our focus, for it is Calvary, and it is to the Cross that we are journeying with Christ.

Pillars

In a Roman basilica, and in many churches, the nave is lined by columns. In Galatians 2:9, Saint Paul refers to three of the apostles (James, Peter, and John) as "pillars." Hence the pillars of the nave are a reminder of the apostolic Faith standing tall and firm; we who gather in the nave do so under the shelter and strength of the apostles' witness. In some churches, this link with the apostles is emphasized either by statues of the apostles flanking the nave or placed on the columns in the nave or by images of the apostles painted on the columns.

Statues of Saints

Similarly, statues of other saints are often seen lining the nave or inside chapels that open off the nave. Often the statues and stained-glass images of the saints stand high up, looking down on the nave. As we gather for worship in the nave, these visible images of the saints and angels remind us that we never come to Mass alone; the whole Church is present and gathered around the altar of God. We are the Church Militant, for we struggle and battle against our sins and temptations, against vices and sorrows in this life; the saints and angels in heaven are the Church Triumphant, for they share fully in Christ's victory over sin and death, and they cheer us onward. The Letter to the Hebrews says, "Since

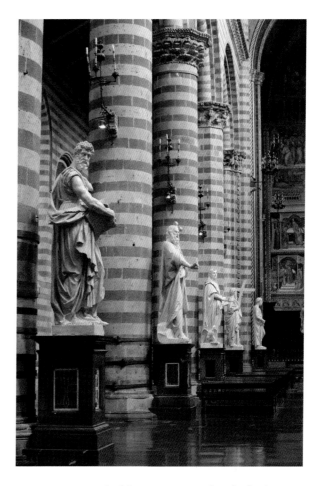

we are surrounded by so great a cloud of witnesses, let us also lay aside every weight, and sin which clings so closely, and let us run with perseverance the race that is set before us, looking to Jesus the pioneer and perfecter of our faith" (12:1–2). And the Church Suffering refers to the faithful departed in purgatory, those souls who, as we have noted, are on the cusp of paradise but are being purified of all worldly attachment to venial sins. Occasionally, you may see images of the holy souls in purgatory being purified by the flames of divine love. These images remind us to pray always for the dead, to remember

them with charity, and to pray the Mass lovingly for their purification and union with Christ in heaven.

The images of the saints throughout the church, which we will examine in more detail later in this book, and especially the images of the saints in the nave of the church, are a reminder to us of our place in the communion of saints. They spur us on to greater Christian love for ourselves and for one another by works of prayer, sacrifice, penance, and works of spiritual benefit. As Pope St. Paul VI said:

> Following in the footsteps of Christ, the Christian faithful have always endeavored to help one another on the path leading to the heavenly Father through prayer, the exchange of spiritual goods and penitential expiation. The more they have been immersed in the fervor of charity, the more they have imitated Christ in his sufferings, carrying their crosses in expiation for their own sins and those of others, certain that they could help their brothers to obtain salvation from God the Father of mercies. This is the very ancient dogma of the Communion of the Saints, whereby the life of each individual son of God in Christ and through Christ is joined by a wonderful link to the life of all his other Christian brothers in the supernatural unity of the Mystical Body of Christ till, as it were, a single mystical person is formed.

So, when you are seated in the nave and praying the Rosary or some other devotion, or kneeling during adoration or Mass, or walking and praying the Stations of the Cross, remember that our prayers can help and comfort the souls in purgatory, even as the saints in heaven can help and comfort us. We are also called to help and comfort one another both in the Church and in the world, following the example of so many great saints who performed concrete works of mercy and charity.

Consecration Crosses and Candles

The nave is also surrounded by twelve (or four) crosses marked out on the walls of the church. Usually, a candle is placed near them, and these candles should be lit at least once a year on the anniversary of the consecration of the church.

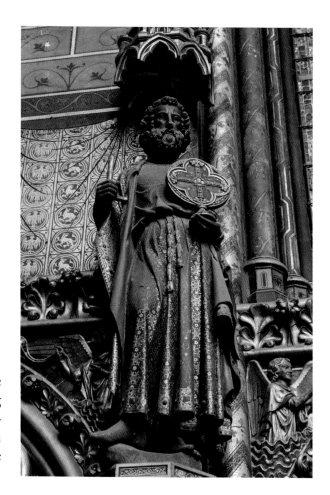

According to Durandus, first the crosses are a sign that the church building belongs to God, and so the demons, seeing the crosses, "will be terrified and not presume to return there." Second, the cross is the sign of Christ's triumph and shows that this place is under his reign. Third, these consecration crosses move us to "reflect on the Passion of Christ, by which he himself consecrated his Church, and that faith in the Passion will be implanted in [our] memory." The twelve candles, when lit, are said to stand for the apostles, who, by their faith in the cross of Christ, "illuminated all the world."

Candles are often lit in church by devotees as a sign of prayer and as a sign of our faith in God, which gives us hope, especially in times of difficulty. Our faith in Christ and his triumph is a light shining in the darkness, as symbolized by the many candles that burn in churches, shrines, and sanctuaries throughout the Christian world.

Lastly, it can be noted that the candle itself, and especially the paschal candle, which is kept in the sanctuary during Eastertide, is a symbol of Christ. The candle, made of wax by virginal bees, is an image of Jesus, whose human body is born of a virgin mother. The flame of the candle is an image of charity, the burning love of God. As the fire consumes the candle, so Christ offers his body up as a sacrifice of love for the salvation of souls. Candles always burn around the altar and are required for the Mass, even when they serve little practical use, because they remain an eloquent symbol of the sacrificial love of the Incarnate God.

Chancel or Sanctuary

From the earliest times, church buildings and even the "house churches" of the first centuries consisted of a space divided into three parts. We have looked

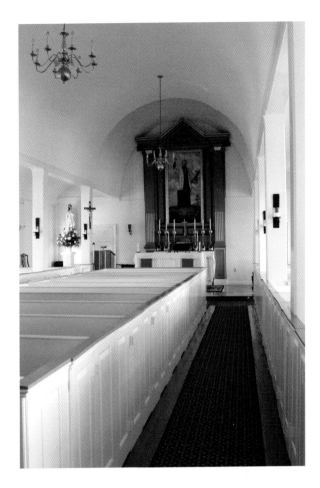

at two of these, the narthex and the nave, and we will now consider the third part, which is the focus of the entire building and its assembly: the chancel, or sanctuary. The name *chancel* comes from the Latin *cancellus*, which refers to a lattice screen or grating used to demarcate an area. The older Greek name for this area, *bema*, meaning "step," tells us that this was a raised part of the church.

As such, the chancel is always distinguished from the nave by being raised higher than the level of the nave or by an archway or by some kind of screen or low wall. Enclosed within this screened-

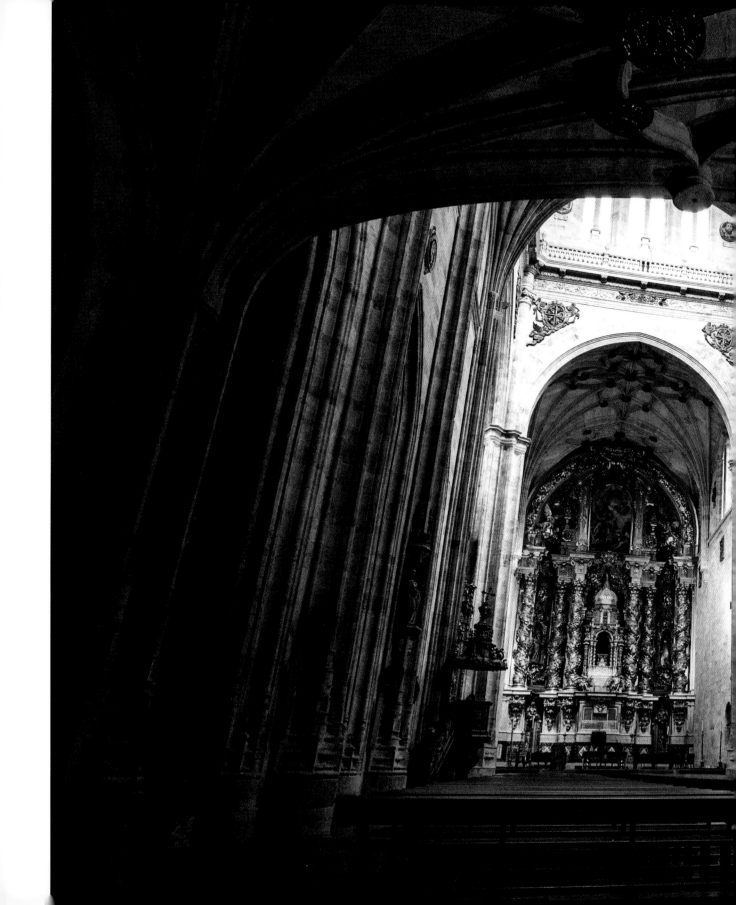

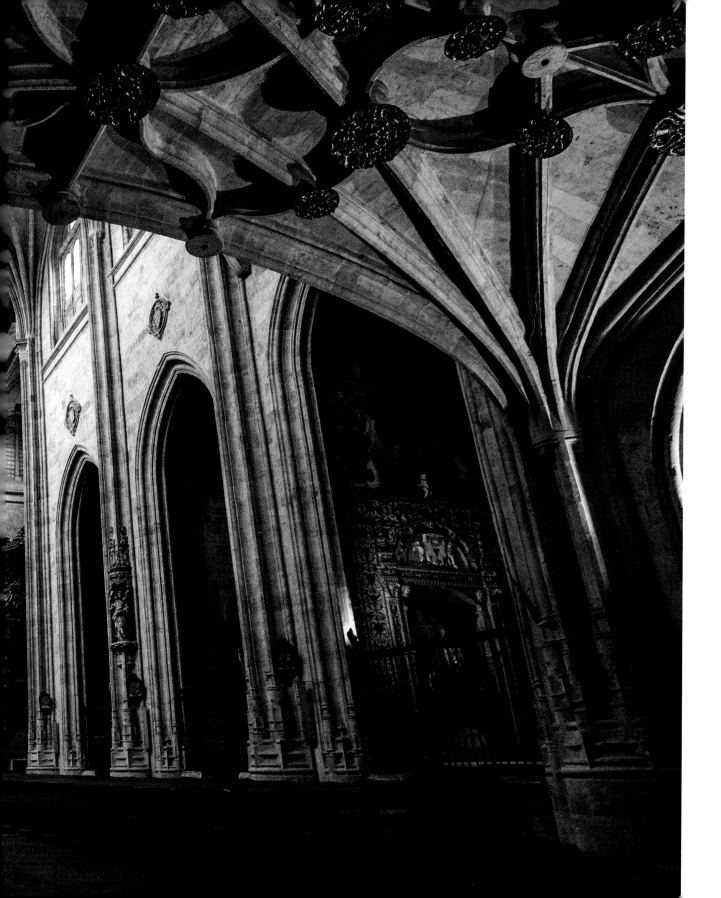

off area is the sanctuary, the holy place, for it is here that the altar is positioned, and it is here that the Sacrifice of the Mass is enacted. The words of Jacob that may be applied to the whole church building are specifically directed to this area around the altar of God: "Surely the LORD is in this place. ... How awesome is this place! This is none other than the house of God, and this is the gate of heaven" (Gn 28:16-17).

The sanctuary, or chancel, therefore, is that most sacred area of a church, in which heaven and earth kiss in the celebration of the holy Mass, and where the Eucharistic Lord, who comes among us and returns to be among mankind, rests on the altar and in the tabernacle. The sanctuary, as such, represents heaven and the goal of the entire pilgrim People of God. Adorned with art, beauty, and color, the sanctuary draws our eye and focuses us. It offers us encouragement and inspiration, drawing us forward as we struggle daily to take up our crosses and follow Jesus so that, at last, we may be where he is.

It is sometimes argued that the chancel should not be separated from the nave by any kind of physical barrier or marker. After all, has not the veil of the Temple, which separated the Holy of Holies from the outer courts, been torn down by the sacrificial death of Christ (see Mt 27:50-51)? Did the Lord not, then, remove such distinctions between priests and people, making us one priestly people? These are important theological questions, but they are red herrings.

The tearing of the Temple veil signifies that, by his death on the cross, Christ has opened the way to heaven for all people. Every human person, regardless of race or gender or any other identifying category, has the potential to be saved from sin and therefore has access to divine life in Christ. Thus Saint Paul says, "There is neither Jew nor Greek, there is neither slave nor free, there is neither male nor female; for you are all one in Christ Jesus" (Gal 3:28). Our fundamental equality as Christians is rooted in our common baptism into Christ, and our fundamental human dignity is rooted in the God who became man for our salvation.

The chancel is not separated from the nave because it is reserved for "better-class" Christians, as some people might mistakenly think, nor is the church set apart for "better-class" human beings! Rather, as I have noted, the church building stands as a sign to all that God lovingly and mercifully deigns to dwell among us and that within this holy place God may be found, and we can have access to his grace, his gifts, and his holiness. Second, recall that the consecration crosses are marked along the walls of the nave as well as around the sanctuary. They indicate that the whole church — nave and chancel — is consecrated to God, just as all Christian people have been redeemed by the cross of Christ and sanctified by his blood and are all baptized into his one Body. The removal of the veil of the Temple, therefore, signifies that all humanity can now become members of Christ's Mystical Body on earth, which is the one, holy, catholic, and apostolic Church. The church building, with all its symbols and beauty, exists to invite and draw people into this mystery of God's dwelling among us and our becoming his people, his visible and tangible Body.

Christ's Body, however, is nevertheless distinguished by parts that are ordered according to different vocations, equipped with different gifts and ministries, and in a way that is ordered toward growth in holiness and in charity (see 1 Cor 12:12-

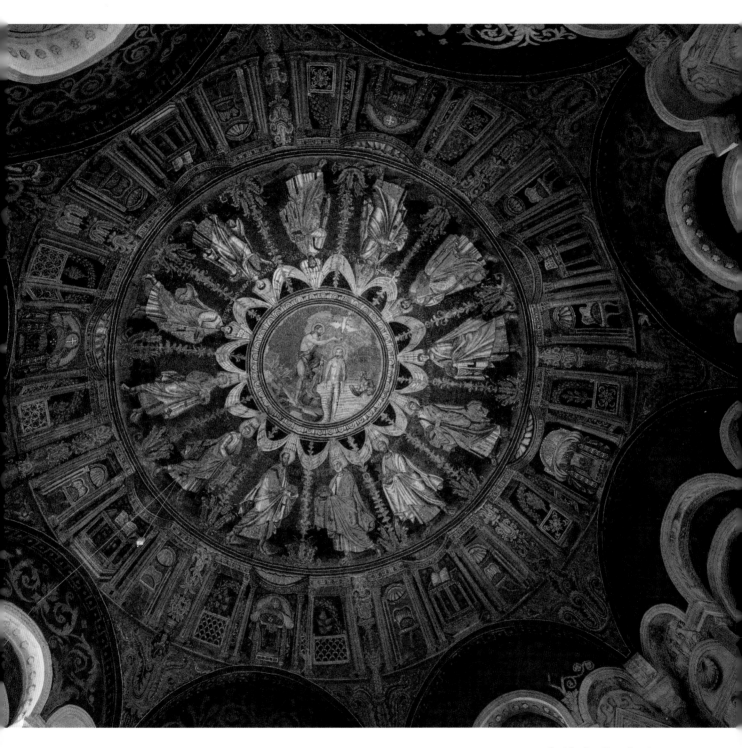

27). Hence the Church is hierarchical, which suggests an ordering or being led to the sacred by the sacred — that is, by the ordained ministers of the Church. The internal arrangement of the church building reflects the ordered hierarchical nature of the Church, so that the chancel is distinguished from the nave. The nave is the proper place of the laity, who participate in the liturgy mainly from there, and the chancel is the proper place of the clergy and the other ministers of the liturgy, who carry out their sacred ministries of the Holy Sacrifice of the Mass mainly from there. The Second Vatican Council said that

> Christ, the one Mediator, established and continually sustains here on earth His holy Church, the community of faith, hope and charity, as an entity *with visible delineation* through which He communicated truth and grace to all. But, the society structured with hierarchical organs and the Mystical Body of Christ, are not to be considered as two realities ... ; rather they form one complex reality which coalesces from a divine and a human element. (*Lumen Gentium*, 8, emphasis added)

The chancel is rightly distinguished in a physical way from the nave, and symbolically and artistically distinguished by its beauty and richness, because it is within the sanctuary that Christ, the Head of his Body, the Church, is present in the most holy Sacrament of the Eucharist. He is present for us, giving us his own Body and Blood in the Mass so that, united to him in love, we might become holy, as he is holy; so that we might, in the end, be found worthy to stand with the angels and saints in the

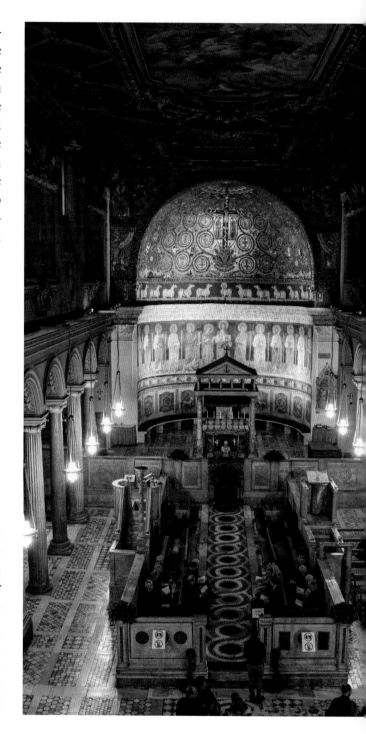

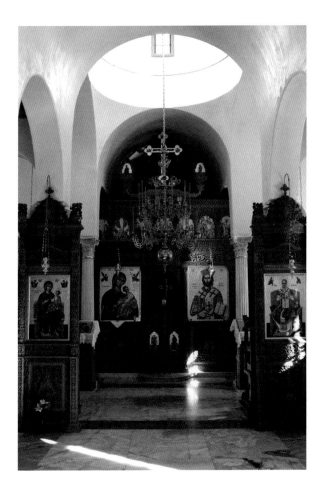

but people also came to use a church's nave for secular reasons, such as conducting business — after all, it was one of the few large, covered spaces in a town. In a sense, not much has changed. Visitors to the great churches of the world know that the nave is where the pious pray but also where beggars seek alms or a bench on which to sleep; where tourists busily chat and take photos; and where vendors might sell souvenirs or devotional objects. In such situations, a chancel wall, or even a screened-off choir enclosure, ensures the sanctity of the sanctuary as the place reserved for liturgical worship. It also keeps safe the altar and other sacred furnishings used in the liturgy, as already attested to by the fourth-century historian and Bishop Eusebius.

Over time, this wall grew taller, even several stories high, and it became an icon stand, or *iconostasis*, for sacred images of Christ and the saints. It has been suggested that from the seventh century onward, when churches were in danger of attack and pillaging, this wall of icons or a stone screen had a very practical protective function. In the Middle Ages in the West, the screen became popular from the twelfth century onward. It was called a *pulpitum*, and sermons were preached from atop it. Like an iconostasis, the Western chancel screen, whether made of wood or carved stone, had images of the saints painted or carved on it, and devotional altars were also placed against it on either side of the central door. For mendicant friars, such as the Dominicans, the chancel screen developed into a small passageway between the sanctuary and the nave and was referred to as the *intermedium* because the friars passed through it. The intermedium suggests both division and interaction between the friars, who lived a life of prayer and contemplation yet preached and carried out apostolic works

true sanctuary that is heaven.

Rood Screens and Altar Rails

Initially, a low wall was used to separate the chancel from the nave. This was done so that those who performed the actions of the Sacred Liturgy and sang the praises of God in the Divine Liturgy could do so unimpeded and without distractions from those who began to use the nave of the church for other activities. Some of these were good and holy activities, such as coming on pilgrimage to venerate the relics of a saint or to light candles before a shrine,

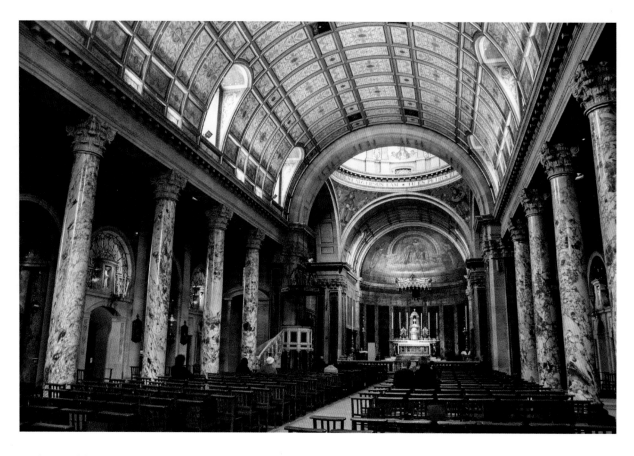

in the world.

Most importantly, however, the screen was surmounted by an image of the Crucified Lord on the cross, who was often flanked by Our Lady and Saint John. Hence it was known as a *rood screen*, from the Old English word referring to the cross. Later on, even when these screens were taken down, the crucifix remained, and some great churches still have a large "rood" suspended from the chancel arch or over the sanctuary.

The prominence of the cross reminds all of our salvation through the passion of Christ and of the Sacrifice of Calvary that is made present on the altar in every celebration of the Mass. The presence of the cross at this point, situated between the chancel and the nave, is also symbolically significant: It tells us that because of the cross and through the grace of the Crucified Lord, we can enter, with him, into heaven; moreover, we receive the fruit of his Sacrifice, which is eternal life. The Letter to the Hebrews says, "Therefore, brethren, since we have confidence to enter the sanctuary by the blood of Jesus, by the new and living way which he opened for us through the curtain, that is, through his flesh ... let us draw near with a true heart in full assurance of faith, with our hearts sprinkled clean from an evil conscience and our bodies washed with pure water" (10:19-22). As such, seeing the Lord

who saved us by his Precious Blood, we can feel confident to approach the altar and to draw near to Christ in holy Communion, which took place at the rood screen.

The Counter-Reformation period (late sixteenth-century onward) saw a rise in the prominence of preaching and of the visual spectacle and splendor of the liturgy, so the chancel screens were taken down or became much truncated. They became, once again, like the low walls of the early Christian churches and came to be known as altar rails or Communion rails. Perhaps, once more, the word used by the medieval Dominicans is appro-

priate. These rails or low walls are actually an intermedium, a place where the awesome and infinite Otherness of God meets our creaturely lowliness, a space wherein our God, who cannot be contained, nevertheless chooses, out of love, to come to us beneath the humble and fragile appearances of the Host. Here, we commune with him, as we "draw near with a true heart" full of faith. So, as in generations before ours, the Communion rail was that place, that support, where people approached the Eucharist with faith and hope, doing what Saint Francis exhorts: "See the humility of God, and pour out your hearts before him! Humble yourselves that you may be exalted by him! Hold back nothing of yourselves for yourselves, that he who gives himself totally to you may receive you totally!"

Ambo

This focus on the Eucharist, the Word-made-flesh sacramentally and given to us in holy Communion, is necessarily integrated with a focus on the word of God proclaimed and preached and given to us in the liturgy, for "Word and Eucharist are so deeply bound together that we cannot understand one without the other: the word of God sacramentally takes flesh in the event of the Eucharist," said Pope Benedict XVI. Citing the Second Vatican Council, he also said: "In considering the Church as 'the home of the word', attention must first be given to the sacred liturgy, for the liturgy is the privileged setting in which God speaks to us in the midst of our lives; he speaks today to his people, who hear and respond. ... Even more, it must be said that Christ himself 'is present in his word, since it is he who speaks when Scripture is read in Church'" (*Verbum Domini*, pars. 55, 52). For this reason, the altar, sometimes known as the "table of the Eucharist," is

supposed to be matched by a so-called "table of the Word." As Benedict XVI says: "Special attention should be given to the *ambo* as the liturgical space from which the word of God is proclaimed. ... It should be fixed, and decorated in aesthetic harmony with the altar, in order to present visibly the theological significance of *the double table of the word and of the Eucharist*" (*Verbum Domini*, par. 68).

We usually refer to the place where the word of God is proclaimed as a *lectern* or a *pulpit*, but the word used in early Christian architecture is *ambo*, from the Greek *anabaino*, meaning "to go up." As Saint Matthew recounts, Jesus "went up on the mountain, and when he sat down his disciples came to him. And he opened his mouth and taught them" (Mt 5:1–2). The ambo, then, was a raised platform that was ideally large enough for the deacon with two acolytes and the thurifer to ascend. It was usually placed in the nave of the church, outside the sanctuary. This tradition continued with the pulpit (from the Latin word for "platform" or "scaffold"), which was often a raised structure but was usually large enough for only one person. The lectern, or "reading desk," is not actually related to either of these permanent stone structures but is merely a kind of portable wooden stand for a book.

The significance of the "table of the Word" — ideally set up as a permanent raised platform to

which one ascends — is that it recalls the mountain from which Moses received the law, and the mount from which Christ preached the Beatitudes and taught the multitudes. It also follows the biblical imagery that divine teaching flows down from on high, just as rain falls to the earth and renders it fruitful. St. Thomas Aquinas said that "it is plain to the senses that from the highest clouds rain flows forth by which the mountains and rivers are refreshed, and send themselves forth so that the satiated earth can bear fruit. Similarly, from the heights of divine wisdom the minds of the learned, represented by the mountains, are watered, by whose ministry the light of divine wisdom reached to the minds of those who listen." Our minds are to be fed by God's wisdom, which we receive from the ambo, and from this same place we are taught by God's eternal Word, Jesus Christ, who "speaks when Scripture is read" from this elevated place during the liturgy. Our prayer is that we shall be uplifted by God's word and healed by the truth of the Gospel, and that it shall bear fruit in our lives by elevating our thoughts and our actions so that we seek to do those things that are pleasing to God.

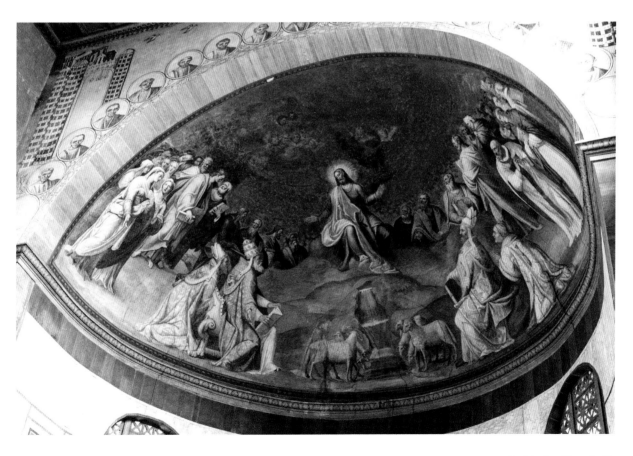

5

The Altar and the Tabernacle

Altare Christus est. "The altar is Christ." This principle is of such antiquity that we might say that the altar, in fact, is the primordial liturgical symbol, and everything we have considered so far should lead us to the altar — architecturally, visually, and theologically. It is here that the "sacred banquet" of Christ's passion is remembered and renewed; here that, through Christ, we "continually offer up a sacrifice of praise to God" (Heb 13:15). Christ himself is the altar of sacrifice, and, at the same time, he is the divine Victim of the sacrifice and the true High Priest who offers the sacrifice. Hence the *Catechism* says: "The Christian altar is the symbol of Christ himself, present in the midst of the assembly of his faithful, both as the victim offered for our reconciliation and as food from heaven who is giving himself to us. 'For what is the altar of Christ if not the image of the Body of Christ?' asks St. Ambrose. He says elsewhere, 'The altar represents the body [of Christ] and the Body of Christ is on the altar'" (1383).

Since the church is built for the liturgy and for the worship of God, we can say that a church is principally built to house the altar. The two are so intrinsically linked that Saint Cyprian would say that if the altar is absent, then the building is not a church. The Scottish architect Sir Ninian Comper says:

> The altar is the heart of the building, made public to the whole body of worshipers ... in such a manner as shall not grossly violate the earlier traditions of the Christian Church which veiled the altar from view. The open chancel screen, the transparency of which is completed by the great windows behind it, the low down east window and those which light the altar from the

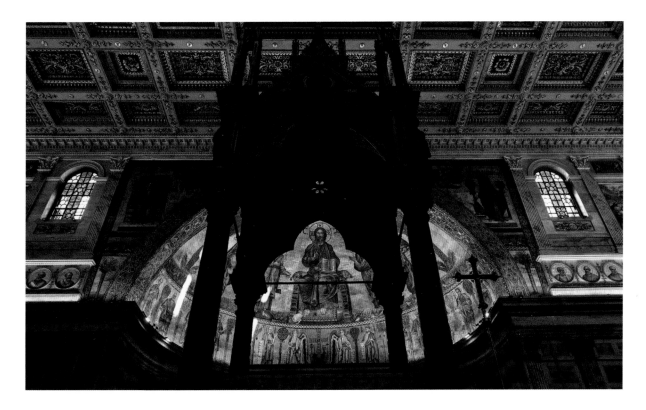

sides, [make] the whole church a lantern, and the altar is the flame within it.

The ornamentation of an altar with gilding, precious stones and mosaic, carvings, and so on serves to dignify the altar, to emphasize its nobility, to make it resplendent, and thus to draw the eye to it.

The church building and all its symbols should rightly draw our attention to the altar, focus us on the altar, and lead us toward the altar. Certain structures — whether a permanent canopy over the altar, properly called a *ciborium*, or a *baldacchino* if made of fabric; or a stone reredos behind the altar; or even monumental sculpture around the altar — serve the same purpose: to draw our attention to the altar and to the Holy Sacrifice that takes place upon it. St.

Germanus of Constantinople said that a ciborium is erected around the altar so as "to represent concisely the [place of the] crucifixion, burial, and resurrection of Christ. It similarly corresponds to the ark of the covenant of the Lord in which, it is written, is his Holy of Holies and his holy place."

Intrinsic to the altar's being a primary symbol of Christ himself is the requirement that it should be made of stone. Scripture refers to Christ as the cornerstone (see Is 28:16; Acts 4:11) and as the rock from which we receive the living waters of salvation (1 Cor 10:4). As such, Christ is our foundation and our strength, and the Eucharist celebrated on the altar is likewise the foundation of our Christian life and the source of its vitality and endurance. The altar stone is incised with five crosses, a symbol of

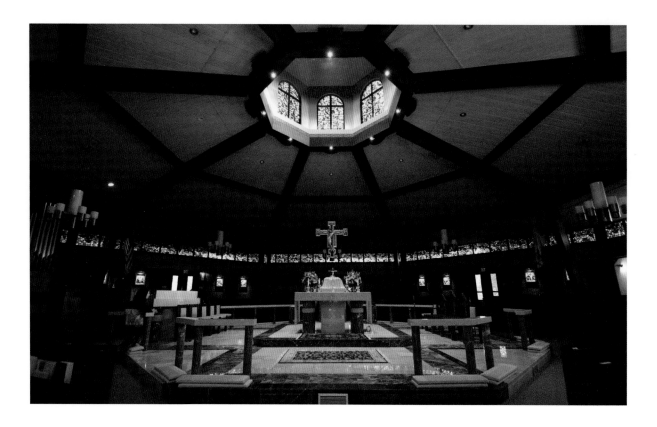

the five wounds of the Crucified Lord.

At its consecration, the altar is first anointed with chrism; then incense is burned on the altar, the altar is covered with a white cloth, and lit candles are placed around it. Each of these liturgical actions emphasizes that the altar is the principal symbol of Christ. First of all, the altar is anointed with chrism because it "makes the altar a symbol of Christ, who, before all others, is and is called 'The Anointed One'; for the Father anointed him with the Holy Spirit and constituted him the High Priest so that on the altar of his body he might offer the sacrifice of his life for the salvation of all," as we read in the instructions for the *Rite of Dedication of a Church and an Altar*. Then incense rises from the altar, a symbol of the prayers of the saints and martyrs being offered to God (see Rv 5:8), which is acceptable and pleasing to God because they are united to the immolation of Christ upon the altar. Often relics of martyrs are placed under the stone altar to underscore this union between the sacrifice of the martyrs and the sacrifice of Christ, King of Martyrs. The covering of the altar with a white cloth recalls the baptismal garment of the saints and martyrs, washed in the blood of Christ (7:14), and it is also a sign of the wedding feast of the Lamb, to which we are all called by virtue of our baptism (19:8–9). Finally, "the lighting of the altar teaches us that Christ is 'a light to enlighten the nations.'" All who see the lights burning around the

altar, all who seek true enlightenment, are called to come to Christ; to come to the altar and receive the Church's sacraments of eternal life.

Fr. Stefan Heid, in his study *Church and Altar*, refers to the altar as the "privileged negotiating space between heaven and earth. Here holiness culminates and is condensed in the powerful effect of prayer." Often this confluence of heaven and earth is expressed in the shape and location of the altar: a cubical altar symbolizes the "four corners" of the earth, and above it rises the dome, which symbolizes the heavens. So in the holy Mass that is celebrated at the altar, God comes to earth to dwell among us, and we are raised up to participate in the life of God, who is charity, perfect Love made flesh, made visible among us.

Although it is right and fitting that the altar of God in our churches should be nobly appointed and made beautiful and splendid as an expression of our love for God and our desire to give our best to God, the striking prophetic words of St. John Chrysostom always remain in the back of my thoughts as a necessary reminder of the order of charity.

The Golden-Mouthed Doctor of the Church exhorted the people of Antioch in his time, saying:

> The poor are a greater temple than the sanctuary; the poor are an altar that you can raise up anywhere, on any street, and offer the liturgy at any hour. Do not, therefore, adorn the church and ignore your afflicted brother, for he is the most precious temple of all. ... Now, in saying this I am not forbidding you to make such gifts; I am only demanding that along with such gifts and before them you give alms. He accepts the former, but he is much more pleased with the latter. In the former, only the giver profits; in the latter, the recipient does, too. ... Of what use is it to weigh down Christ's table with golden cups, when he himself is dying of hunger? First, fill him when he is hungry; then use the means you have left to adorn his table. Will you have a golden cup made but not give a cup of water? What is the use of providing the table with cloths woven of gold thread, and not providing Christ himself with the clothes he needs?

We are called by Christ to love him present in the poor and the needy (see Mt 25) and so to pay atten-

tion to the needs of the least of our brethren, each of whom is truly, through sacramental grace, made into a temple of the living God. This love for the poor must take priority and not be neglected while we adorn our churches so as to express our love for God, truly present in the Eucharist.

These words of St. John Chrysostom remind us that our churches and their artworks and fittings are symbols; that is to say, they point us to divine realities. They point to the Eucharist, which is Love made visible and present among us. These buildings and their beautiful things are made in order to stir up in us a deeper and truer love for God; they invite us into a deeper and more authentic relationship with God and with our fellow men and women. Indeed, if we understand their meaning, then the architecture of the church and its symbols demand of us a movement toward the altar, not just physically and exteriorly but interiorly. We are called to make of our own hearts an altar — to immolate our selfish desires, our pride, our vanity, our false images of God and self — and so to offer to God our "spiritual worship" (Rom 12:1).

Pope Benedict XVI commented at length upon this in his exhortation *Sacramentum Caritatis*. These passages have an enduring resonance for me that I wish to share here:

> Christians, in all their actions, are called to offer true worship to God. Here the intrinsically eucharistic nature of Christian life begins to take shape. The Eucharist, since it embraces the concrete, everyday existence of the believer, makes possible, day by day, the progressive transfiguration of all those called by grace to reflect the image of the Son of God (cf. Rom 8:29ff.). Pope John Paul II stated that the moral life "has the value of a 'spiritual worship' (Rom 12:1; cf. Phil 3:3), flowing from and nourished by that inexhaustible source of holiness and glorification of God which is found in the sacraments, especially in the Eucharist: by sharing in the sacrifice of the Cross, the Christian partakes of Christ's self-giving love and is equipped and committed to live this same charity in all his thoughts and deeds." In a word, " 'worship' itself, eucharistic communion, includes the reality both of being loved and of loving others in turn. A Eucharist which does not pass over into the concrete practice of love is intrinsically

is absent or dead! God works within us Christians both as the charity that empowers our works of love and is present among us, in our streets, in the least of our brethren, in the "distressing disguise of the poor," in those in need — and so we are being called to serve and love him visibly. For "he who does not love his brother whom he has seen, cannot love God whom he has not seen. And this commandment we have from him, that he who loves God should love his brother also" (1 Jn 4:20-21).

Tabernacle and Lamp

In the Book of Exodus, God gives instructions to Moses for the construction of the tabernacle, the great tent of meeting that the people of Israel erected during their journey from slavery to nationhood. God said, "Let them make me a sanctuary, that I may dwell in their midst" (Ex 25:8). Within our churches, the fixed structure for the secure reservation of the consecrated Eucharist is called a *tabernacle* in reference to this verse — for through the Eucharist, God dwells in our midst.

Over the centuries, there have been many ways of reserving the Eucharist. The main reason for doing this was so that it could be taken to the sick, both as *Viaticum* — that is to say, food for the final journey of those who are gravely ill — and also as Communion, to unite in charity those who are housebound and cannot be physically present at the community Mass. Initially, the Blessed Sacrament was reserved in a locked box in the sacristy, the room used for storing and preparing everything required for the celebration of the Sacred Liturgy.

Gradually, the tabernacle was moved into the wall of the sacristy, so it could be accessed either from the church or from within the sacristy. This meant that the tabernacle would be in a wall at the side of

fragmented." ... Here it is important to consider what the Synod Fathers described as *eucharistic consistency*, a quality which our lives are objectively called to embody. Worship pleasing to God can never be a purely private matter, without consequences for our relationships with others: it demands a public witness to our faith. (pars. 71, 82-83)

Our church buildings, visible on the landscape and prominent in towns, were constructed to be public witnesses to our faith that God is with us. So, too, we Christians, by our love and compassion for others, give public witness in a world that does not care that, in truth, God is with us — or that thinks God

the church, often beside the sanctuary. In Germany and other northern European countries, this developed into an often elaborate freestanding towerlike structure of wood or stone called a *sacrament tower*. This marked the laudable rise in devotion to the Eucharist, and people clearly came to church to adore the Eucharist. Candles often burned around the sacrament tower as signs of faith and sacrificial love for God. Nevertheless, the sacrament tower was always situated on the side of the church, sometimes in a transept, and not in the sanctuary.

The idea of associating the reserved Eucharist with the altar of the Mass, and thus giving it a central location, seems to have originated in England, Scotland, and France. There it became common to reserve the Blessed Sacrament in a pyx (a small locked metal container, often shaped like a dove) that was suspended above the altar and, when needed, was pulled down onto the altar. This descent of God upon the altar was evocative of these lines of Scripture: "And I saw the holy city, new Jerusalem, coming down out of heaven from God, prepared as a bride adorned for her husband; and I heard a great voice from the throne saying, 'Behold, the dwelling of God is with men'" (Rv 21:2–3).

The pyx would be veiled with a tentlike canopy, evoking the tabernacle of old. Mindful of Moses' tabernacle, Saint John writes that the eternal Word of God became man "and dwelt among us" (Jn 1:14). The Greek text of this verse can be rendered more literally as "The *Logos* became flesh and *pitched his tent* among us." Therefore, God himself builds the sanctuary whereby he shall dwell in our midst, and this sanctuary is the person of Jesus Christ himself, who, through the Eucharist, comes to dwell in us and we in him. The veiled, hanging pyx surely emphasized this sublime reality.

From the sixteenth century onward, the Church mandated that the tabernacle be placed on the main altar of the church, in the center, although cathedrals have always had tabernacles placed on another altar in a side chapel and not on the main altar. Today there is a return to some flexibility regarding the placement of the tabernacle that draws on the history and development of its location within a church.

Two things were required to distinguish and mark out the tabernacle: a veil, which gave the tabernacle the similitude of a tent, which, by definition, was made of fabric; and a lamp to be kept burning nearby. Although the veil is now no longer obligatory, the sanctuary lamp is still required. It is explained in the *Catholic Encyclopedia* as "a mark of honor [and]

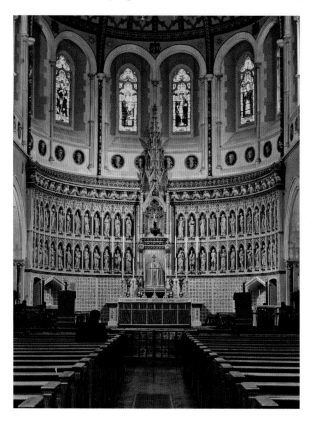

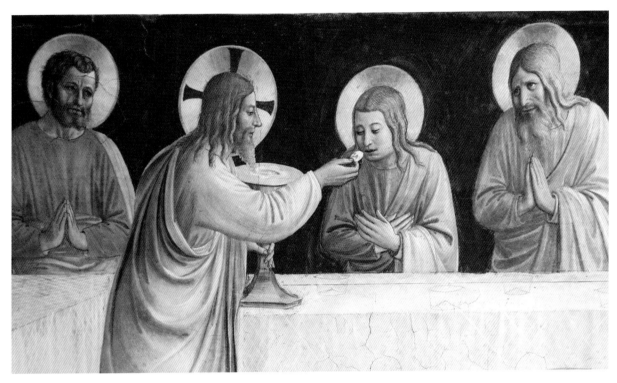

to remind the faithful of the presence of Christ, and [as] a profession of their love and affection." The loss of the fabric veil, however, and this description of the lamp seem to me to be an indication that the original Old Testament reference to the tabernacle has been forgotten. If the tabernacle refers back to the dwelling of God among his pilgrim people, then the lamp surely evokes the "pillar of fire" that guided the people of Israel in the desert and was a sign of God's presence with his people, dwelling in their midst (see Ex 13:21). The lamp, therefore, doesn't just honor God but rather is a reminder to us that God, out of his extraordinary love for mankind, has honored us! For he has pitched his tent and dwells among us, present in the person of Jesus Christ, who is truly and substantially God-with-us in the Eucharist.

And then, when we receive holy Communion, God comes to dwell in us, making each of us, in our bodies, tabernacles of the Lord. The Book of Revelation foretells that in the new Jerusalem, that is to say, in the realm of the saints, it shall be said: "Behold, the dwelling of God is with men. He will dwell with them, and they shall be his people, and God himself will be with them" (21:3). Heaven comes to earth, and indeed is within us, when God pitches his tent and dwells within us, and we become God's people and show we belong to him by living lives worthy of our Christian vocation. Thus Jesus says: "He who has my commandments and keeps them, he it is who loves me; and he who loves me will be loved by my Father, and I will love him and manifest myself to him. ... If a man loves me, he will keep my word, and my Father will love him, and we will come to him and make our home with him" (Jn 14:21–23).

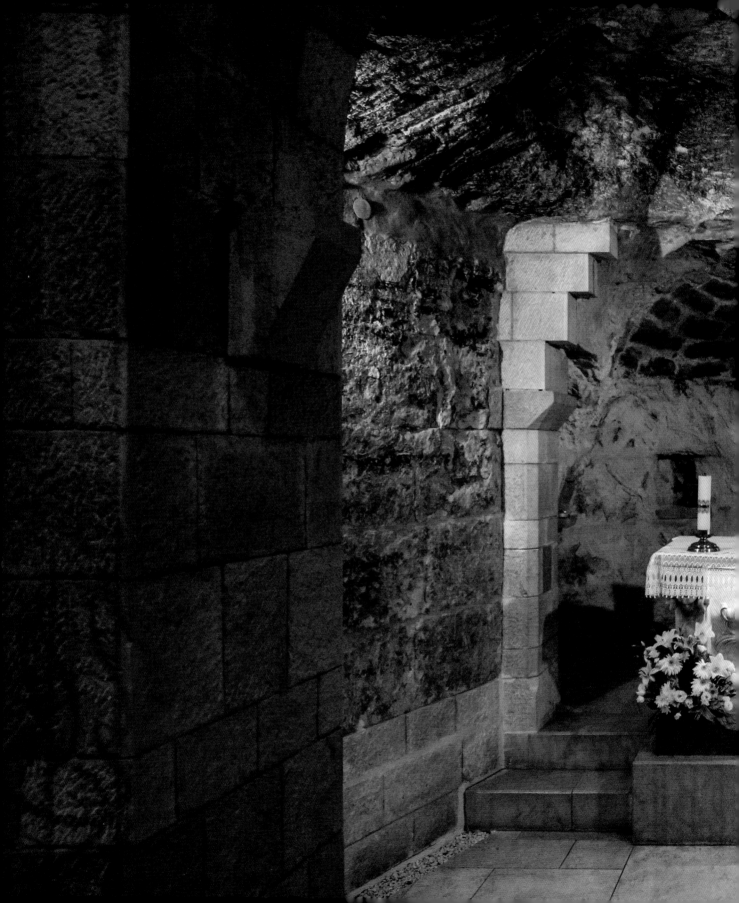

Part 2

6

The Way of Beauty

*And the Word became flesh and dwelt among us, full
of grace and truth; we have beheld his glory, glory as
of the only-begotten Son from the Father. And from
his fulness have we all received, grace upon grace.*

— John 1:14, 16

This fullness of the Christian life, of being alive in the Holy Spirit and
becoming fully mature in Christ, is embodied in the lives and actions
and witness of the saints. If, as I have shown, a church building is a
tangible and visible sign of God in our midst, God dwelling among us
and giving us a share in the life of God the Son — then, even more viv-
idly, a Christian who has received grace upon grace from the fullness of
God is called to become a living testimony of God-with-us, God acting
within us, God sanctifying and saving us. As Saint Paul said, "We are
his workmanship, created in Christ Jesus for good works, which God
prepared beforehand, that we should walk in them" (Eph 2:10).

The church building, therefore, is rightly beautiful and points to
heaven, where we hope to behold Beauty face to face. The beauty and
splendor of a church building, moreover, serve always to remind us of
what God wants to do with us, who have been called to be temples of
the Holy Spirit. Saint Augustine said: "The work we see complete in
this building is physical; it should find its spiritual counterpart in your
hearts. We see here the finished product of stone and wood; so, too,
your lives should reveal the handiwork of God's grace." Within the walls
of the church, God is with us in order to communicate to us his good-
ness, his majesty, his beauty. In the sacraments of the Church, in the
Sacred Liturgy, God gives himself to us so that we might become trans-

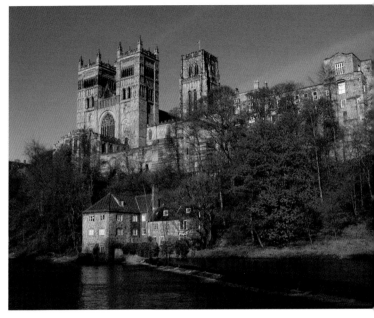

formed by his grace, made beautiful by the beauty of Christ, his beloved Son; made beautiful by grace so as to reflect the beauty of Mary, our immaculate and most beautiful mother; so that we might become saints and be made beautiful in ourselves.

For beauty is deeply attractive. During my years as a university student, I sang in a chamber choir, in which I was one of the few practicing Christians. Nonetheless, the music we sang was predominantly sacred music written for the liturgy, and we all loved to visit and sing in the great medieval cathedrals and churches that are found all over England, Scotland, and Wales. Although several of my fellow choir members claimed to be atheists, and several others were indifferent to God and the teachings of the Gospel, I could not help but notice the impact that beauty made on us all, regardless of our creed. When visiting a town, all of us would be drawn to see the cathedral, to marvel at the beauty and grandeur of the building, to admire the art within. And, of course, we loved the beauty of the music we sang and heard in the church. This experience sparked my interest in beauty and sacred art because I realized that beauty was attractive, that it

had the great potential to preach and draw souls to the truth of Jesus Christ. The Church thus speaks of the *via pulchritudinis*, the "way of beauty," that can lead souls to contemplate Beauty himself. Pope Benedict XVI observed that "to admire the icons and the great masterpieces of Christian art in general, leads us on an inner way, a way of overcoming ourselves; thus in this purification of vision that is a purification of the heart, it reveals the beautiful to us, or at least a ray of it. In this way we are brought into contact with the power of the truth."

But ours is not a contemplative age, and in our hasty scrolling through a myriad of images on our screens, it is harder to be struck by beauty and purified by it. The ubiquity of images makes even the beautiful commonplace or merely a commodity to be consumed. Tourists and students alike are often found viewing reality through their screens, photographing the art and buildings rather than stopping to look at the art and to truly see. I, too, am often guilty of this.

Beauty does attract, but what we need is some help to stop and see. Through my photography and through this book, I aspire to help draw people's attention to beauty, to try to arrest their attention so that they can pause and look and see. As the Anglican missionary and painter Lilias Trotter said: "Come and look. ... [My] intent is to make you see. Many things begin with seeing in this world of ours."

But I realize, too, that often the symbols and stories within the church building do not communicate as fully as they could, because the people looking at them do not understand or know what they are referring to. This affects not just my non-religious friends; even practicing Christians may not appreciate what they're looking at. Many years ago, I undertook to decipher for myself the symbols and stories found in the various depictions of the saints and to better understand the symbols found in church architecture. I then set about to explain these to my friends, and I began to add explanations to the captions in my photographs that I posted on Flickr.com. I enjoyed finding out about the saints and their symbols in art, and I delighted in the various ways that artists have depicted Christ, Our Lady, and the stories of the Bible.

The remainder of this book is my attempt to share that delight with you. I hope you will discover with me the saints and the Scriptures within our churches (and many of our museums) and the stories that lie behind the rich treasury of symbols that decorate church buildings. I pray that this exploration of church architecture and the symbols of sacred art and the saints will inspire you to read and understand the Bible more deeply and to examine the lives of the saints and to befriend them. Equipped with this knowledge and with the example of the saints in mind, you will also be able to help others — your own family, your friends, and maybe even the tourists around you — to appreciate more profoundly the beauty they behold in our churches. Beauty attracts, but we must help ourselves and others to walk the *via pulchritudinis* toward God, who, as Gerard Manley Hopkins said, is "beauty's self and beauty's giver." So Pope Benedict said: "I have often affirmed my conviction that the true apology of Christian faith, the most convincing demonstration of its truth against every denial, are the saints, and the beauty that the faith has generated. Today, for faith to grow, we must lead ourselves and the persons we meet to encounter the saints and to enter into contact with the Beautiful."

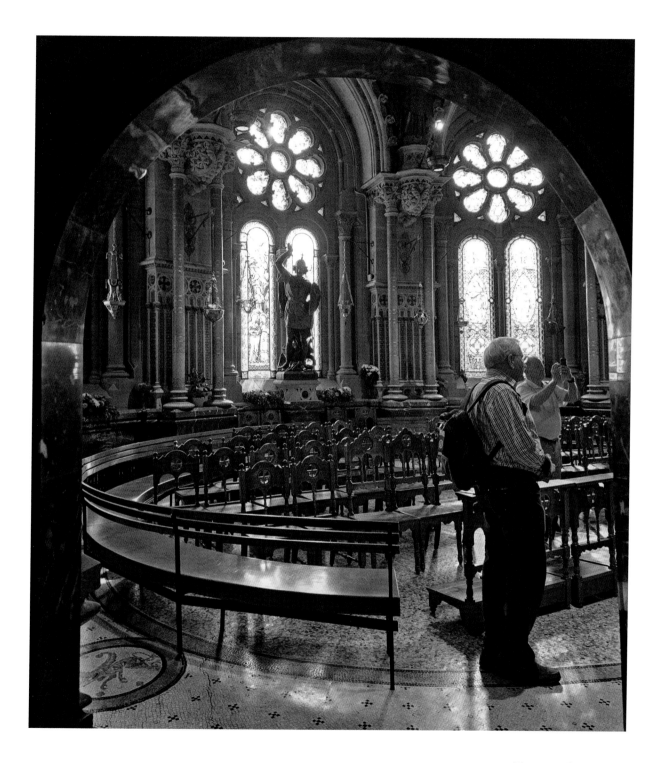

The Organization of Part II-IV

Having looked at the symbolism of the church building and its structural parts in part I, in parts II through IV, we will look at the signs and symbols one finds in and around the church building. In part II, we will look at symbols and decorative emblems or signs that are found incorporated into the church building and its furnishings. All the symbols, signs, and attributes that we shall examine in our church buildings and also in the sacred art of the saints can be divided into two kinds: living things, or animate creatures; and nonliving things, or inanimate objects. We will look first at living things in the symbols around a church and then at nonliving things, all presented in alphabetical order.

In part III, we will look at biblical scenes that are often found in a church. It is not possible to provide an exhaustive account of these here, but to help us focus, I shall present depictions of the fifteen mysteries of the traditional Dominican Rosary and also ten Old Testament scenes that prefigure the New Testament. Also in this section, I will consider the various ways in which God, Jesus Christ, the Blessed Virgin Mary, the angels, the apostles, and the sacraments of the Church are depicted and how to identify them.

Finally, in part IV, I will explain how we can

identify the saints in sacred art. We shall consider things such as what they are wearing, what they are holding, and any other emblems, signs, and creatures that are associated with them, which are known as *attributes* of a saint. Attributes are usually drawn from the lives of the saints or their works. As with the first section, I shall divide the attributes of the saints into the living and the nonliving, again arranged alphabetically.

A Universe of Symbols

The word *symbol* is derived from the Greek *symballein*, which denotes bringing two halves together so as to see the whole reality. As such, a symbol shouldn't be thought of as a mere nominal representation in the way that a logo represents a company or a national flag represents a country — neither image makes present the corporate entity or the nation's people. We might call these *emblems* or *signs* that point us to a reality. A true symbol, however, is one that brings together the visible external reality and the invisible reality to make the whole reality present, just as the whole reality of the human person is composed of both that which is seen, the body, and that which is unseen, the soul. Man, therefore, may be regarded as a symbol of the created universe, both material and spiritual.

The British science writer Philip Ball helps us to clarify this understanding of symbolism. He says in *Universe of Stone*:

> The notion of a medieval church as a representation of heaven is easy to misunderstand. ... It would not be stretching the point too far to say that this art was performing a function that science aims to fulfill today: to simplify the world, to

strip away what is contingent from what is essential, to reveal the framework. Art existed to reveal the deep design of God's creation. That was equally true of the art we call architecture. So when we say that the church was conceived as an image of heaven, we should not regard it as a kind of theatrical set intended to depict God's realm. ... Rather the structure of a church encoded a set of symbols and relationships that mapped out the universe itself.

As we saw in part I, the church building, in fact, maps out the Christian journey of salvation, and the baptized person is led deeper into union with God. The result is that we should come to realize that the universe doesn't revolve around us — we are made for God. All creatures, all things, ultimately must revolve around God, for all being depends on him.

As Joseph Ratzinger said: "Becoming a Christian ... is something quite simple and yet completely revolutionary. It is just this: achieving the Copernican revolution and no longer seeing ourselves as the center of the universe, around which everyone else must turn, because instead of that we have begun to accept quite seriously that we are one of many among God's creatures, all of whom turn around God as their center." The church building and its rich combinations of signs and symbols should aid in this revolution, this reorientation of our lives and our focus.

For the medieval Christian, the world itself and all creatures were a symbol, pointing to a divine truth and revealing in their being something of the majesty and wisdom and beauty of the Creator. As the French medieval art historian Émile Mâle says in *The Gothic Image*: "The world therefore may be defined as 'a thought of God realized through the Word.' If this be so then in each being is hidden a divine thought; the world is a book written by the hand of God in which every creature is a word charged with meaning. ... All being holds in its depths the reflection of the sacrifice of Christ, the image of the Church, and of the virtues and vices." The Dominican saint Albert the Great, who is

the patron of natural scientists, said that "the whole world is theology for us, because the heavens proclaim the glory of God."

Therefore, when we look at a church building, and look at its ornamentation, few things are superfluous or merely decorative. In a church building that is properly derived from and understands this medieval Christian mindset, every symbol, whether animate or inanimate, has a meaning and a reality that discloses Christ, who is, as Saint Paul says, "the power of God and the wisdom of God" (1 Cor 1:24). Mâle observed that the Gothic churches of medieval Europe, with their rich array of carved foliage, animal life, earthly and heavenly creatures, and even monsters and beasts, depicted in carved stone and stained glass showed that "the Church ... was the ark to which every creature was made welcome." Indeed, it seems to me that all of creation — animate beings as well as minerals and metals, stone and silica, and also plant materials represented by textiles and silks — is brought together in the church building, converging on the Sacred Liturgy, wherein all creation is caught up in the worship of God, in the offering of the Son to the Father.

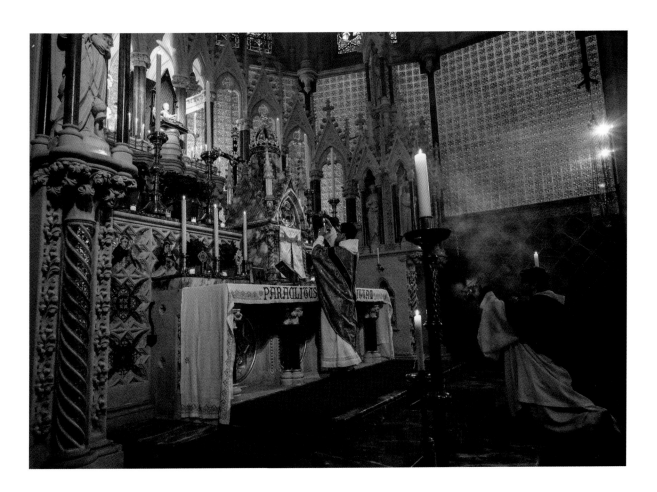

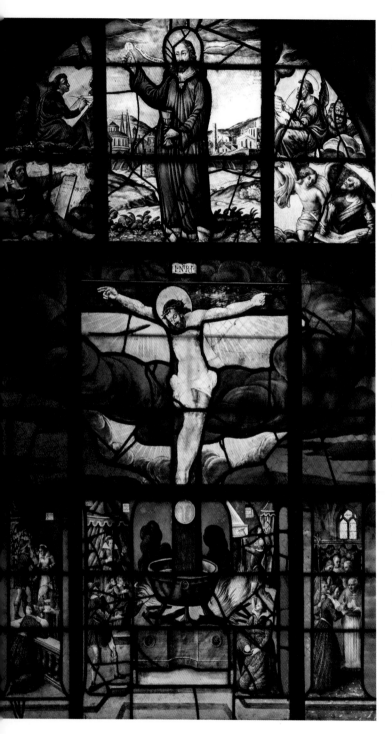

This understanding of symbols gives rise to the kind of symbolism that we Catholics would call "sacramental." Neither Ball nor Mâle uses this term, but the people who built our churches, certainly in the Middle Ages, would have understood that their buildings were external realities, outward signs, that disclosed an interior grace, a deeper truth. Sacramentals reveal the divine presence working in the world, in our lives, in the things we use and relate to. Hence church buildings, with all their symbolic art, must be understood in relation to the liturgy, because their symbolic sense is derived from it. The liturgy itself is a sacramental sign, the symbol *par excellence*, for it is a re-presentation of the Sacrifice of Calvary, an actualization of Christ's living Presence among us. Through it, truly, God is with us. Klemens Richter says that "in speaking of the liturgy as sign we can say that it not only points to something else, like every sign, but that it makes a reality present." So, too, the church building, within which the Divine Liturgy takes place, makes the reality of God present in our world. Moreover, the symbols and signs of created realities both within and outside the building, wrought by skilled craftsmen and artists, makes present the whole created world, offered to God in worship and praise and for his greater glory, even as Christ comes among us in the Eucharist.

While all symbols are signs, and while the church building itself is one great symbol, not all signs are symbols. Incorporated into the church building and its furnishings and vesture are signs that act as *aides-memoire*, pointing to sacred realities or reminding onlookers of truths of the Faith. Often, these signs and emblems are graphic representations of people or of institutions — for example, a heraldic shield or the monogram of the Holy Name

of Jesus. Or they might refer us to an event, as do the instruments of the passion of Christ. Sometimes they point us to a doctrine; for example, a trefoil can be seen as a reference to the Triune God. Each of these signs leads the mind of the viewer to the things of God, to help us to remember the sacrifice of Christ, or the motherly compassion of Our Lady, or the good works of the saints. As we walk around a church and slowly take in these signs and emblems, as we view them with understanding, we can grow in our faith in God, in our hope for heaven, and in our love within the communion of saints.

What follows aims to help you view the symbols and signs in a church building with more understanding so that you can see the whole reality, and, by reflecting on those symbols and signs,

you can be brought closer in devotion and love to the One who makes all that is. It is not possible to present an exhaustive list of these things, but I hope that what is included here will cover most of what you are likely to encounter. Neither has it been possible to provide a comprehensive explanation of Christian symbolism; for this, one would need to consult a bestiary and dedicated books, of which some good translations are currently being prepared and others are already in print. I hope, however, that what I have been able to include will satisfy your curiosity, deepen your appreciation and understanding of our churches, and pique your interest so that you'll want to find out more about these symbols.

7

Signs and Symbols: Living Creatures

Let everything that breathes praise the LORD.

— Psalm 150:6

Apple

In Old English, *apple* is the general word for a fruit; hence a fifteenth-century English carol says that Adam fell from grace, "And all was for an apple, / An apple that he took. / As clerkes finden, / Written in their book." Scripture does not mention an apple specifically but just the fruit of the tree of the knowledge of good and evil (see Gn 2:17, 3:3). Nevertheless, in the popular imagination and in sacred art, Adam and Eve are sometimes shown eating of a fruit that looks like an apple (*Malus domestica*). Saint Jerome, when he translated the Bible from Hebrew into Latin, chose the word *malus* for *fruit*. It sounds similar to the Latin word *malus*, meaning "evil," so it's a good pun. When the term *malus* later came to be associated exclusively with the fruit we now call an apple, the apple came to be a symbol of the fruit that Adam and Eve disobediently ate. Sometimes shown with a snake entwined around it, the apple is thus a symbol of the temptation and Fall of humanity into the condition of original sin.

Birds

Many diverse species of birds are depicted in churches, but some have a particular symbolic resonance or refer to passages from Scripture. Here are ten of the more common birds that you might find in a church building.

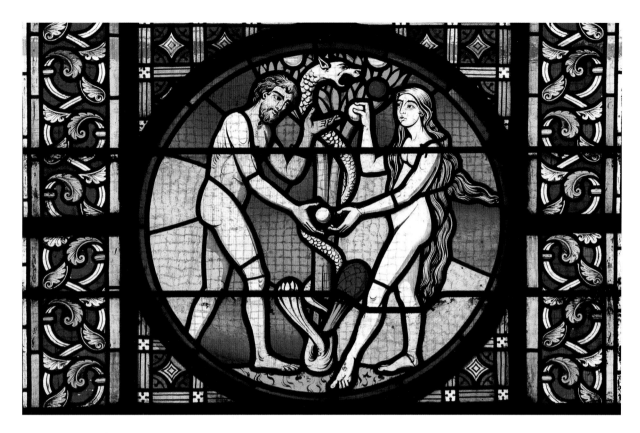

Dove: Of all the ways of depicting the Third Person of the Holy Trinity, the Holy Spirit, the dove is the one most commonly employed by artists, based on this verse of Scripture: "The Holy Spirit descended upon him in bodily form, as a dove" (Lk 3:22). Doves are also to be found in depictions of the Presentation of Jesus in the Temple (see Lk 2:22-39) because they were offered by the poor as a sacrifice (Lv 12:8), and so Joseph and Mary brought "a pair of turtledoves, or two young pigeons" to be offered to the Lord in the Temple.

In early Christian art, doves were a symbol of the soul and might be shown resting in the tree of life, which is the cross. Interestingly, places where containers for cremated remains are stored are known as *columbaria* because the little niches resemble a dovecote, and *columba* is the Latin word for *dove*.

In medieval churches in France and England, the Blessed Sacrament was sometimes reserved in a hanging pyx (see chapter 5) and these pyxes were sometimes fashioned into the shape of a dove, perhaps as a sign of the Holy Spirit descending upon the altar, as it is by the Holy Spirit's power that the Host is consecrated; in the words of the third Eucharistic prayer: "By the same Spirit graciously make holy these gifts we have brought to you for consecration."

Occasionally, a dove is also used as an attribute for a saint (see chapter 22).

Eagle: St. Albert the Great observes that the eagle "is a high flyer and has a vision so sharp that it can gaze into the orb of the sun." Consequently, the eagle is sometimes regarded as a symbol of the contemplative soul or of St. John the Evangelist, the model for theologians who, being borne aloft on the breath of the Holy Spirit and directed toward the heights of prayer, can gaze into the light of divine truth.

The eagle is one of the symbols for the evangelist Saint John (see chapter 19), and a custom arose of making church lecterns or bookstands in the form of an eagle with its outstretched wings supporting the Gospel book or large volumes of chant used by cantors. In England and the Low Countries, many of these medieval bronze eagle lecterns survive, with a magnificent eagle perched on a globe, a sign that the word of God, proclaimed by Saint John and the other evangelists, has gone out to the whole world. Often these eagle lecterns had small lions perched at the bottom, forming the feet of the lectern, and this is a sign perhaps that Christ has overcome the lions (see below), who symbolize death, in reference, perhaps, to Daniel 6.

The eagle is also regarded as the king of birds, and an influential second-century Greek book of Christian allegory, the *Physiologus*, describes the eagle as a symbol of Christ. The Romans had an eagle on their military standard as a symbol of victory, and the eagle also came to symbolize Christ's victory over death.

Finch: The European goldfinch has distinctive plumage: a splash of red on its head, a sign of the passion, and brilliant yellow on its wings, a sign of the Resurrection. It also feeds on thistles and thorns, which shows its fortitude and association with the passion of Christ. One occasionally sees the goldfinch in Renaissance paintings of Our Lady with the Christ Child as an indication of the destiny of the Child. As Simeon prophesied: "Behold, this child is set for the fall and rising of many in Israel, and for a sign that is spoken against (and a sword will pierce through your own soul also)" (Lk 2:34-35).

Owl: In Greek mythology, the owl was associated with Athena, the goddess of wisdom, and this association of the owl with wisdom has continued in Christian buildings. Sometimes the owl is associated negatively with the creatures (and works) of darkness and the night, but I don't think this is necessarily a bad thing, for all creatures are called to worship God, whether they be diurnal or nocturnal. In some medieval bestiaries, the owl was even associated with Christ, who went off into solitude and was hidden from view, as owls are, and who preached to those in sin and darkness, even as the owl calls out in the night. The English stained-glass artist John Piper features the owl among other animals in his Nativity window in the medieval church of St. Mary the Virgin in Iffley (near Oxford): It was believed that on Christmas night, the animals were given the power of speech, and in the window's design, speech bubbles are drawn, emanating from the beasts, as they tell of the miracle of Christ's birth. While the rooster proclaims that Christ is born, the owl says, "*Ubi? Ubi?*" meaning "Where? Where?" to which the lamb replies, "Bethlehem!"

Peacock: The ancient Greeks believed that the peacock, associated with the queen of the gods, Hera, had flesh that did not decay after death. Saint Augustine writes in *The City of God*: "Who but the Creator of all things gave to the peacock the power of resisting putrefaction after death?" He

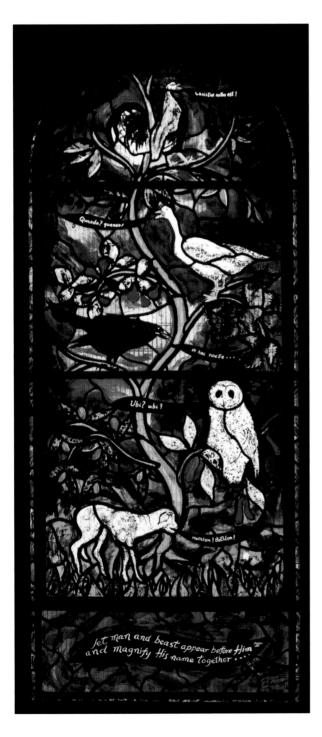

put this to the test, setting aside some cooked peacock breast meat for a year, after which he found it "had no offensive smell ... except that the flesh was somewhat dry and shriveled." Because of this belief that the peacock's flesh did not decay after death, the animal became a symbol of the risen body, of life after death, and of the Resurrection.

A particularly beautiful symbol found in early Christian art shows two peacocks drinking from a vessel or flanking the monogram of Christ or a cross. This shows that we derive our immortality or the power of resisting decay after death from Christ, by drinking of his Precious Blood in the Eucharist or by drinking the waters of eternal life. For the Lord said, "Whoever drinks of the water that I shall give him will never thirst; the water that I shall give him will become in him a spring of water welling up to eternal life" (Jn 4:14).

Pelican: St. Thomas Aquinas's Eucharistic hymn "Adoro Te Devote" has a verse that says (in the translation of Fr. Gerard Manley Hopkins, SJ): "Bring the tender tale true of the Pelican; / Bathe me, Jesu Lord, in what thy bosom ran — / Blood whereof a single drop has power to win / All the world forgiveness of its world of sin." The belief, then, was that the pelican is a symbol of self-sacrifice and love, for the pelican was said to nourish her young with blood from her own breast. As such, the pelican symbolizes Christ, who, in his sacrificial love for humanity, gives us life and feeds us with his own Body and Blood in the Eucharist.

Pelicans in nature do, in fact, often point their bills to their breasts when they groom themselves, and the pouches of the bills of certain pelicans turn bright red during their breeding season.

The "tender tale," first recounted in the *Physiologus* and repeated in other medieval bestiaries, is a

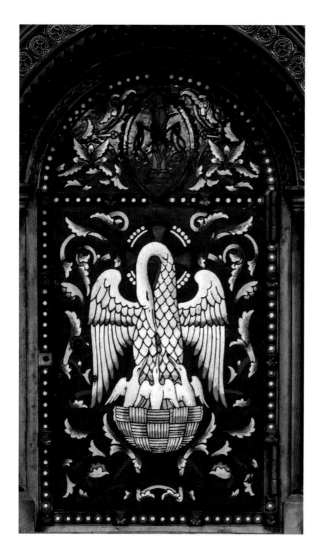

with its own blood." Analogously, then, one finds in this tale a certain image of the Son, the offspring of the Father, who is killed (albeit most certainly not by the Father!) and lies dead for three days. One also finds, separately, the image of the Divine Son who wounds himself to give eternal life to us, his "offspring," who are dead through sin. The latter image is more obvious and easier to comprehend, whereas the former is problematic; hence it is often left unstated.

Signs are not always unambiguous, and these allegories drawn from nature and bestiaries are often ambivalent and equivocal. At best, however, they are a glimpse of the divine mystery of Christ, which is dimly reflected in the mirror of the created world, as Saint Paul says: "For now we see in a mirror dimly" (1 Cor 13:12).

The pelican was also observed in some places to feed on lizards and serpents, and this became a figure of Christ devouring the demonic and so ridding the world of sin. From this, the pelican came to symbolize the protective and healing and nourishing works of the Savior, Jesus Christ, who sacrificed himself for the salvation of all.

Phoenix: The phoenix is a mythological beast, one of several that are found in church buildings and Christian art. The Greek historian Herodotus first describes the phoenix in the fifth century BC: It is a bird, roughly the size of an eagle, that can live for more than five hundred years. When the end of its life is near, it builds a funeral pyre and immolates itself, and, on the third day, a new phoenix rises from the ashes. The phoenix, therefore, was an ancient symbol of rebirth that was appropriated by Christian artists as a sign of the self-immolating sacrifice of Christ and of his resurrection on the third day.

little more complex. Saint Isidore's seventh-century text *Etymologies*, for example, reports that "the pelican (*pelicanus*) is an Egyptian bird inhabiting the solitary places of the river Nile, whence it takes its name, for Egypt is called *Canopos*. It is reported, if it may be true, that this bird kills its offspring, mourns them for three days, and finally wounds itself and revives its children by sprinkling them

In the fourth century, a poem attributed to the Christian poet Lactantius gives such a Christian interpretation to the myth of the phoenix. A ninth-century Old English poem, *The Phoenix*, is based on this work and suggests that the phoenix lived in the Garden of Eden. The poem begins: "There lies a place far off, on the eastern edge of the world, / A blessed place, where the great portal of the eternal skies stands open." In Christian art, the phoenix has become also an indication of heaven or paradise, where it is said to dwell.

Raven: The raven or crow is one of the first birds to be mentioned in the Bible. Perhaps because ravens are good scavengers and have keen sight, Noah sends out a raven after the great Deluge to feed off the carrion, which it does. It does not return to the ark, presumably because it has found food for itself (perhaps washed up into branches and rocky crags), but Noah deduces from this that the raven has not yet found arable land that is habitable; eventually, the dove would give evidence of such land emerging (see Gn 8:11).

Likewise, as scavengers, the ravens bring food to the prophet Elijah in the wilderness (see 1 Kgs 17:4), so they are a sign of God's providence and care for humanity. In this vein, Jesus, when teaching about divine providence, tells his disciples to "consider the ravens: they neither sow nor reap, they have neither storehouse nor barn, and yet God feeds them. Of how much more value are you than the birds!" (Lk 12:24).

Occasionally, a raven or crow is also used as an attribute for a saint (see chapter 22).

Rooster: The rooster or cockerel — that is, a male chicken — is often depicted at the top of a church spire. When the great fire of 2019 devastated Notre Dame Cathedral, the spire toppled

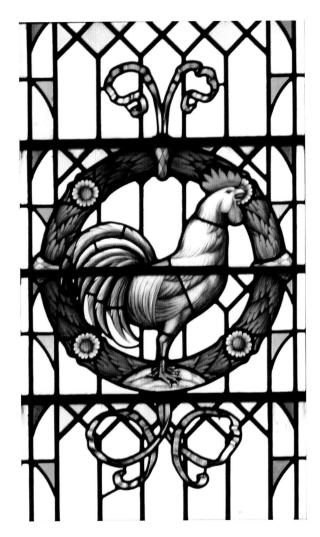

and took with it a bronze rooster that contained three relics: a small thorn from the Lord's crown of thorns, which is the singular most important relic in the cathedral treasury; a relic of Saint Denis, the first bishop of Paris, martyred in the third century at Montmartre; and a relic of Saint Genevieve, patroness of Paris. Miraculously, the rooster survived intact, and the relics were recovered.

On the night before his death, Jesus had fore-

told: "Peter, the cock will not crow this day, until you three times deny that you know me" (Lk 22:34); and when this prophecy came to pass, Peter wept and repented. A church outside the walls of Jerusalem commemorates this event — the church of St. Peter in Gallicantu, meaning "of the cockcrow." Consequently, Saint Peter is sometimes shown with a cockerel.

Pope Gregory the Great decided that, because of this incident, the rooster is a suitable emblem for Christianity, and, in the ninth century, Pope Nicholas I decreed that all churches should display a rooster. This led to the creation of weathercocks — weathervanes with the figures of roosters mounted on them — at the tops of spires.

It seems to me that the constant movement of the weathervane, changing with the direction of the wind, reminds us of the vacillation of the human will and of our thoughts and opinions, which are always subject to change. But the most important change that we human beings are capable of is that we can repent of our sins and change our sinful habits and desires — which is precisely what the rooster calls us to.

Sparrow: These are among the smallest of birds, and they are mentioned in the psalms and in the Gospels. So Jesus uses them in his instruction to the Twelve Apostles to illustrate the care that

God has for every creature, even the littlest. He says: "Are not two sparrows sold for a penny? And not one of them will fall to the ground without your Father's will. But even the hairs of your head are all numbered. Fear not, therefore; you are of more value than many sparrows" (Mt 10:29–31).

Cat

Admittedly, domestic cats (as distinguished from "big cats") are seldom seen depicted in churches, even though we know that many churches have kept cats. They are drawn in medieval illuminations, and the *Ancrene Rule* for anchoresses in the thirteenth century even specified that the anchoresses "must not keep any [other] animal except a cat." However, I love cats and didn't want to leave them off this list!

Deer

In Psalm 42 (41) we read: "As a deer longs for flowing streams, so longs my soul / for you, O God." In early Christian art, we see two deer drinking from a fountain as a symbol of souls drinking from the waters of eternal life. In the rabbinic tradition, deer were believed to be "the most pious of animals," so the deer is a sign of piety, one of the seven gifts of the Holy Spirit.

Dog

Like the domestic cat, the domestic dog is also not often seen in church art. But as we shall see below, it is the attribute of a few saints, including one whom I greatly love and revere! Occasionally, a dog is shown accompanying Tobit, who is often depicted in the company of an angel or holding a fish. These latter two attributes, however, are more often associated with Tobit than the dog is.

Dolphin

A dolphin, often quite stylized, is sometimes seen around a cross or around the font. Dolphins are regarded as fish, and, as such, they symbolize individual Christian souls. In Greek mythology, the dolphin is the helper of those who are shipwrecked or lost at sea, so they are also regarded as a symbol of our Christian hope that those who are lost may be led safely to the port of salvation.

Dragon

In chapter 41 of the Book of Job, there is a description of "Leviathan," a powerful creature that inhabits the deep seas. It appears that Leviathan is, in fact, what we would term a dragon. Job says: "He beholds everything that is high; he is king over all the sons of pride" (41:34). In the Book of Revelation, Satan, whose principal sin is pride, is called the dragon (see 20:2). The dragon, as such, is God's most powerful creature, which, in its prideful folly, thinks it can rival God, though no creature can ever match its Creator. The dragon, therefore, is a symbol of pride, of the futility of sin, and of any rebellion against God's goodness and wisdom. For Scripture also records the downfall of the dragon, saying:

> The great dragon was thrown down, that ancient serpent, who is called the Devil and Satan, the deceiver of the whole world — he was thrown down to the earth, and his angels were thrown down with him.

And I heard a loud voice in heaven, saying, "Now the salvation and the power and the kingdom of our God and the authority of his Christ have come, for the accuser of our brethren has been thrown down, who accuses them day and night before our God." (Revelation 12:9-10)

Occasionally dragons are seen at the foot of the cross as a sign that sin and death have been conquered by Christ Crucified, for his supreme act of humility and love has overcome the pride and hatred of the Devil.

Fish

The fish is an ancient symbol, an acrostic for "Jesus Christ, Son of God, Savior," and it was used as a secret code by the early Christians to identify one another during times of persecution. In Greek, the word for fish is ἸΧΘΥC, which are the first letters of the phrase above in Greek. The fish symbol is found in the Roman catacombs where Christians were buried and is mentioned in the very early Christian texts known as the *Pseudo-Sybilline Oracles*.

At the same time, given that Jesus had called his apostles to become "fishers of men" (Mk 1:17), the fish was also an early symbol of the Christian

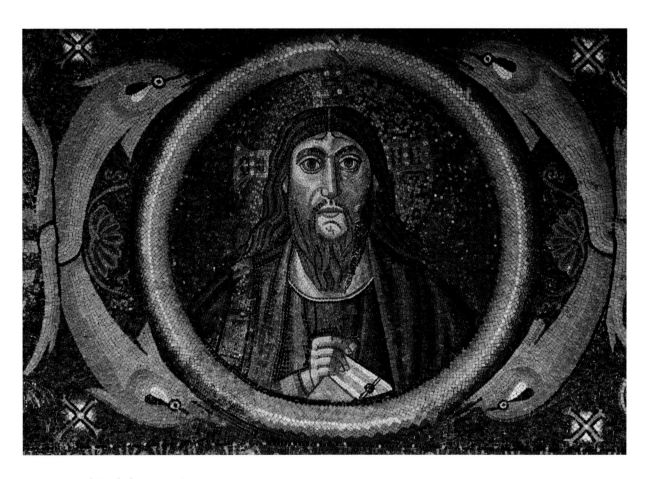

who had been fished out of the murky depths of the ocean — the world of sin — into the fresh and living waters that flow from the baptismal font. Tertullian says that "we, little fish, are born in water."

Two fish, when shown with a basket of (usually) five loaves, are a symbol of the Eucharist (see Jn 6:9–13).

Flowers

In the Song of Songs, we're told that after the winter rains, "the flowers appear on the earth, / the time of pruning has come, / and the voice of the turtledove / is heard in our land" (2:12). Flowers, therefore, indicate the spring, a time of growth and renewal. They are also a sign of joy and festivity, which is why they are not permitted during the penitential season of Lent. In Solomon's Temple, flowers ("almond blossoms") were fashioned out of gold for the menorah that were placed in the Temple, and also "open flowers" were carved on the olive-wood doors of the Holy of Holies. So flowers have long adorned the house of God because of their beauty and as signs of life offered to God. Several flowers have a particular symbolism, and below are five of the most common:

Fleur-de-lis: The fleur-de-lis is a stylized flower

with three yellow or gold petals, instantly recognizable because it is used in heraldry, usually as an emblem of France or of the Scouting movement or of the New Orleans Saints, an American football team. It is often claimed that this popular medieval symbol takes its form from the lily, and, indeed, its name seems to indicate this. Several French heraldists have argued, however, that the name refers to yellow flowers that grew by the banks of the river Lys, where the Franks originated, and that this flower is, in fact, the yellow flag iris. Others have said that Clovis, the king of the Franks, forded a river at a point where irises were growing and that this led to a decisive victory in a battle in 496, which

he attributed to Christ. He was then baptized, and he became the first Christian king of the Franks and took the fleur-de-lis as his emblem.

The iris, with its swordlike leaves, came to be associated with Our Lady, whose heart, Simeon prophesied, would be pierced by a sword (see Lk 2:35).

Some also think that the three petals of the fleur-de-lis reference the Trinity or the three theological virtues of faith, hope, and charity.

As they grow by the water, irises are also like the plant equivalent of the deer or the peacock (see above) because they draw life and beauty from the living water, which is Christ.

Lily: In his Sermon on the Mount Jesus said: "Why are you anxious about clothing? Consider the lilies of the field, how they grow; they neither toil nor spin; yet I tell you, even Solomon in all his glory was not clothed like one of these" (Mt 6:28–29). In this context, the lily is a sign of God's providence and a reminder of the beauty that God has given his creation.

Although the English translation of this passage uses the term *lily*, however, this does not equate with the type of flower we now call a lily. Jesus was probably referring to wildflowers that grew by the sea of Galilee, which were different from lilies as we know them, such as those that are used to adorn many churches during the Easter season. The word *lily* is derived from an Egyptian word that means "flower" generically, so a vast number of unrelated flowers can be termed "lilies."

The white lily (*Lilium candidum*), which is what we usually think of when we hear the word *lily*, is a symbol of new life, the Resurrection, and purity. As the lily is mentioned in the Song of Songs as the flower of the Beloved (see 2:1–2, 16), the lily has also been associated with the Immaculate Virgin Mary and the spotless Church, made pure by Christ, the Divine Bridegroom (see Eph 5:25–27). In some medieval depictions of the Annunciation, however, a vase of lilies is also shown bearing the Crucified Lord, which suggests that the white lily became an emblem of the sinless Christ, who died and rose again for our salvation; Mary Immaculate, of course, is the first recipient of the saving grace of Christ.

Passion flower: This flower was discovered only in the late sixteenth century by Spanish missionaries to the New World, who saw it as a potent symbol of Christ's passion. The ten petals of the flower are said to stand for the apostles who remained faithful to Christ during his passion; Judas and Peter are excluded. The purple color is the color of penitence; the three stigma at the center represent the nails that pierced the Lord, and the five anthers symbolize the five wounds of Christ. Around these, the radial filaments are reminiscent

of the crown of thorns, and the three-pointed leaves resemble the lance that pierced the Lord's side.

Passion flowers are tropical plants, and their discovery is relatively recent, so they are not found in medieval European buildings, but they are seen in later church architecture and art.

Rose: "As the rose is the flower of flowers, so is this the house of houses." This sentence in Latin is found in the great Chapter House of Westminster Abbey in London, and it sums up the primacy of the rose among all other flowers in Christian symbolism. The Greeks said that the rose was the flower of Aphrodite, goddess of love, and Christians continued to associate it with the Queen of Heaven, the Virgin Mary (see chapter 10); the Rosary, after all, takes its name from a garland of roses offered in courtly chivalry to Our Lady.

In church buildings, the rose, as a flower with many petals, is alluded to in round patterns on the floor and above all in geometrically complex round windows with petal-like tracery that are known as "rose windows." Painton Cowen suggests that as the rose symbolizes love and union, so these windows, which arose in French architecture from around 1200, "represent an eternal truth — that of the Logos, the Word itself," and they symbolize "man's highest aspirations" for union with God through the Word-made-Flesh.

We are united to God through charity; thus the Chapter House was likened to the rose because, within it, the monastic community gathered to exchange words and ideas so as to find harmony and unity as a community, centered on Christ, the Eternal Word. As Saint Augustine said in his Rule: "The chief motivation for your sharing life together is to live harmoniously in the house and to have one heart and one soul seeking God."

Sunflower: Another discovery from the New World, the sunflower is seen in later church architecture and art. In nature, the flower begins its life with its head facing east and then moves west throughout the day in tandem with the sun. This heliotropism continues until the flower reaches maturity, after which the sunflower head faces east at all times. In part I, we saw that churches and Christian worship were initially east-facing in anticipation of Christ's return from the east. The sunflower, therefore, is a symbol of the spiritual orientation of the Christian, who should always be facing Christ, the rising Sun of justice, and looking forward to his return in glory.

Foliage

Émile Mâle observes that the stonemasons of medieval Europe decorated their churches with carved flowers, leaves, and buds "chosen for their beauty.

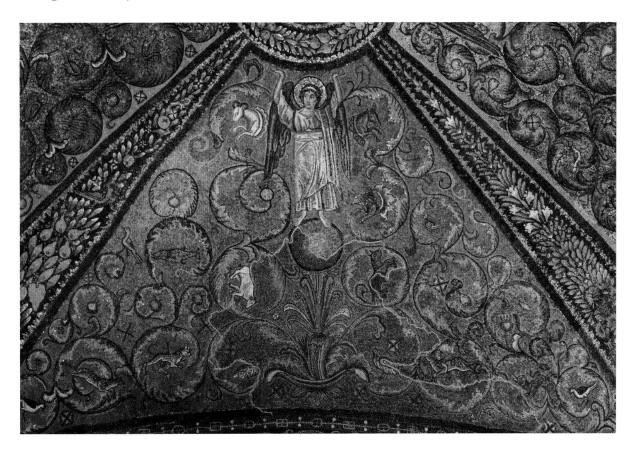

... The great sculptors despised nothing, for at the root of their art, as of all true art, sympathy and love are found. They believed that the plants of the meadows and woods [from their home regions, beloved from their childhood] were worthy to grace the house of God." In this way, the artisans showed their love for nature and, through it, for the Creator of such beauty and variety. One need not search too deeply for any further symbolic value than, perhaps, to express this love of God's creation and to show that the church building was burgeoning with vitality and budding with new life coming from the Risen Christ. Certain leaves, however, do have a particular symbolism:

Palm branches: In Revelation we read, "After this I looked, and behold, a great multitude which no man could number, from every nation, from all tribes and peoples and tongues, standing before the throne and before the Lamb, clothed in white robes, with palm branches in their hands" (7:9). Palm branches, therefore, are a symbol of the Resurrection, of Christ's victory over death, which the martyrs share. Whereas the waving of palm branches when Christ entered Jerusalem is a sign of the expected victory of the Messiah, entering triumphantly into the holy city, for the Christian people, they become a sign of our sharing in the victory of Christ over sin and death so that we may also enter the heavenly Jerusalem.

Reeds: When the Roman soldiers mocked Jesus before his crucifixion, they placed a reed in his right hand as a scepter (see Mt 27:29). Occasionally, the reed is shown as one of the instruments of Christ's passion. It also serves as a reminder of God's passionate love for humanity, for he tenderly deals with us who have been bruised and injured by life. As Isaiah says, "a bruised reed he will not break ... [but] he will faithfully bring forth justice" (42:3).

Shamrock (trefoil): The three-leaf shamrock, which is believed to be native to Ireland, is the well-known symbol of the Trinity that Saint Patrick used as an illustration for the central doctrine of our Christian faith. Consequently, shamrocks and other three-lobed patterns are seen as a reference to the Holy Trinity and are an attribute of the patron saint of Ireland.

Grapes and Vines

Roman mosaics and carvings of grapevines, the harvesting of grapes, and winemaking were incorporated into the imagery of the early Christians. Drawing on the prophetic image of Israel as the

vineyard of the Lord (see Is 5:1–7), Christ said of himself: "I am the vine, you are the branches" (Jn 15:5), so the vine with its fruit became a symbol of Jesus Christ and of us Christians. Hippolytus, for example, says: "The spiritual vine was the Savior. The shoots and vine-branches are his saints, those who believe in him. The bunches of grapes are his martyrs." This imagery of the vine encompassing or representing all believers in the Church of Christ has been vividly portrayed in the early twelfth-century apse mosaic of the basilica of San Clemente in Rome.

The fruit of the vine, pressed in the wine press, produces wine, which is, of course, offered in the Mass, wherein it is consecrated and becomes the Blood of Christ. The grape and vine also became Eucharistic symbols, often combined with the wheat sheaf and the chalice containing wine (see below and chapter 8).

Green Man

We saw in phoenix (above), a mythological figure with a pedigree in Greek mythology, being used as a Christian symbol of the Resurrection and new life. Another such symbol, drawn from the mythology and imagery of the lands of the pagan European North, is the Green Man. Lady Raglan, who was the first to write in 1939 about its appearance in various significant English medieval churches, describes it as "a man's face, with oak leaves growing from the mouth and ears, and completely surrounding the head." Originally thought to have been a pre-Christian personification of spring and nature's vitality, it was incorporated into the carvings of some churches as a sign of new life in Christ. Perhaps the most interesting interpretation is that it represents the head of Adam, from which, it was

death itself. Images of Daniel being rescued from the lions' den (see Dn 6) are a sign of God's delivering us from death, and in early Christian art, this biblical episode is frequently depicted on sarcophagi and in the catacombs. In some churches, a lion is shown supporting a pillar or under the feet of a knight, and again, this shows death being conquered by the Church or by an individual Christian through the power of the Risen Christ.

The lion, often shown with wings, is also a symbol of one of the evangelists — namely, Saint Mark. The symbols of the four evangelists will be discussed in chapter 19.

said, upon his death the seed of a tree germinated and grew, and the wood from this was fashioned into the cross, the tree of life.

Gryphon

Sometimes spelled "griffin," this Greek mythological creature continued in the Christian world to be mentioned in medieval bestiaries, such as Saint Isidore's *Etymologies*, as being winged animals who are "lions in their entire torso, but they are like eagles in their wings and faces." The lion and the eagle are regarded as the kings of the earth and of the air, and they came to be associated with Jesus Christ, who combines in his person both a human and a divine nature. In later medieval art, the gryphon was a representation of the two natures of Christ.

Lion

As noted above, the lion is the king of the beasts of the earth. Given that Christ has the title "Lion of Judah" (see Rv 5:5), it is a symbol of Jesus and his victory over sin and death.

Sometimes, however, the lion is a symbol of

Monkey

The monkey or ape features in a story from the life of Saint Dominic, in which the Devil appears to him one night as he is studying and mischievously tries to distract him. Saint Dominic tells him to make himself useful and hold a candle for him, which the monkey does; he cannot disobey the saint. When the candle burns all the way down, it burns the monkey's hand, and the Devil squeals and disappears. Monkeys, therefore, often symbolize the Devil, or temptation and sin, but they are also somewhat ridiculous.

Sometimes, monkeys are shown aping us human beings, doing human things — such as in the border of one of York Minster's famous stained-glass windows, where monkeys can be seen holding a funeral; or in the carved woodwork of churches, hidden under the choir stalls, where monks sat in prayer; and monkeys can be seen as musicians and nurses. This isn't because the medieval artist had a prescient knowledge of the Darwinian theory of evolution; rather, it is thought, it points to the ultimate folly of human activity and is meant to encourage people to take themselves less seriously. As Chesterton said: "Angels can fly because they can take themselves lightly [but] pride cannot rise to levity or levitation. ... Seriousness is not a virtue. ... For solemnity flows out of men naturally; but laughter is a leap. It is easy to be heavy: hard to be light. Satan fell by the force of gravity."

Pomegranate

The pomegranate was a Greek symbol of fertility and fecundity. Pomegranates were also found in the Jewish Temple, adorning the tops of the pillars (see 1 Kgs 7:18) and on the hems of the priests' robes (Ex 28:33). They are a symbol of plenteousness and the abundance of God's gifts and of the gift of di-

vine life.

The greatest of God's gifts, of course, is charity. St. Francis de Sales says that "pomegranates, by their vermilion color, by the multitude of their seeds, so close set and ranked, and by their fair crowns, vividly represent ... most holy charity, all red by reason of its ardour towards God, loaded with all the variety of virtues, and alone bearing away the crown of eternal rewards." As an emblem of divine love, the pomegranate is sometimes taken as a symbol of the Sacred Heart of Jesus and of God's love being presented to us in the Christ Child or by the Virgin Mary.

St. Gregory the Great writes that the pomegranate signifies "the unity of the faith" because a diverse number of peoples are held within the unity of the Church, just as many seeds are held inside the skin of the pomegranate.

Serpent

Like the dragon (see above) the snake is a symbol of the Tempter, who deceived Eve and Adam and who would ultimately be trodden underfoot and defeated by Christ. So, in reference to the promise of Genesis 3:15, Our Lady is often shown crushing the serpent's head.

The snake is also paradoxically a sign of God's healing and regenerative power (an idea that persisted in Greek mythology), and in Saint John's Gospel, it is even a type of Christ. Two serpents are sometimes depicted around the cross-shaped croziers of Orthodox bishops, or even at the foot of the cross, for Moses had commanded that a bronze serpent be put on a pole so that all who had suffered snakebites had only to look upon it to be healed (see Nm 21:6-9). Saint John's Gospel references this, saying that "as Moses lifted up the serpent in the wilderness, so must the Son of man be lifted up, that whoever believes in him may have eternal life" (3:14–15). Moreover, Jesus tells his disciples to be "wise as serpents and innocent as doves" when engaged in ministry in the world (Mt 10:16). Hence

the snake, like the lion (see above), is an ambivalent creature in the Bible and is not to be regarded uniformly as a sign of evil or malice.

Sheep

The Lamb of God is obviously a symbol of Christ (see chapter 11), and if Christ is the Good Shepherd, then his flock, which the Lord entrusts to Saint Peter (see Jn 21:17), is a symbol of the Church and of the Christian people, who are being led to the green pastures of eternal life.

In early Christian basilicas, twelve sheep are shown converging on the Lamb of God, who is often enthroned on a hillock from which four streams flow, a symbol of paradise and of the living waters of eternal life. The sheep, like the peacock and the deer (see above), will presumably drink from these waters and so receive a share in the divine life won for us by the sacrifice of the Lamb of God. It is sometimes said that these sheep represent the apostles and hence the Church of Christ.

Tree of Life

The tree (or even a cross) from which luxuriant leaves and many fruits grow is known as a "tree of life," which is an ancient religious symbol across many cultures. In Psalm 1:3, we're told that the righteous man is "like a tree / planted by streams of water, / that yields its fruit in its season, / and its leaf does not wither"; this most righteous of men is

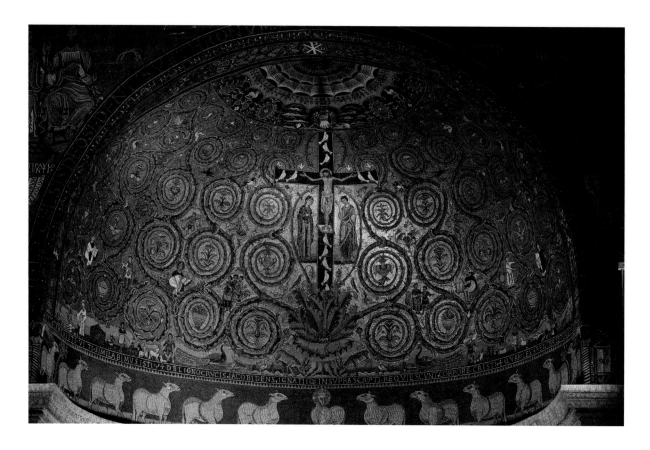

Christ and the saints who follow him. Christ and also his cross are identified by the Fathers of the Church as the tree of life.

In the Book of Ezekiel, there is a paradisal image of trees planted by the living waters, teeming with fish, that flow from the Temple, and "their fruit will be for food, and their leaves for healing" (47:12). Saint Cyprian says that "the Church, like Paradise, includes fruit-bearing trees within her walls. ... She waters the trees from four rivers, which are the four gospels, by which she dispenses the graces of baptism." Here, the trees of life become signs of the Christian, who is to be fruitful by the working of God's grace and so offer God's word and God's

healing to the world (see Jn 15:16).

Unicorn

The last of the mythological beasts to be considered here is the unicorn, much loved by little girls in our time — my niece is especially fond of them. According to the *Physiologus*: "The hunter cannot approach the [unicorn] because he is extremely strong. How then do they hunt the beast? Hunters place a chaste virgin before him. He bounds forth into her lap, and she warms and nourishes the animal and takes him into the palace of kings." This mythological tale of the hunt of the unicorn was loved in the Middle Ages as an image of the Incar-

grapes (see above) or a chalice (see chapter 8). As such, it is also a symbol of sacrificial love reflecting these words of the Lord: "Unless a grain of wheat falls into the earth and dies, it remains alone; but if it dies, it bears much fruit" (Jn 12:24). We think of the martyrs' witness when we hear these words of Christ, but, in fact, every Christian is called to become "bread broken for the life of the world," as Pope Benedict XVI said in *Sacramentum Caritatis*:

> Our communities, when they celebrate the Eucharist, must become ever more conscious that the sacrifice of Christ is for all, and that the Eucharist thus compels all who believe in him to become "bread that is broken" for others, and to work for the building of a more just and fraternal world. Keeping in mind the multiplication of the loaves and fishes, we need to realize that Christ continues today to exhort his disciples to become personally engaged: "You yourselves, give them something to eat" (Mt 14:16). Each of us is truly called, together with Jesus, to be bread broken for the life of the world. (par. 88)

nation. The Benedictine monk Honorius of Autun, for example, preached that "By the beast [the unicorn] Christ is figured, by the horn of his insuperable strength. Resting in the womb of a virgin, he was taken by the hunters, that is, he was found in human form by those who loved him."

The unicorn is a symbol of Christ, who, like this beast, is pure, noble, strong, hunted and even wounded by men, and tenderly held by a chaste virgin. Perhaps if we teach our little girls this, they can be led by the unicorn to love Christ, too!

Wheat

Sheaves of wheat, from which bread is made for the Eucharist, is a symbol of the Mass, often depicted alongside a round Host (unleavened bread) and

8

Signs and Symbols: Nonliving

And Moses said to the sons of Israel, "See, the LORD has called by name Bezalel the son of Uri, son of Hur, of the tribe of Judah; and he has filled him with the Spirit of God, with ability, with intelligence, with knowledge, and with all craftsmanship, to devise artistic designs, to work in gold and silver and bronze, in cutting stones for setting, and in carving wood, for work in every skilled craft."

— Exodus 35:30–33

Anchor

The anchor is an early Christian symbol for the cross and is seen, for example, in the Catacombs of Domitilla in Rome. It may be that just as the fish (see chapter 7) was a clandestine sign to identify Christians, so, too, the anchor was a sign of the Christians' hope in the cross as the instrument of our salvation. In the Letter to the Hebrews, hope in Christ is described as "a sure and steadfast anchor of the soul" (6:19).

The anchor is also seen as an attribute of some of the saints, as we shall see.

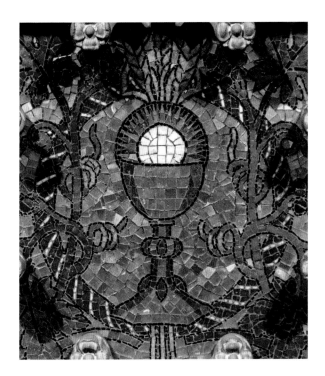

Chalice

As mentioned in relation to the grapevine and the wheat (see chapter 7), the chalice is a symbol of the Eucharist, particularly the Precious Blood of Christ, which it holds. In the Christian liturgical tradition, things that are sacred and holy because of what they contain are veiled, such as the tabernacle (see chapter 5) but also the chalice and even women, who are by nature privileged to be bearers of new human life, at least in potentiality. The chalice, therefore, which was seldom seen by the layperson, would nevertheless be used in art as an emblem of the Eucharist or, occasionally, as an attribute of certain saints.

Cross

The cross is without doubt the most common and well-known symbol of Christianity, but there are many ways in which the cross is depicted both in church buildings and in heraldry. In early Christian art, the cross is a symbol not of Christ's passion and death but of his victory. As Jean Daniélou, SJ, says: "The sign of the cross is seen to have its origin, not in an allusion to Christ's passion but as a signification of his divine glory. Even when it comes to be referred to the cross on which he died, that cross is regarded as the expression of the divine power which operates through his death: and the four arms of the cross are looked on as the symbol of the cosmic significance of that redeeming act."

These are some of the variations of the cross that can be seen in churches:

The **Greek cross** has arms of equal length, like a plus sign, and it is so called because it originated in Greek culture and was used by Pythagoras as a holy symbol. The origins of this cross in Christian use, however, must look to the Hebrew letter *taw*, which looks like a plus sign or an *x*. It is seen in Palestinian ossuaries from the first century AD and is possibly the oldest Christian representation of the cross.

The **Latin cross** is the one we're probably most familiar with, and it looks like the cross on which Christ was crucified.

The **Jerusalem cross** is like a Greek cross but with four smaller Greek crosses in between each of its arms. It represents the five wounds of Christ, or Christ and the four evangelists, and it was used as the heraldic device of the Crusader Kingdom of Jerusalem.

The **Maltese cross** is formed of four arrowheads or V-shaped arms and has eight points, which stand for the eight Beatitudes. It is the heraldic device of the Knights of Malta.

The **Crux Gemmata**, or "jeweled cross," is com-

monly seen in early Christian art; it is a Latin cross adorned with jewels and pearls. Until the fifth century, the body of Christ (the corpus) was not depicted on the cross because it was still too shameful to represent the Lord dying on the cross. Rather, a jeweled cross was the more common depiction, or the anchor (see above). The precious cross represented both the suffering and triumph of Christ, as well as a reminder that the kingdom of heaven is like precious treasure (see Mt 13:44).

The **Saltire** is the X-shaped cross, most commonly associated with Saint Andrew (see chapter 19.)

The **Tau cross** is shaped like the letter T (*tau* in Greek) and is associated with St. Anthony of Egypt or, more popularly, the Franciscans. However, reference to the cross as being *tau*-shaped can be found in the writings of early Christians such as St. Clement of Alexandria and Tertullian, so it is also one of the oldest signs of the cross.

Perhaps the greatest sign of the cross is not one that is depicted in artistic form or church architecture but the one that we trace on ourselves when we enter the church building, when we pray, or that is made over us when we're being blessed. As Romano Guardini says, the cross is "the holiest of signs. Make a large cross, taking time, thinking what you do. Let it take in our whole being — body, soul, mind, will, thoughts, feelings, your doing and not-doing — and by signing it with the cross strengthen and consecrate the whole in the strength of Christ, in the name of the triune God."

Crown

"Blessed is the man who endures trial, for when he has stood the test he will receive the crown of life which God has promised to those who love him"

(Jas 1:12). The crown is a symbol of eternal life promised by God; it is a sign of the saints' victory over sin, temptation, and tribulation (see Rv 2:10) and a symbol of the hope of immortality, of reigning alongside Christ forever.

What does the crown look like? It is commonly depicted as a circlet, usually of gold, to which are attached radiating points, jewels, and other ornaments, including fleurs-de-lis, orbs, trefoils, and so forth. This radiant form of the crown "studded with sunbeams," according to Lucian, originated in ancient Rome and was worn by Roman emperors as part of their worship of the Unconquered Sun. Since Christ is the true *Sol Invictus*, this kind of crown is appropriately used in art by Christians who worship him.

In Scripture, though, Saint Paul speaks of athletes who train and compete for a "perishable" crown (1 Cor 9:25), sometimes translated as a "wreath that will wither," whereas we Christians discipline ourselves for a "wreath that will never wither." This tells us that the crown that the early Christians had in mind wasn't necessarily the golden circlet worn by the Roman emperor but the wreath of laurel bequeathed on successful athletes or worn by victorious soldiers. To this day, graduates of some Italian universities will be seen wearing laurel crowns on their graduation day. Incidentally, the name Laurentius (or Laurence or Lawrence) could mean "one who is crowned with laurels" — that is, a victor.

On the Jewish feast of Tabernacles, crowns were worn in procession on the eighth day; these were wreaths made of palm leaves (see chapter 7), myrtle, or willow. Jean Daniélou, SJ, states that "the use of crowns of foliage is attested both by Jewish documents about the feast and by Judeao-Christian documents which show it persisting in the rite of baptism. ... The eschatological character of the crown as denoting eternal blessedness is clear." It is

"the symbol of the glory of the elect, in the biblical sense of the word, and of the imperishable life which is their lot."

In early Christian art — for example, at Ravenna — we may see a procession of saints shown holding golden wreaths, or a hand coming from heaven bequeathing a wreath on a martyr.

Finally, the Book of Revelation refers to the twenty-four elders who flank the throne of God in heaven, and wear "golden crowns upon their heads" (4:4). Sometimes they, too, are shown holding these crowns in their hands, offering them to the Lord, such as in the basilica of St. Paul outside the Walls, in Rome.

Shell

The scallop shell is an ancient symbol of rebirth, seemingly derived from Greek mythology, wherein Venus, the goddess of love and beauty, is said to have been born from an oyster, which, in Botticelli's famous depiction of this tale, becomes a giant scallop shell. In any event, shells are found in pagan cemeteries. The early Christians appropriated the shell symbolism and united it with images of St. John the Baptist baptizing, so that the shell became a symbol of our rebirth into eternal life.

In the Middle Ages, because scallop shells were plentiful by the sea near Santiago de Compostela on the Galician coast, it became a souvenir of the ev-

er-popular pilgrimage (the *Camino*) to the Shrine of St. James the Apostle. Hence the scallop shell became a symbol of pilgrims and of every Christian's pilgrimage through this life to our heavenly destination.

Ship

In part I, we saw that the nave of the church is so called because the ship is a symbol of the Church, the ark of salvation and the Barque of Saint Peter. Sometimes the image of a ship is found in the decoration of a church building, on a vestment, or as an attribute of a saint who fostered unity in the Church, such as St. Catherine of Siena, who had a vision of the ship of the Church being laid upon her shoulders. In early Christianity, the mast of the ship (mentioned by St. Justin Martyr) also became, like the anchor (see above), a disguised cross and hence an early Christian symbol.

Star

The star, six-pointed or sometimes five-pointed, is usually a reference to the star seen and followed by the Magi at Christ's birth (see Mt 2:9). It has been called the *signum fidei*, the "sign of faith," for it leads us by its light to adore Christ, our incarnate God, just as faith does by its own light. Pope Francis says in *Lumen Fidei*,

> For [the Magi,] God's light appeared as a journey to be undertaken, a star which led them on a path of discovery. The star is a sign of God's patience with our eyes which need to grow accustomed to his brightness. Religious man is a wayfarer; he must be ready to let himself be led, to come out of himself and to find the God of perpetual surprises. ... Christian faith in Jesus, the

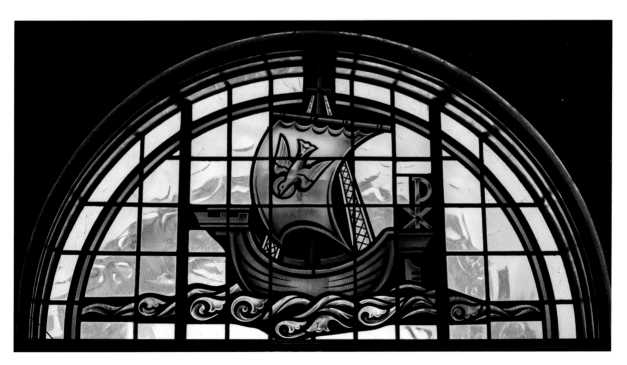

one Savior of the world, proclaims that all God's light is concentrated in him, in his "luminous life" which discloses the origin and the end of history.

A field of stars painted across the ceiling of the church, for example, is a reminder of God's promise to Abraham that God would make his descendants as numerous as the stars of heaven (see Gn 15:5). Abraham, of course, is our "father in faith," as the Roman Canon of the Mass says. Seeing those stars in the church, we are reminded that God has been faithful to his promise to Abraham, for we sit there looking up, we who are the spiritual children of Abraham.

Concerning Abraham and his faith, the Letter to the Hebrews declares:

> Therefore from one man, and him as good as dead, were born descendants as many as the stars of heaven and as the innumerable grains of sand by the seashore. These all died in faith, not having received what was promised, but having seen it and greeted it from afar, and having acknowledged that they were strangers and exiles on the earth. For people who speak thus make it clear that they are seeking a homeland. (11:12-14)

That faith is now fulfilled in Christ, who is with us in the sanctuary of the church, within the tabernacle; and the heavenly homeland for which we long is, as we've seen, anticipated and foreshadowed in the symbolism of the sanctuary and made present in the Mass, particularly through holy Communion. Indeed, Christ is, as the Easter Proclamation (the Exsultet) declares: "the one Morning Star who nev-

er sets ... who, coming back from death's domain, has shed his peaceful light on humanity, and lives and reigns for ever and ever." As such, the star is also sometimes a symbol of Christ himself.

Torch

In Greek and Roman art, a flaming torch that points downward is a sign of death, a life extinguished. A burning torch is a sign of life and, for Christians, of hope in the Resurrection. The torch is also a sign of the light of God's truth, as Psalm 119:105 says: "Your word is a lamp to my feet / and a light to my path."

Zodiac

Christians are sometimes surprised to see the twelve signs of the zodiac depicted in a church, whether in paint or in sculpture. These are sometimes known as astrological signs or star signs, and the immediate assumption is that any depiction of these signs has to do with divination and astrology, which is forbidden by the Church as a superstition that is contrary to faith in God (see CCC 2116). These twelve astrological signs in Christian art, however, are just a symbolic way of depicting the twelve months of the year, and they show that all time belongs to God.

Certain Fathers of the Church, including Origen, Saint Cyprian, Saint Ambrose, and Saint Augustine, delighted in speaking of Christ as being like the sun with the twelve starry signs moving around him through the course of the year, just as there are twelve apostles. They also spoke of Christ as the day, with twelve rays of light representing twelve hours of daylight and each hour representing an apostle.

The zodiac, therefore, is a symbol that Christ governs the cosmos and that he is Lord and Master of all times, all creatures, and all seasons. Indeed, anyone who is tempted to consult the stars must realize that, in fact, such superstitions are futile because Christ, as God, governs the stars, the planets, and every celestial sphere. It is always wiser to place one's trust in the living and true God.

The psalm declares — and this applies to every sign and symbol in the church building — that "one generation shall laud your works to another, / and shall declare your mighty acts. / On the glorious splendor of your majesty, / and on your wondrous works I will meditate. / All your works shall give thanks to you, O Lord, / and all your saints shall bless you" (Ps 145 [144]:4–5, 10).

Indeed, we who gather within the church, called together as friends of Christ, shall repeat the blessing of all creatures in the divine worship that we offer to God!

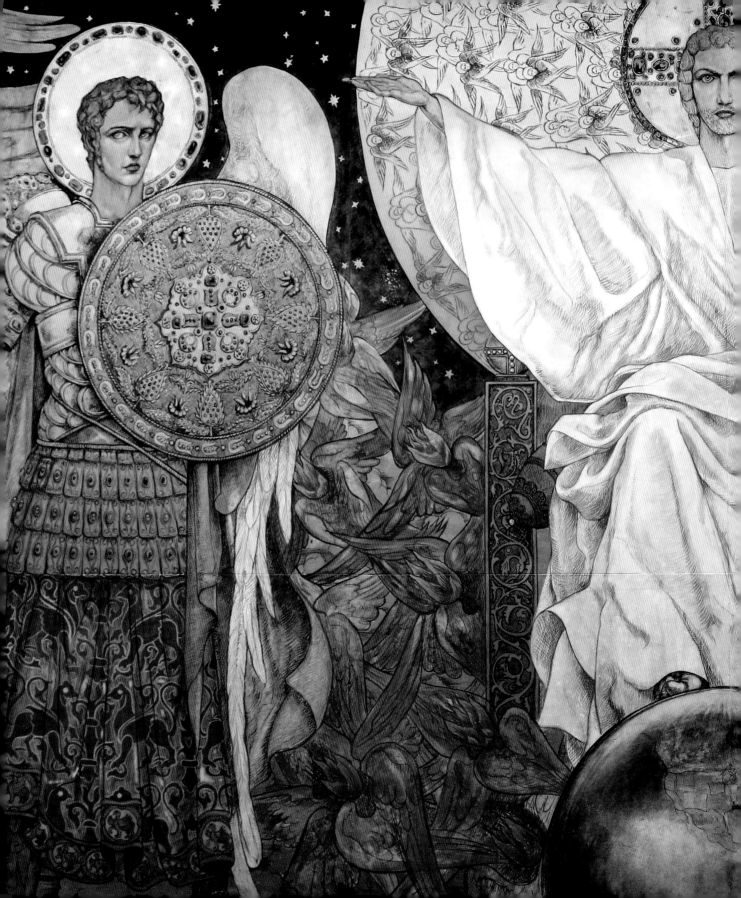

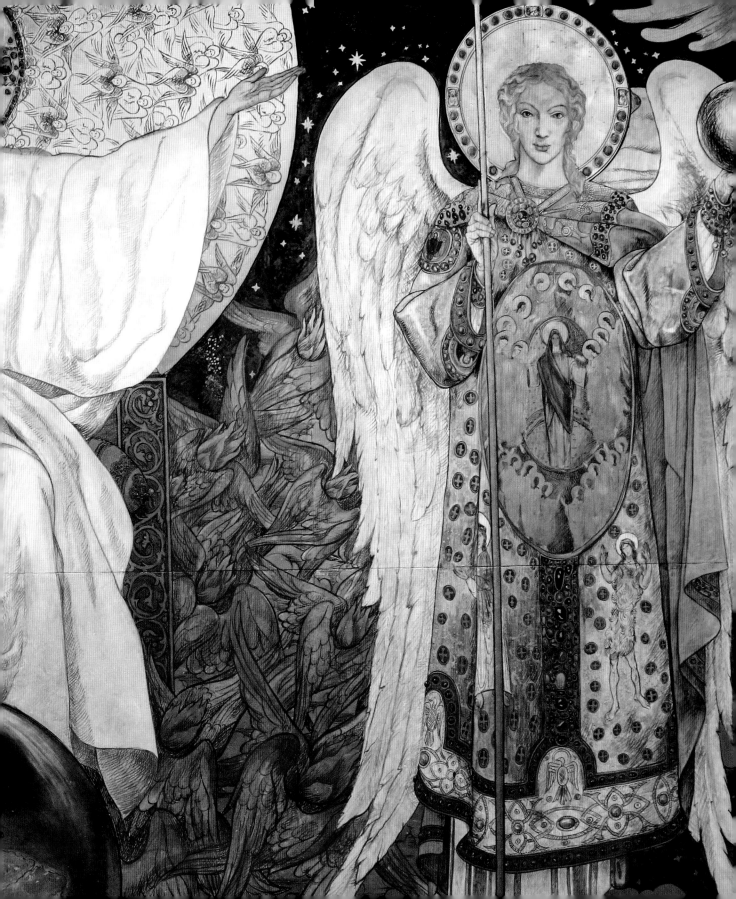

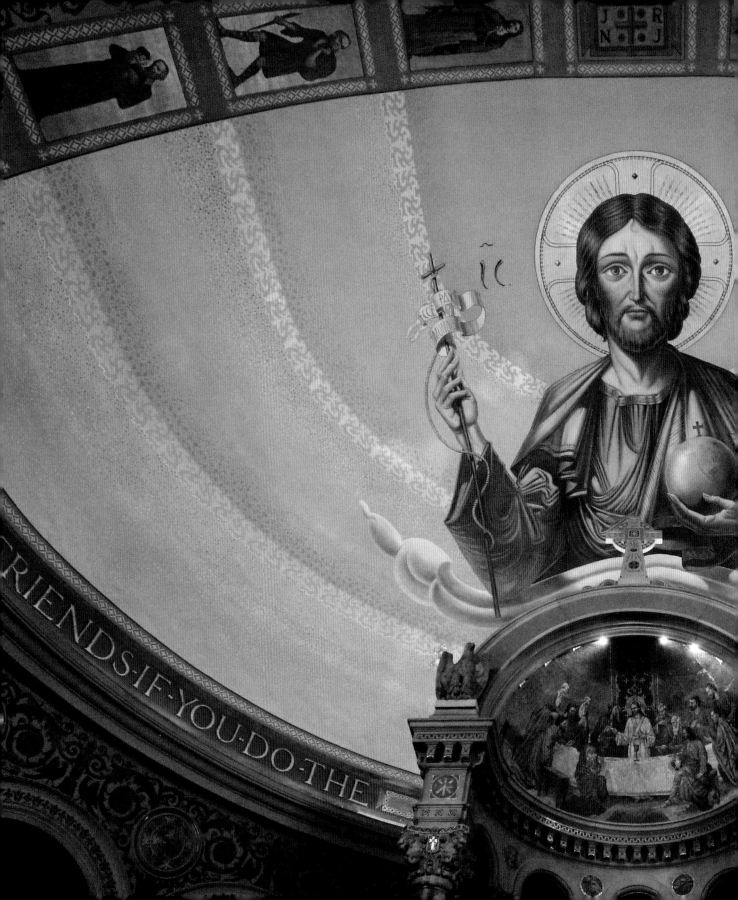

Part 3

THINGS·THAT·I·COMMAND·YOU — ST·JOHN·XV·14

9

The *Biblia Pauperum* and the Beauty of Holiness

Saint Ansgar, the ninth-century "Apostle to the North," who became archbishop of Hamburg-Bremen in Germany, is credited with having compiled a collection of pictures of the life of Christ paired with Old Testament scenes that foreshadowed it. This sort of pairing is called *typology*. As the *Catechism* says: "The Church, as early as apostolic times, and then constantly in her Tradition, has illuminated the unity of the divine plan in the two Testaments through typology, which discerns in God's works of the Old Covenant prefigurations of what he accomplished in the fullness of time in the person of his incarnate Son" (128). Saint Ansgar's collection of typological images developed into what would be called a *Biblia pauperum*, or "Bible of the poor," presumably because the poor could not afford to learn to read.

It wasn't only the poor who were illiterate, however. In Anglo-Saxon England, for example, even kings and nobility could not read and write. They relied on Christian monks to be their scribes and would sign official documents with an *X*. So the vast majority of people relied on images rather than on written texts, on illustrative preaching and teaching, on the visual impact of the church building and its liturgy, and of a visibly Christian way of life.

Saint Bede records that when St. Augustine of Canterbury arrived in Kent in 597 to evangelize the Anglo-Saxons, he and his monks came "bearing a silver cross for their banner, and the image of our Lord and Savior painted on a board" — that is, with an icon. Images, then, are instrumental in the instruction of people in the Faith, and they play an important part in evangelization. Indeed, Bishop Robert Barron has proposed that "the best evangelical strategy is one that moves from the beautiful to the good and finally to the true. ... Moralizing and intellectualizing are often nonstarters in

regard to persuasion. But there is something unthreatening about the beautiful."

I certainly agree, and I have already mentioned my own experience of the beautiful drawing my fellow university students to sing sacred music and visit the finest churches around us. It is true that beauty attracts and is a powerful and effective bridge with the world, an invitation to anyone with eyes to see to come and see. But if, as Bishop Barron also says, our "cultural matrix" is "dominated by relativism and the valorization of the right to create one's own system of meaning," then surely the beautiful in our cathedrals and churches will not necessarily in and of itself lead onlookers to faith in Jesus Christ. As such, beauty *by itself* cannot evangelize, and indeed, beautiful

things *by themselves* cannot save souls. Dostoyevsky's line "Beauty will save the world" is properly understood only if we realize that Beauty is none other than God, whose face is revealed to the world in the person of Jesus Christ, the Incarnate Word, the God who is with us and whose Eucharistic presence fills a church with his beauty.

Saint Augustine came with an icon, but he used it as the basis for his preaching. He still had to preach and teach and, above all, to live the Christian life. Saint Bede says that Saint Augustine and his monks lived with

> constant prayer, watchings, and fastings;
> preaching the Word of life to as many as

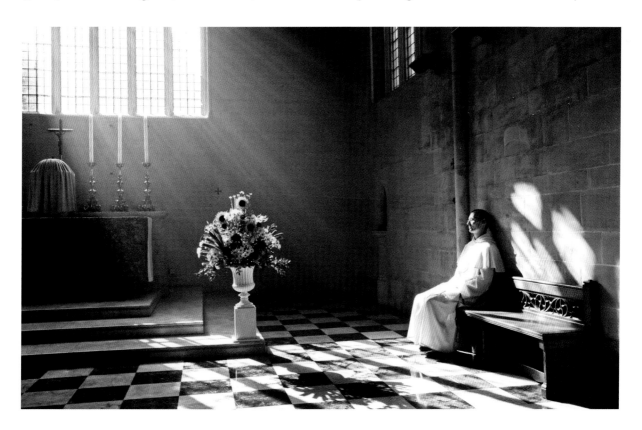

they could; despising all worldly things, as in nowise concerning them; receiving only their necessary food from those they taught; living themselves in all respects conformably to what they taught, and being always ready to suffer any adversity, and even to die for that truth which they preached. In brief, some believed and were baptized, admiring the simplicity of their blameless life, and the sweetness of their heavenly doctrine.

Eventually, the king of Kent also converted to Christianity, "attracted by the pure life of these holy men and their gracious promises."

While beauty attracts, it is the beauty of a life that is changed for the good, the beauty of holiness, that converts souls. As we have already seen, Pope Benedict XVI rightly observed that "the true apology of Christian faith, the most convincing demonstration of its truth against every denial, are the saints, and the beauty that the faith has generated."

The lives of the saints need to be told, and people need to encounter the saints in art and in preaching and in stained-glass windows, as well as to encounter us Christians as sinners who are forgiven, redeemed by grace, and mostly bumbling along

the pilgrim path of becoming saints. Bishop Barron puts it this way:

> The pattern is more or less as follows: first the beautiful (how wonderful!), then the good (I want to participate!) and finally the true (now I understand!). ... Then, the wager goes, the captivation [of beauty] would lead to a desire, perhaps vague at first, to participate in the moral universe that made those artistic expressions possible. And finally, the participation would conduce toward a true and experiential understanding of the thought patterns that undergird that way of life. First the beautiful, then the good, then the true.

When people are drawn to the beautiful in our church buildings, they will need guides — they will always need us who believe to live the Christian faith authentically, joyfully, and confidently yet with humility. At the same time, they need us to be informed about our faith, the stories told in our Scriptures, the good works of our saints, and the richness of our Catholic traditions and symbolic world — which is what this book aims to provide, at least in part.

The following section of this book will first explain how we can identify the Bible stories that can be found in a church, especially through its stained-glass windows, carvings, and wall paintings which form a *Biblia pauperum*. It is not possible to include every story, so I have chosen twenty New Testament scenes that are taken from the traditional fifteen mysteries of the Dominican Rosary and supplemented with the five Mysteries of Light introduced by Pope St. John Paul II. In addition, faithful to the tradition of the *Biblia pauperum*, I will look at ten examples of typology drawn from the Old Testament and explain how we can identify them.

I will not offer much theological reflection on these scriptural scenes; if you seek a richer theological reflection on the mysteries of the Rosary, you can find many good works available, such as the writings of the Dominican Ven. Louis of Grenada, or perhaps *Mysteries Made Visible*, which I wrote in 2021. My aim here is to help you seek and identify the work of art you're looking at in a church and to encourage you to pray with the images in the church with the relevant passages from the Bible to assist you. As ever, familiarity with the Scriptures will enrich your engagement with the Church's sacred art and the liturgy and, I hope, lead you to love the word of God still more.

10

The Bible Depicted: The Rosary Mysteries

The Annunciation

The Annunciation is the pivotal moment in salvation history because it is the moment of the Incarnation. There are numerous depictions of this scene in churches (and in art museums!), especially from the twelfth century onward, as Marian devotion increased. We should begin by re-familiarizing ourselves with the scriptural account:

> In the sixth month the angel Gabriel was sent from God to a city of Galilee named Nazareth, to a virgin betrothed to a man whose name was Joseph, of the house of David; and the virgin's name was Mary. And he came to her and said, "Hail, full of grace, the Lord is with you!" (Luke 1:26–28)

One expects to see in depictions of this passage an angel greeting a woman, and we have already noted some indications of how we might identify the Virgin Mary — for example, through the color of her clothing. Below we shall see other symbols that help us to identify Our Lady. Sometimes, a flowing ribbon of text comes from the angel, a bit like the speech bubble that we see in comic books, and usually the angel's greeting is in Latin. The greeting is well known, and has been set to music many times, so we should be able to identify it: *Ave Maria, gratia plena*.

The angel Gabriel is usually shown with wings (an artistic indicator common for all angelic beings), and he often kneels before Our Lady. In later depictions, he is shown holding a lily or a scepter adorned with a fleur-de-lis (see chapter 7). The reason for this may be to indicate that he comes from paradise because, as Saint Ambrose says, "Lilies are not born on steep mountains or in uncultivated forests, but in gardens

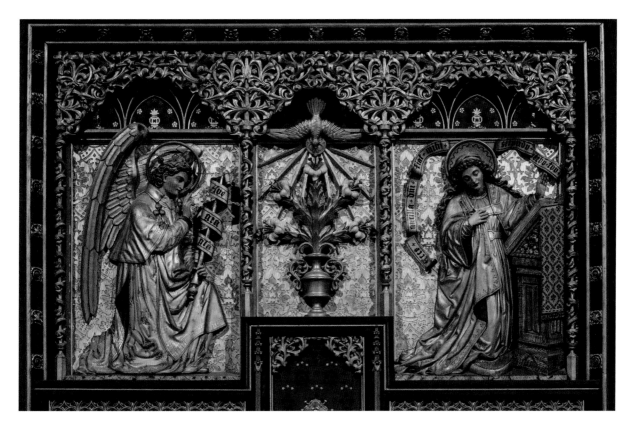

[i.e., cultivated in the eternal garden of Eden]. ... And no one must find it inappropriate for the lilies to be compared to the angels, since Christ himself recalls that he is a lily." The scepter is also a sign of authority, the sign of a herald who comes with a message, and the fleur-de-lis, as a symbol of the Trinity, tells us the source of the angel's authority and of his announcement.

Alternatively, or sometimes additionally, there is a vase or a pot between the angel and the lady, with a lily (or, rarely, a palm branch) growing in it. The lily in a pot or vase is a symbol that from the Middle Ages came to be associated with the Annunciation scene. As noted above, it has become commonplace to regard the white lily as a symbol of the purity of the Blessed Virgin Mary, and Saint Bede was among the first to do so. The Venerable Bede, however, also follows the more ancient tradition, going back to Saint Ambrose, in which the lily with its golden stamens is identified with Christ and his resurrection.

The lily pot, sometimes even marked with the monogram of Mary (see chapter 18) is, in fact, an image of Our Lady, the "singular vessel of honor," as the Litany of Loreto calls her. This pot is enclosed and intact, a sign of Mary's perpetual virginity, and from her springs the flower who is Christ, recalling the words of Isaiah: "There shall come forth a rod out of the root of Jesse, and a flower shall rise up out of his root" (11:1, Douay-Rheims translation).

The flowering lily pot is emblematic of the Incarnation, of the central Christian mystery taking place and being announced by the angel Gabriel.

The Visitation

In those days Mary arose and went with haste into the hill country, to a city of Judah, and she entered the house of Zechariah and greeted Elizabeth. And when Elizabeth heard the greeting of Mary, the child leaped in her womb; and Elizabeth was filled with the Holy Spirit and she exclaimed with a loud cry, "Blessed are you among women, and blessed is the fruit of your womb!" (Luke 1:39–42)

This scene is easily identified by two women facing or embracing each other, both visibly pregnant. Elizabeth is usually older, and she is sometimes

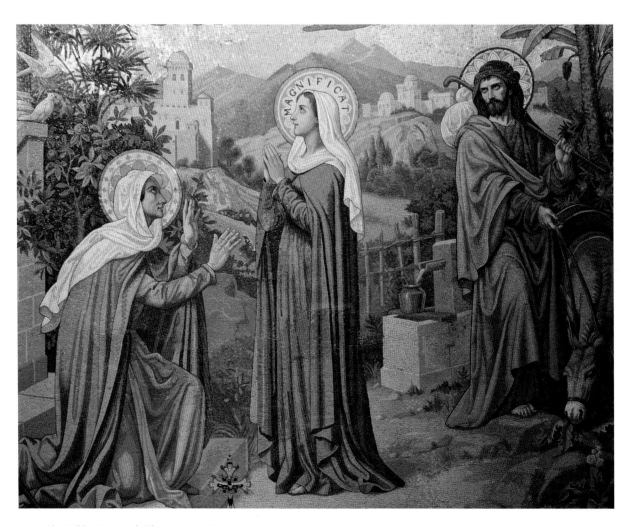

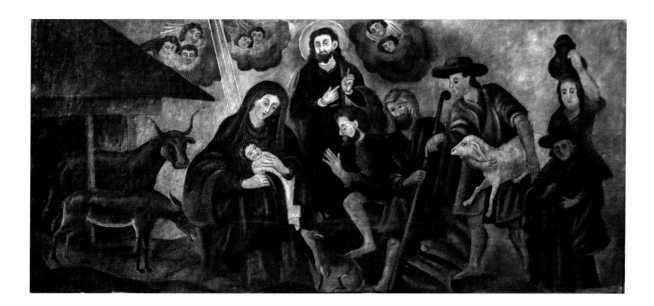

seen on her knees before the younger woman, Mary. The gestures of the two women show their closeness, their kinship, and their joy. There is a sense of mutual love and support between these holy cousins.

Sometimes, in the background, we will see Saint Joseph and Zechariah, the former often leading a donkey or with a staff in hand to show that he has been traveling.

The Nativity of the Lord

The scene of the Blessed Virgin Mary and Saint Joseph with the infant Jesus is universally recognizable. Often the baby Jesus, lying in a manger or on the ground, is depicted as the source of light, for Christ said: "I am the light of the world; he who follows me will not walk in darkness, but will have the light of life" (Jn 8:12).

Larger scenes include winged angels around the central scene, sometimes holding scrolls with the words *Gloria in excelsis Deo* (see Lk 2:14), or a star shining above — a reference to the star of Bethlehem, which led the wise men to the manger (Mt 2:2).

Often an ox and a donkey are shown in the Nativity scene with Christ between them. This is thought to be a reference to these words of Isaiah: "The ox knows its owner, / and the donkey its master's crib; / but Israel does not know, / my people does not understand" (Is 1:3).

There are usually two depictions of the Christmas story. In one, the shepherds are shown coming to the manger: "When the angels went away from them into heaven, the shepherds said to one another, 'Let us go over to Bethlehem and see this thing that has happened, which the Lord has made known to us.' And they went with haste, and found Mary and Joseph, and the baby lying in a manger" (Lk 2:15-16).

In the other, we see the wise men (or Magi) coming from the East to adore the Lord, and sometimes they're attended by a large retinue. The

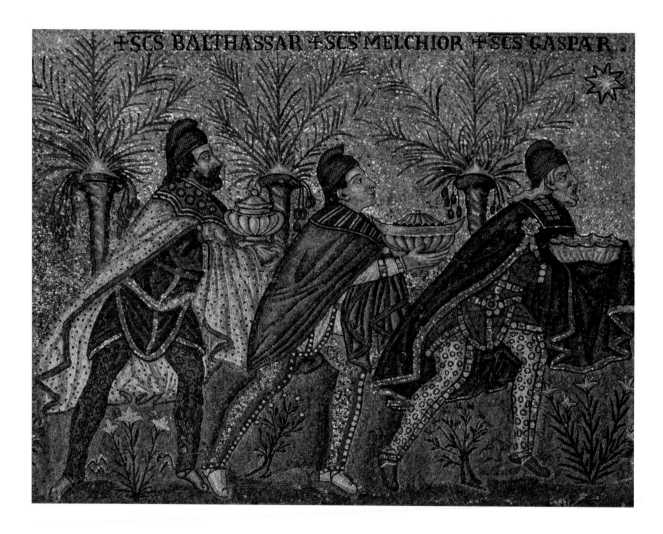

"Adoration of the Magi" is one of the most ancient depictions in Christian art; around eighty-five versions of this scene can be found in the Roman catacombs dating to the third century AD. The popularity of this scene is due to the identity of the wise men from the East. As representations of pagan knowledge, or astronomy, or idolatry, they show the conversion of the pagan world to the true God, Jesus Christ.

Almost invariably the tradition has been to show *three* wise men because Scripture speaks only of three gifts brought to Bethlehem, even though these three gifts have a symbolic significance rather than an indication of the number of Magi who had come in search of the newborn Jesus. The passage from Saint Matthew is as follows: "When they saw the star, they rejoiced exceedingly with great joy; and going into the house they saw the child with Mary his mother, and they fell down and worshiped him. Then, opening their treasures, they of-

fered him gifts, gold and frankincense and myrrh" (Mt 2:10–11).

The symbolic meaning of these gifts, first mentioned by Origen in his work *Contra Celsum*, which dates to around AD 248, is that of "gold, as to a king; myrrh, as to one who was mortal; and incense, as to a God." This meaning has remained stable and was even enshrined in a popular carol, "We Three Kings," by John Henry Hopkins Jr.

Early depictions of the Magi, such as may be seen in Byzantine icons, often show them wearing floppy conical caps known as Phrygian caps, which were associated with the Persians and people from the East. It is said that when the Muslim armies from Persia captured the Church of the Nativity in Bethlehem, they refrained from destroying the church because they saw the Magi in Persian clothing depicted in the mosaic above the main entrance. Although those mosaics have not survived, we get a sense of what they might have looked like from the sixth-century mosaics of the Magi in Sant'Apollinare Nuovo in Ravenna.

Origen and Tertullian associated the Magi with this prophecy of Isaiah: "Nations shall walk by your light, / and kings in the brightness of your rising. / They shall bring gold and frankincense" (60:3, 6); and so the wise men came to be depicted as kings with regal robes. Over time, each king came to represent a different continent — namely, Europe, Asia, and Africa. The names given to the wise men, venerated as saints, are Caspar, Melchior, and Balthasar, and their relics are enshrined in Cologne Cathedral in Germany. The Germanic custom arose of blessing the threshold of homes with blessed chalk on the Epiphany. Lintels are marked with the numbers of the year and the letters C + M + B which are the initials of the three wise men, as well as the letters of a Latin phrase, *Christus mansionem benedicat*, which means "May Christ bless this house."

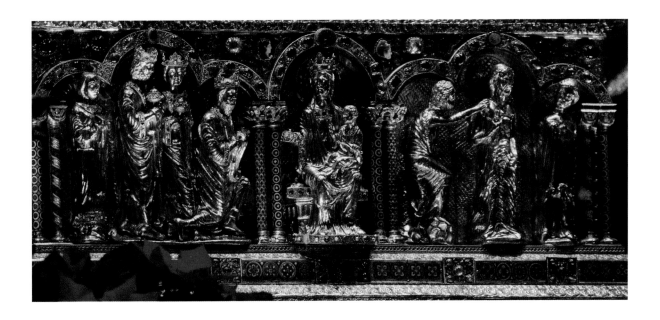

The Presentation of the Lord in the Temple

And when the time came for their purification according to the law of Moses, they brought him up to Jerusalem to present him to the Lord ... and to offer a sacrifice according to what is said in the law of the Lord, "a pair of turtledoves, or two young pigeons." Now there was a man in Jerusalem, whose name was Simeon. ... And inspired by the Spirit he came into the temple; and when the parents brought in the child Jesus, to do for him according to the custom of the law, he took him up in his arms and blessed God and said, "Lord, now let your servant depart in peace, according to your word; for my eyes have seen your salvation which you have prepared in the presence of all peoples, a light for revelation to the Gentiles, and for glory to your people Israel." (Lk 2:22, 24–25, 27–32)

In this scene, look for the infant Jesus being held by an older man who raises his eyes in prayer. Sometimes the infant is placed on an altar, and the man is dressed in robes that resemble a Jewish priest's or even a Christian bishop's, but with the miter on his head turned sideways.

Our Lady and Saint Joseph are with the infant Jesus, and sometimes an older woman, the prophetess Anna, also appears in this scene (see Lk 2:36–38). Often Saint Joseph is shown holding two young pigeons, as mentioned in Scripture, or they are held by someone else, or placed on the ground in a cage.

The main symbol for the Presentation, candles, are not mentioned in Scripture but are used in the Church's liturgy on the feast of the Presentation and so are often seen in artistic depictions of this event. The feast of the Presentation is even called "Candlemas" because, as Simeon hails the Lord Jesus as "the light for revelation" to the nations and carries him in his arms, so candles are blessed and distributed on this day for the people who come to church to light and hold in procession. The symbolism is explained by Saint Sophronius, who was patriarch of Jerusalem in the seventh century:

In honor of the divine mystery that we celebrate today, let us all hasten to meet Christ. Everyone should be eager to join the procession and to carry a light. Our lighted candles are a sign of the divine splendor of the one who comes to expel the dark shadows of evil and to make the whole universe radiant with the brilliance of his eternal light. Our candles also show how bright our souls should be when we go to meet Christ.

The Finding of the Child Jesus in the Temple

The final episode from the infancy narrative of Christ's life is also found in Saint Luke's Gospel:

Now his parents went to Jerusalem every year at the feast of the Passover. And when he was twelve years old, they went up according to custom; and when the feast was ended, as they were returning, the boy Jesus stayed behind in Jerusalem. His parents did not know it. After three days they found him in the temple, sitting among the teachers, listening to them and asking them ques-

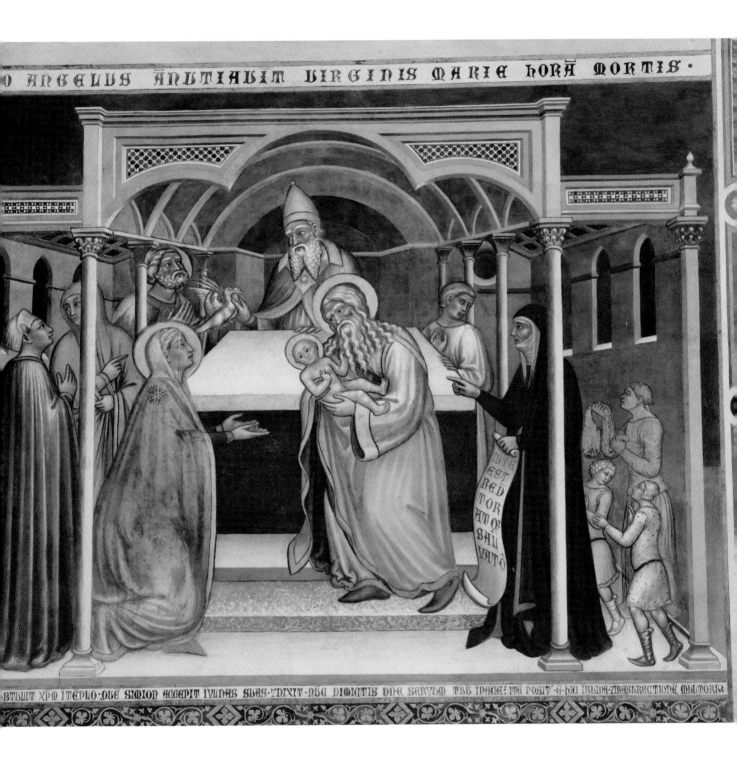

tions; and all who heard him were amazed at his understanding and his answers." (Luke 2:41–43, 46–47)

The boy Jesus is frequently shown seated or standing in this scene, and he is usually surrounded by a group of men (often bearded) holding scrolls and books, consulting the Jewish prophetic writings and Scriptures. In the background, Our Lady and Saint Joseph are often shown approaching, their look of concern giving way to joy.

The Agony in the Garden of Gethsemane

And going a little farther, he fell on the ground and prayed that, if it were possible, the hour might pass from him. And he said,

"Abba, Father, all things are possible to you; remove this chalice from me; yet not what I will, but what you will." And he came and found them sleeping, and he said to Peter, "Simon, are you asleep? Could you not watch one hour? Watch and pray that you may not enter into temptation; the spirit indeed is willing, but the flesh is weak." (Mark 14:35–38)

This opening scene of Christ's passion is easily recognized: Christ is shown on his knees, his hands in a gesture of prayer and supplication. Sometimes he is shown kneeling on a rock like the one that is in the Church of All Nations in Gethsemane in the Holy Land; a winged angel may be shown holding a chalice before him or comforting him (see Lk 22:43).

Often blood runs down the face of the Lord (v. 44), and in the background or in a corner of the scene, three apostles can be seen in slumber.

The Scourging at the Pillar

> So Pilate, wishing to satisfy the crowd, released for them Barabbas; and having scourged Jesus, he delivered him to be crucified. (Mark 15:15)

The Gospels are laconic in their account of the Lord's flagellation by the Roman soldiers and, indeed, neither pillar nor post is mentioned. Nevertheless, tradition holds that Jesus was bound to a short, freestanding stone post, and his exposed back was scourged by Roman soldiers with a whip known as a cat-o'-nine-tails, and this is how it is sometimes depicted in art.

More recently, artists might have been inspired by the writings of Bl. Anne Catherine Emmerich, an Augustinian canoness and mystic who died in 1824.

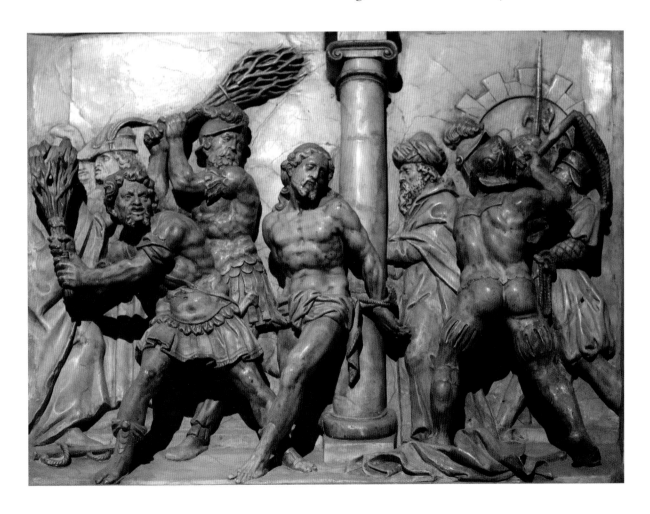

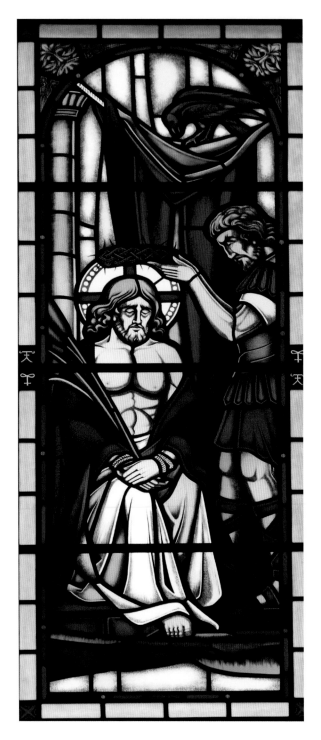

In her accounts of her visions of Christ's passion, which were published posthumously in 1833, she describes that "this pillar, placed in the center of the court, stood alone, and did not serve to sustain any part of the building; it was not very high, for a tall man could touch the summit by stretching out his arm; there was a large iron ring at the top, and both rings and hooks a little lower down." The relic of the pillar, which now looks like a speckled black stone bollard, is housed in the chapel of San Zeno in the basilica of Santa Prassede in Rome.

The Crowning with Thorns

In this scene, Christ is usually shown as the Scriptures describe: "And they clothed him in a purple cloak, and plaiting a crown of thorns they put it on him. And they began to salute him, 'Hail, King of the Jews!'" (Mk 15:17–18).

The crown of thorns is an important symbol of the Lord's passion, often depicted around the Holy Name of Christ or the title above the cross (see chapter 13).

Among the saints, St. Louis IX, king of France, is frequently shown holding the crown of thorns because in 1238 he sent two Dominican friars to bring the precious relic to Paris from Constantinople. The king went on to build the splendid Sainte-Chapelle in Paris to house the crown of thorns and the rest of his relic collection, and to this day the crown of thorns remains in Paris at the Cathedral of Notre Dame, where it may be venerated.

The Carrying of the Cross

> They cried out, "Away with him, away with him, crucify him!" Pilate said to them, "Shall I crucify your King?" The chief priests an-

swered, "We have no king but Caesar." Then he handed him over to them to be crucified. So they took Jesus, and he went out, bearing his own cross, to the place called the place of a skull, which is called in Hebrew Golgotha. (John 19:15–17)

Depictions of Christ carrying his cross follow this account by John, which states that Jesus carried his own cross, and so Jesus is shown bearing the weight of the cross by himself, isolated and alone. Sometimes the pathos is intensified by a chaotic crowd of Roman soldiers and a mob of Jerusalem townsfolk who are milling about him. In some versions, invit-

ing our compassion, Our Lady is also shown nearby, or some of the other disciples, such as Saint John or Saint Veronica holding a cloth imprinted with the face of Christ.

Sometimes this scene is paired with an image of Isaac, shown as a young man or even a boy, carrying a bundle of sticks. As we shall see in the next chapter, this is an example of typology.

The Crucifixion and Death of the Lord

There they crucified him, and with him two others, one on either side, and Jesus between them. Pilate also wrote a title and

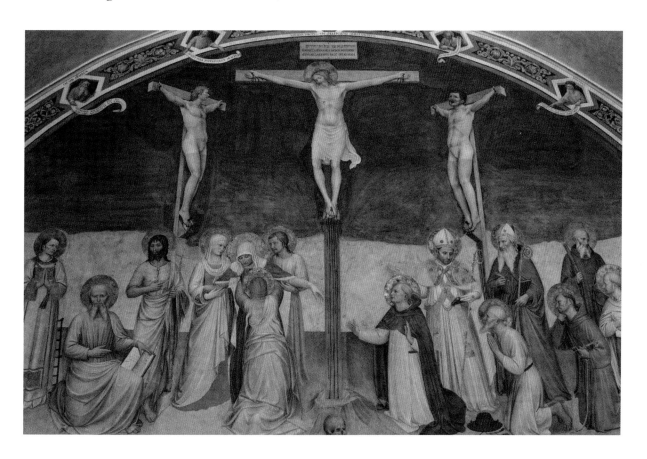

put it on the cross; it read, "Jesus of Nazareth, the King of the Jews." But standing by the cross of Jesus were his mother, and his mother's sister, Mary the wife of Clopas, and Mary Magdalene. When Jesus saw his mother, and the disciple whom he loved standing near, he said to his mother, "Woman, behold, your son!" Then he said to the disciple, "Behold, your mother!" And from that hour the disciple took her to his own home. (John 19:18–19, 25–27)

An image of the crucifixion of the Lord needs little explanation. The crucifix is for us Catholics the most ubiquitous and prominent Christian symbol in our churches, and it should be largely uncontroversial. It is worth pausing to consider, however, that, as Robin M. Jensen observes, "art historians have been unable to identify an unambiguously Christian crucifix before the fourth or fifth century, and only a few examples before the sixth century." This means that more than half a millennium would pass before Christians were sufficiently comfortable with

the "scandal of the cross" to regularly display images of the Crucified Savior for public veneration. Until then, the cross (see chapter 8) was shown encircled by a wreath of triumph or covered in gems or enthroned and flanked by angels or other signs of the passion. Indeed, even when the body of the Lord came to be shown on the cross, he would be serene and triumphant, as though enthroned. It isn't until the mid-ninth century that, with the growth of monastic devotion to the suffering Christ, Jesus is shown suffering and dying on the cross. Nevertheless, it was thought to be vital to show that from the body of the dead Christ flowed blood and water (see Jn 19:34), for these are signs of eternal life, which Christ's death secures for his Church. The ninth-century deacon George of Nicomedia thus said that the effusion of blood and water "bears witness to the simultaneity of life and death, divinity and humanity."

The earliest surviving public image of the Lord upon the cross, starkly portrayed and simply stretched out serenely between two thieves, is found on the carved cypress-wood doors of the basilica of Santa Sabina in Rome. It is a small wooden panel dating to around 432, one of twenty-eight carved biblical scenes, and it is found on the top left, almost hidden in the shadows. Incidentally, Santa Sabina was given by Pope Honorius III to Saint Dominic; hence, since 1219, it has been the home of the master of the Dominican order and his general curia. Since 2019, I have had the honor to serve the master of the order as a member of this body, in my role as promoter general of the holy Rosary, so I have had a good many opportunities to gaze upon this little image of the crucifixion, to pray before it, and to photograph it.

Images of the Crucified Christ were offered to the faithful to stir up devotion in them and to invite them to imitate the supreme humility of the Incarnate Word. Hence St. Thomas Aquinas reflected: "Lest anyone fear a shameful death for the sake of the truth, [Jesus] chose the most horrible kind of death, that of the cross. Thus it was fitting that the Son of God made man should suffer and by his example provoke men to virtue, so as to verify what Peter said (1 Pt 2:21): 'Christ suffered for you, and left an example for you to follow in his steps' " (*De rationibus fidei*, 7).

The Resurrection of the Lord

Although nobody witnessed the Lord's resurrection from the dead, Christian art does often show images of the Lord stepping out or ascending from a stone

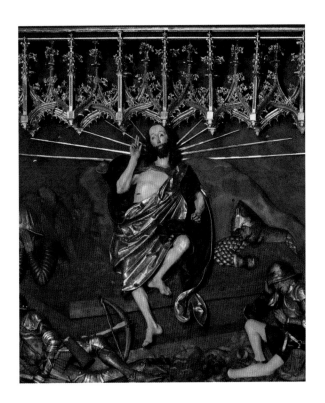

tomb, sometimes scattering the terrified Roman guards. We know it is the risen Lord because he has the wounds, the marks of the nails, in his hands and feet, and his side is pierced. He may also be shown carrying a white flag or gonfalon with a red cross upon it, a medieval symbol of the risen Lord; statues of the Lord thus arrayed are often displayed in churches during Eastertide. An angel dressed in white robes might also be seen, as is attested in Scripture: "And behold, there was a great earthquake; for an angel of the Lord descended from heaven and came and rolled back the stone, and sat upon it. His appearance was like lightning, and his clothing white as snow" (Mt 28:2–3).

Other depictions of the Resurrection are more firmly founded in Scripture and show three women coming to the empty tomb; these are "Mary Magdalene, and Mary the mother of James, and Salome, [who] bought spices, so that they might go and anoint him" (Mk 16:1). These women are often portrayed holding a jar of ointment, and that jar is one of the attributes of St. Mary Magdalene.

Other depictions of the risen Lord are taken from the Scripture accounts of his first appearances. First, Christ appears to St. Mary Magdalene as a gardener (see Jn 20:15), and so he is shown holding a hoe and sometimes wearing a broad-brimmed hat, or she is shown reaching out for his feet (Jn 20:17). Second, Christ appears to two disciples on the road to Emmaus, so he is depicted as a pilgrim with a traveler's staff, a broad-brimmed hat, and even a pilgrim's shell (see chapter 8). Another version of the Emmaus apparition has Christ seated at table, breaking bread with the two disciples, who are often depicted in traveling garb (Lk 24:13–35). The wounds in Christ's hands as he breaks the bread distinguish this scene from images of the Last Supper.

Third, Christ appears to Saint Thomas the apostle, who places his finger into the wound in the risen Lord's side (Jn 20:24–29). There are other scenes of the risen Jesus cooking fish, eating fish, and causing the disciples to have a miraculous catch of 153 fish (Jn 21).

In the iconographic tradition, the Resurrection of Christ is depicted not according to these biblical apparitions but with an image of Christ robed in white and bestriding broken doors or planks of wood. He grasps by the hand a man, who is Adam, and pulls him and Eve out of the darkness of hell into the light. This is called the "Harrowing of Hell," by which we understand the netherworld of the patriarchs, where the righteous awaited the destruction of death by Jesus Christ. The hell referred to here is not the same as the eternal punishment of the damned; rather, it is the Old English word for the realm of the dead. Hence we say in the Apostles' Creed: "He descended into hell; on the third day he rose again from the dead." Sometimes the Harrowing of Hell shows Adam and Eve emerging from the jaws of a monster or a lion, which is a representation of death, as I have said.

One of the more moving resurrection appearances, which is a beautiful tradition, albeit not recounted in Scripture, is that of the Risen Christ to the Virgin Mary, which one sometimes sees depicted in Marian sanctuaries or even enacted in pious devotional plays and processions.

The Ascension of the Lord

When he had said this, as they were looking on, he was lifted up, and a cloud took him out of their sight. And while they were gazing into heaven as he went, behold, two

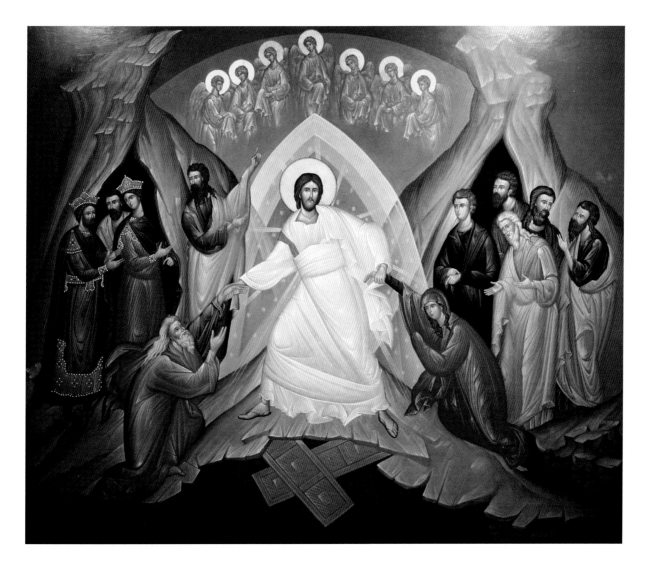

men stood by them in white robes, and said, "Men of Galilee, why do you stand looking into heaven? This Jesus, who was taken up from you into heaven, will come in the same way as you saw him go into heaven." (Acts of the Apostles 1:9–11)

This scene is often depicted quite literally, with Christ rising into the clouds, sometimes with angels on either side of him as he ascends. The apostles (usually just eleven men) are shown looking up into the heavens, and Christ might have his hands raised in blessing as he goes (see Lk 24:51) or might be giving them the Great Commission: "Go therefore and make disciples of all nations, baptizing them in the name of the Father and of the Son and

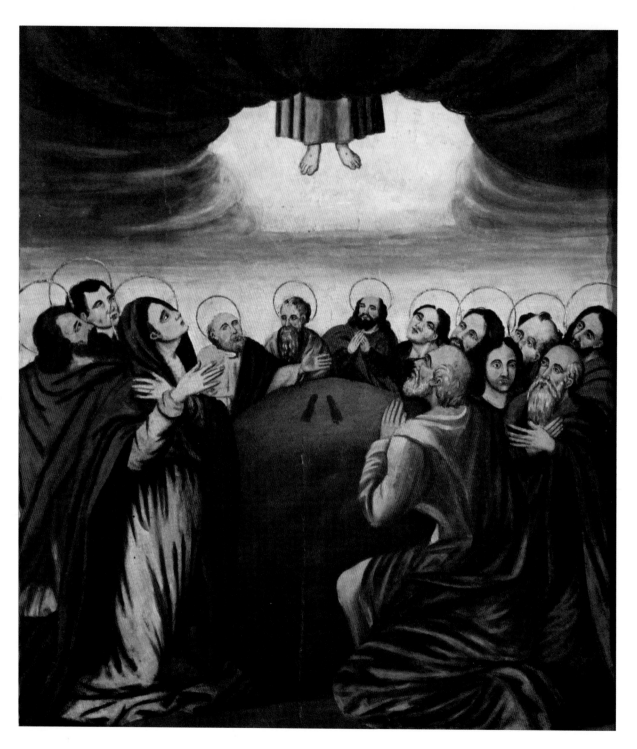

of the Holy Spirit, teaching them to observe all that I have commanded you; and behold, I am with you always, to the close of the age" (Mt 28:19–20).

I delight in the older medieval depictions of the Ascension in which one sees only two feet sticking out of the clouds as the apostles look up, for Our Lord has been taken out of their sight. I know of one church in England where this is portrayed in sculpture, so one sees two feet sticking out of the ceiling of the chapel above a side altar!

The Descent of the Holy Spirit at Pentecost

> When the day of Pentecost had come, they were all together in one place. And suddenly a sound came from heaven like the rush of a mighty wind, and it filled all the house where they were sitting. And there appeared to them tongues as of fire, distributed and resting on each one of them. (Acts of the Apostles 2:1–3)

Catholic depictions of this scene usually have Our Lady seated in the center, flanked by the twelve apostles, including Matthias, chosen by lot to replace Judas Iscariot, who had betrayed the Lord and subsequently killed himself. The Holy Spirit is usually depicted in the form of a dove, even though Scripture makes no mention of this, and rays of light emanate from on high; these might terminate in flames of fire floating above the heads of each of the apostles and of the Virgin Mary. A more scripturally precise depiction of this scene might omit the dove but show these flames being blown by the heavenly wind, one of the principal symbols of the Holy Spirit, who is the *ruah Adonai*, the sacred Breath of God.

Alternatively, non-Catholic depictions of this scene tend to show only the apostles, with Saint Peter sometimes prominently standing in the center and holding two keys (see chapter 19), a symbol of the ecclesial authority entrusted to him.

The Assumption of Our Lady into Heaven

Mary's assumption, body and soul, into heaven, as the *Catechism* says, "is a singular participation in her son's Resurrection and an anticipation of the resurrection of other Christians" (966). As such, Saint Paul gives us a biblical vision of what the Assumption might look like:

> The dead will be raised imperishable, and we shall be changed. For this perishable nature must put on the imperishable, and this mortal nature must put on immortality. When the perishable puts on the imperishable, and the mortal puts on immortality, then shall come to pass the saying that is written: "Death is swallowed up in victory." (1 Corinthians 15:52–54)

Consequently, Our Lady's assumption has often been shown as a dramatic and victorious event, an unexpected joy for the apostles, who are often depicted looking into an empty stone coffin that is typically filled with flowers. Our Lady is shown rising above the grave, being taken up into heaven by winged angels. Sometimes Our Lady is depicted in an almond-shaped halo of light called a *mandorla*, which shows heaven breaking into earth.

In the 1350s, a tradition emerged in Italy of depicting Our Lady being assumed into heaven

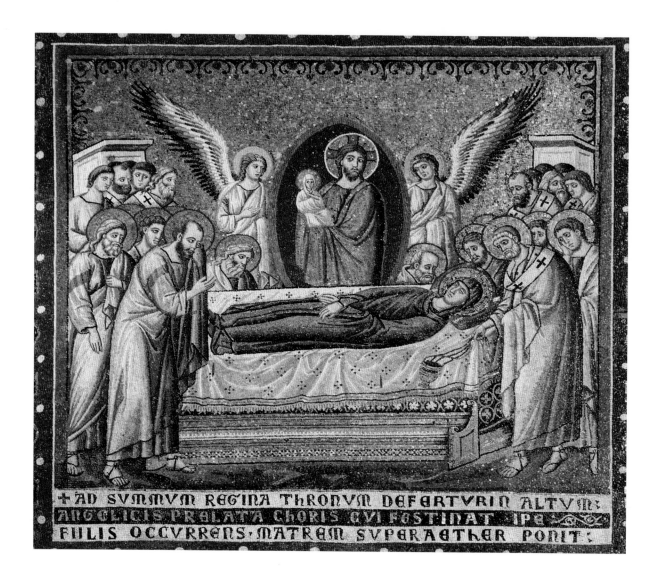

+ AD SVMMVM REGINA THRONVM DEFERTVR IN ALTVM:
ANGELICIS PRELATA CHORIS CVI FESTINAT IPE
FILIS OCCVRRENS · MATREM SVPERAETHER PONIT:

and dropping her girdle or cincture down to Saint Thomas the apostle, who is shown beside the grave, now filled with flowers, a symbol of joy and the new life of the resurrection.

A variation of the Assumption, taken from the Byzantine iconographic tradition, shows Our Lady on her deathbed, surrounded by the apos-tles. Christ comes, sometimes in a mandorla of light, to carry Mary into heaven. He holds a miniature form of Mary, looking almost childlike, in his hands, as angels surround them. This scene is also called the Dormition, or Falling Asleep, of the Virgin Mary.

The Coronation of Our Lady as Queen of Heaven and the Glory of the Saints

Psalm 45:9 declares: "At your right hand stands the queen in gold of Ophir," and Saint John writes that he saw in heaven "a woman clothed with the sun, with the moon under her feet, and on her head a crown of twelve stars" (Rv 12:1). The *Catechism*, moreover, says that in heaven, " 'in the glory of the Most Holy and Undivided Trinity,' 'in the communion of all the saints,' the Church is awaited by the one she venerates as Mother of her Lord and as her own mother" (972).

Scenes of Mary's coronation often show the Blessed Trinity (see chapter 13) bestowing a crown on Our Lady, who is robed in glory and kneels in humility before God, who alone is the source of every grace. A more concise depiction of this mystery might show Our Lady being crowned by Our Lord or seated next to Christ as the queen mother, such as in the apse of the basilica of Santa Maria in Trastevere, Rome. More-expansive depictions of this scene include a host of saints and angels looking upon the Blessed Virgin Mary as their queen, such as in the Rosary Shrine in London.

Imitating them, we do well to look to Mary's virtuous example, to find hope in her glory, and to seek her constant intercession for us as we continue life's journey. As Pope Bl. Pius IX said: "Since she has been appointed by God to be the Queen of heaven and earth, and is exalted above all the choirs of angels and saints, and even stands at the right hand of her only-begotten Son, Jesus Christ our Lord, she presents our petitions in a most efficacious manner. What she asks, she obtains. Her pleas can never be unheard."

The Baptism of Christ in the Jordan

The figure of John the Baptist is usually identified by his garments, as Saint Matthew describes it: "John wore a garment of camel's hair, and a leather belt around his waist" (3:4). He is also often seen holding a staff. In scenes where he is baptizing Jesus, he is frequently shown holding a shell (see chapter 8), and the two cousins are standing in the river Jordan; sometimes the river itself is personified by an old man pouring water into the river.

Almost invariably, the Holy Spirit, in the form of a dove, is seen hovering over the scene, and sometimes God the Father is represented. This is most fitting because the baptism of Christ is a moment of divine revelation in which the Blessed Trinity is made manifest, and it is through our own baptism into Christ that we Christians enter into

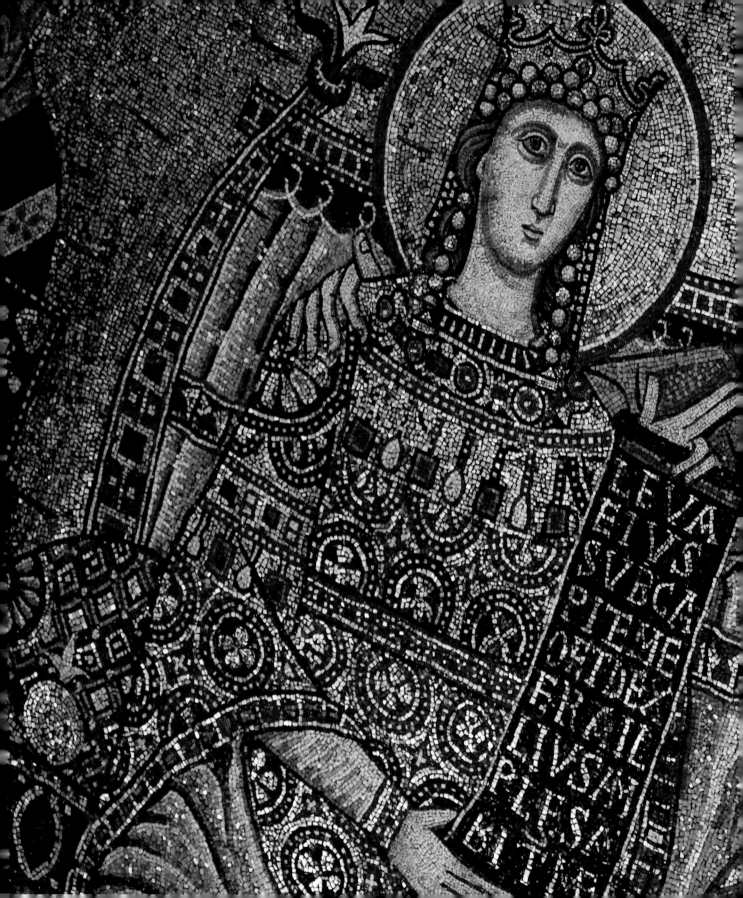

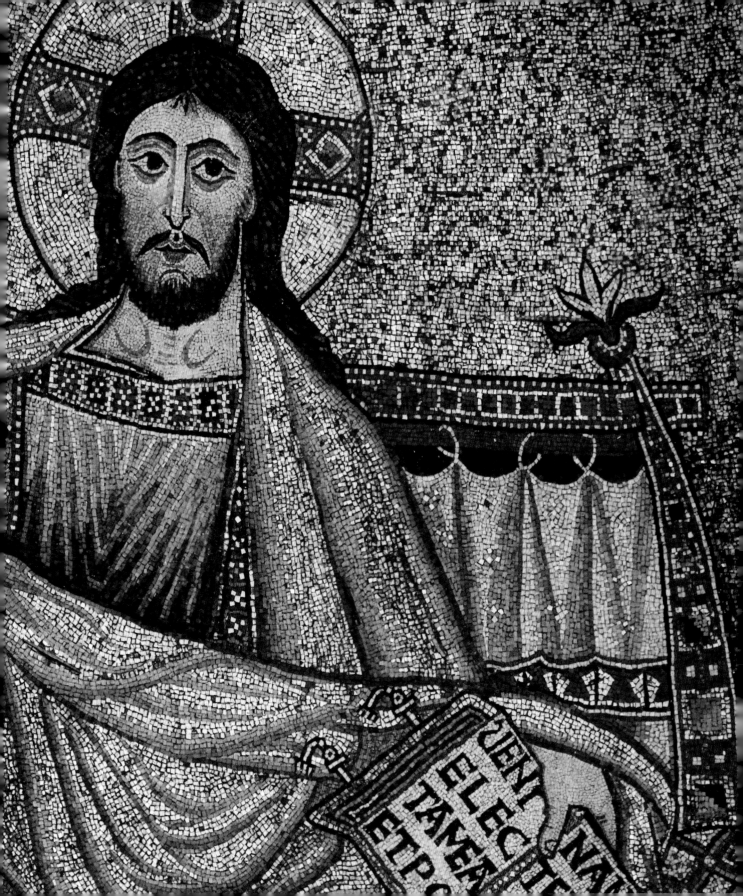

the life of God, the Most Holy Trinity. As Scripture says: "And when he came up out of the water, immediately he saw the heavens opened and the Spirit descending upon him like a dove; and a voice came from heaven, 'You are my beloved Son; with you I am well pleased'" (Mk 1:10–11).

Angels are also often present in this scene, sometimes serving by holding the robes of Christ, or adoring the Blessed Trinity, thus inviting us to do likewise.

The Miracle at the Wedding at Cana

> On the third day there was a marriage at Cana in Galilee, and the mother of Jesus was there; Jesus also was invited to the marriage, with his disciples. When the wine failed, the mother of Jesus said to him, "They have no wine." And Jesus said to her, "O woman, what have you to do with me? My hour has not yet come." His mother said to the servants, "Do whatever he tells you." Now six stone jars were standing there, for the Jewish rites of purification, each holding twenty or thirty gallons. Jesus said to them, "Fill the jars with water." And they filled them up to the brim. He said to them, "Now draw some out, and take it to the steward of the feast." So they took it. When the steward of the feast tasted the water now become wine, and did not know where it came from (though the servants who had drawn the water knew), the steward of the feast called the bridegroom and said to him, "Every man serves the good wine first; and when men have drunk freely, then the poor wine; but you

have kept the good wine until now." This, the first of his signs, Jesus did at Cana in Galilee, and manifested his glory; and his disciples believed in him. (John 2:1–11)

This beautiful scene is usually shown as part of a Marian sequence of windows or carvings, and the main identifying signs are several jars that are filled with the *vinum bonum*, the "good wine" — which is, in fact, a prefiguration of the Eucharist and the heavenly banquet. In the center of the image might

be a bride and groom, with Jesus standing near the jars of water and Our Lady close by. Together, Our Lord and Our Lady come to bless our marriages, and Christ's grace will transform the water of our lives into the new wine of love and fidelity, making our Christian families and marriages signs of God's merciful and loving presence in the world.

The Preaching of the Kingdom and the Call to Conversion

Scenes of Jesus preaching and teaching, either to crowds of people (apart from the apostles) or to children specifically, are quite often seen in church art. Sometimes, the Beatitudes (see Mt 5:1–12) are highlighted and illustrated, perhaps through the actions of certain saints who have lived out these words of Christ. More generally, one sees depictions of Christ seated, perhaps on a small mound, or standing in a boat, preaching to an assortment of people, and we are meant to interpret this as a depiction of these words of Scripture: "Seeing the crowds, he went up on the mountain, and when he sat down his disciples came to him" (Mt 5:1). For the content of Christ's preaching, we recall the words of Saint Matthew: "From that time Jesus began to preach, saying, 'Repent, for the kingdom of heaven is at hand'" (4:17), for repentance brings us ever closer to our holy and all-loving God.

The Transfiguration of the Lord

> Jesus took with him Peter and James and John, and led them up a high mountain apart by themselves; and he was transfigured before them, and his garments became glistening, intensely white, as no fuller on earth could bleach them. And there appeared to them Elijah with Moses; and they were talking to Jesus. And a cloud overshadowed them, and a voice came out of the cloud, "This is my beloved Son; listen to him." (Mark 9:2–4, 7)

We will know a Transfiguration scene by Christ standing on a mountain between two men, one (the lawgiver, Moses) often shown holding the two stone tablets with the Ten Commandments and the other (the prophet Elijah) holding a scroll or a book. Often, Christ's robes are shown in white and gold, and a mandorla or many rays of light surround him, or he might be lifted up into the clouds! Mirroring these three heavenly figures but falling

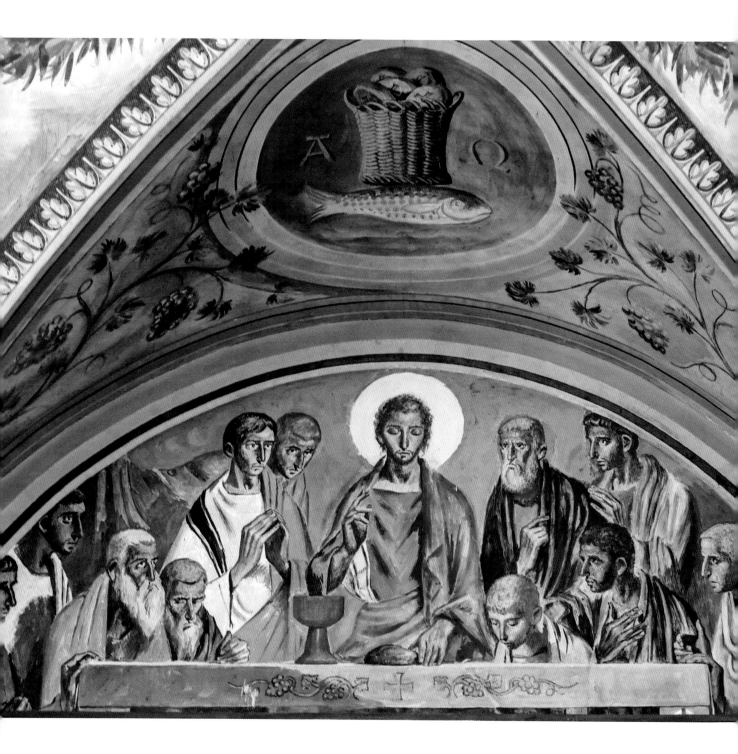

on the barren ground or shielding their faces from the bright light are the three apostles mentioned in Scripture, often with Peter in the center.

The Institution of the Holy Eucharist

Christ instituted the holy Eucharist, and, indeed, ordained the Christian priesthood at the Last Supper. As Saint Paul says:

> I received from the Lord what I also delivered to you, that the Lord Jesus on the night when he was betrayed took bread, and when he had given thanks, he broke it, and said, "This is my body which is for you. Do this in remembrance of me." In the same way also the chalice, after supper, saying, "This chalice is the new covenant in my blood. Do this, as often as you drink it, in remembrance of me." (1 Corinthians 11:23–25)

For reasons of space, depictions of the Last Supper do not always show all twelve apostles around Jesus. As noted above, however, we can distinguish even a reduced Last Supper scene from the Supper at Emmaus by the fact that, in the former, Jesus' hands do not bear the marks of the nails that pierced him on the cross. The bread and wine, or wheat and grape motifs, of the Eucharist also feature prominently in scenes of the Last Supper. Sometimes the scene is shown with a lamb that is slain, a symbol of Christ's sacrifice on the cross, which the Mass makes present again.

Turning toward a darker side of the Last Supper, almost invariably Judas Iscariot is shown — either standing up or in a corner and with his face turned away and always holding a little bag of money, his thirty pieces of silver, the price of a slave (see Ex 21:32). For as Saint Matthew recounts: "One of the Twelve, who was called Judas Iscariot, went to the chief priests and said, 'What will you give me if I deliver him to you?' And they paid him thirty pieces of silver. And from that moment he sought an opportunity to betray him" (26:14–16). The color yellow has long been associated with Judas Iscariot, who is frequently painted in yellow robes, perhaps because it is the color of gold and riches, and, as Scripture says, "the love of money is the root of all evils; it is through this craving that some have wandered away from the faith and pierced their hearts with many pangs" (1 Tm 6:10). Because of the association of yellow with the betrayer, some say that yellow is symbolic of betrayal, envy, jealousy, and greed. It is in this pejorative context that the Nazi regime forced the Jewish people to wear a yellow Star of David.

The Last Supper is also represented in art by the scene of Christ washing the feet of his disciples, usually Saint Peter. For Saint John says that Jesus "rose from supper, laid aside his garments, and tied a towel around himself. Then he poured water into a basin, and began to wash the disciples' feet, and to wipe them with the towel that was tied around him" (Jn 13:4–5). Although Peter balked at the idea at first, he eventually agreed to let Jesus wash his feet and so learned the Lord's lesson of humble service. We do well, as Christ's followers, to heed and put into practice these words of the Lord, too: "You call me Teacher and Lord; and you are right, for so I am. If I then, your Lord and Teacher, have washed your feet, you also ought to wash one another's feet. For I have given you an example, that you also should do as I have done to you" (Jn 13:13–15).

11

The Bible Depicted: Old Testament Scenes and Typology

Christ himself told the two disciples on the road to Emmaus that "everything written about me in the law of Moses and the prophets and the psalms must be fulfilled" (Lk 24:44). For example, Jesus had explicitly engaged in typology, saying that "as Jonah was three days and three nights in the belly of the whale, so will the Son of man be three days and three nights in the heart of the earth" (Mt 12:40). We shall see that there are other instances in which Christ and his saving work have been prefigured in the lives of Old Testament figures and also in the laws and ceremonial rites of the Jewish people. St. Thomas Aquinas explained that "all these things had reasonable causes, both literal, in so far as they were ordained to the worship of God for the time being, and figurative, in so far as they were ordained to foreshadow Christ" (*Summa Theologiae*, Ia-IIæ, q.102, a.5).

Below, we shall look at ten Old Testament prefigurations of the mystery of Christ, beginning with the ones mentioned by Our Lord in the Gospels and continuing with those that are prominent in early Christian art and the writings of the Fathers. This area of typology is one that has fascinated me for many years, and I have enjoyed seeing it displayed in stained-glass windows, medieval churches, illustrated missals, vestments, and so on. For the sake of brevity, however, I can offer only a few examples, which I hope will stimulate your interest and spur you on to look for more instances of typology, showing that what God has done in the Old Covenant has been "accomplished in the fullness of time in the person of his incarnate Son" (CCC 128), in the New Covenant, of which we have become partakers.

Jonah

The sign of Jonah (see Mt 12:39) promised by the Lord is his death and resurrection and the conversion of the Gentiles. The saving mission of Christ is prefigured in the mission of the prophet Jonah, who was swallowed by a whale or a large fish, spent three days and nights in its belly, and then preached to the city of Nineveh; and everybody, both man and beast, repented.

In art, the whale, often shown as a monstrous fish with sharp teeth, spitting Jonah onto the shore is the main way in which the prophet is depicted. An alternative is an image of Jonah seated under a large, leafy plant as he looks upon the expanse of the city of Nineveh, which becomes a parable of God's loving mercy for sinners and his desire that we repent and be saved (see Jon 4:5–11). Sometimes this plant is portrayed as a vine (see chapter 7) in which case it can be seen as an image of the Church or of being united to Christ, who saves us from our sins.

Moses and the Serpent of Bronze

Jesus said to Nicodemus that " 'as Moses lifted up the serpent in the wilderness, so must the Son of man be lifted up, that whoever believes in him may have eternal life.' For God so loved the world that he gave his only-begotten Son, that whoever believes in him should not perish but have eternal life. For God sent the Son into the world, not to condemn the world, but that the world might be saved through him" (Jn 3:14–17).

As we discussed above, the serpent is also a sign of Christ and redemption, and so images of Moses lifting up a pole with a bronze or golden serpent on it are often paired with images of the crucifixion of Christ. Both are seen to be signs of the mercy of God, who desires not the death and destruction of

wicked men but rather that they should believe and be saved through beholding the mercy and love of God.

Incidentally, if we can find the bronze serpent, we can identify Moses. How do we know it is Moses? As we mentioned above, he is sometimes shown holding the tablets of the law, but without these attributes, we might know it is Moses because, in the Middle Ages, he came to be portrayed with two shafts of light or even two horns coming from his head. This is because, in Exodus 34:30, we're told that because Moses spoke with God on Mount Sinai, "his face shone, and [the Israelites] were afraid to come near him." Unfortunately, in Latin the word for "his face shone" or "shining," *cornutam*, could also be translated as "he had horns"! Even Michelangelo sculpted Moses with two small horns on his head.

Moses and Manna from Heaven

The word *manna* is the name given to the bread-like food that God rained down from heaven every morning for forty years to feed his people in the desert (see Ex 16). Nehemiah calls this "bread from heaven" (9:15), and Psalm 78:25 calls it the "bread of the angels." In fact, the word *manna* comes from the Hebrew *ma'n hu?*, which means "what is it?" God fed his people with this heavenly food, otherwise unknown to mankind, to strengthen them on their journey through the wilderness.

Manna is a prefiguration of the Eucharist, the bread from heaven, which feeds us with Christ himself and so strengthens us for our journey to the promised land that is heaven. Saint John writes that the Jews said: " 'Our fathers ate the manna in the wilderness; as it is written, "He gave them bread

from heaven to eat." ' Jesus then said to them, 'Truly, truly, I say to you, it was not Moses who gave you the bread from heaven; my Father gives you the true bread from heaven. For the bread of God is that which comes down from heaven, and gives life to the world' " (Jn 6:31–33).

The miraculous fall of manna is typically shown as white disks or what looks like snow, falling from the skies. Moses and the people are shown gathering this into baskets. Sometimes, as a symbol, just a basket with white disks falling into it is shown.

Moses Striking the Rock

Saint Paul writes that the Jewish people of God "all ate the same supernatural food and all drank the same supernatural drink. For they drank from the supernatural Rock which followed them, and the Rock was Christ" (1 Cor 10:3–4). This connects the typology of the manna with the typology of the rock that Moses struck with his staff so that the people could have a refreshing drink in the desert. As Scripture recounts: "Moses and Aaron gathered the assembly together before the rock, and he said to them, 'Hear now, you rebels; shall we bring forth water for you out of this rock?' And Moses lifted up his hand and struck the rock with his rod twice; and water came forth abundantly, and the congregation drank, and their cattle" (Nm 20:10–11).

The image of Moses striking the rock is, on one hand, a sign of God's providence, but it is also a prefiguration of Christ, who is the rock, struck by the nails and the lance when he is crucified, and from whom flows living water (as mentioned above). The image of Christ as a rock is also found in 1 Peter 2:4, which says that Christ is "that living stone, rejected by men but in God's sight chosen and precious." We are called to receive life and grace from this living

stone, just as Moses and the people of Israel did, so that we can be refreshed on life's journey and so follow Christ to the promised land of heaven.

The Binding of Isaac

As mentioned briefly above in our discussion of the depiction of the crucifixion, the figure of Isaac — the beloved only son who was promised to Abraham and was miraculously conceived but is now carrying a bundle of sticks or firewood for his own sacrifice — is regarded as a prefiguration of Christ carrying his cross on his way to be sacrificed on Calvary. The whole account is found in Genesis 22:2–18, but our focus is on these verses which the artists tend to portray:

> Abraham took the wood of the burnt offering, and laid it on Isaac his son; and he took in his hand the fire and the knife. [And

Isaac said], "Behold, the fire and the wood; but where is the lamb for a burnt offering?" Abraham said, "God will provide himself the lamb for a burnt offering, my son." So they went both of them together. And Abraham lifted up his eyes and looked, and behold, behind him was a ram, caught in a thicket by his horns; and Abraham went and took the ram, and offered it up as a burnt offering instead of his son. (vv. 6, 7–8, 13)

In art, one sees Isaac carrying the wood or laid on the altar with Abraham poised to strike, but an angel holds him back, and his eyes turn to see a ram in a thicket.

The Fathers of the Church, from the second century onward, have preached on Isaac and the sacrifice of the ram as a type of Christ and his sacrificial death on the cross. St. John Chrysostom said in his *Homily on Genesis*:

All this, however, happened as a type of the Cross. Hence Christ too said to the Jews, "Your father Abraham rejoiced in anticipation of seeing my day; he saw it and was delighted." How did he see it if he lived so long before? In type, in shadow: just as in our text the sheep was offered in place of Isaac, so here the rational lamb was offered for the world. You see, it was necessary that the truth be sketched out ahead of time in shadow. Notice, I ask you, dearly beloved, how everything was prefigured in shadow: an only-begotten son in that case, an only-begotten in this; dearly loved in that case, dearly loved in this. The former was offered as a burnt offering by his father; and the lat-

ter his Father surrendered.

Noah and the Ark

In 1 Peter 3:20–21, the apostle writes: "God's patience waited in the days of Noah, during the building of the ark, in which a few, that is, eight persons, were saved through water. Baptism, which corresponds to this, now saves you." This is another example of biblical typology, and, as we have seen, the ark or a ship is thus a symbol of the Church, who saves humanity from the watery depths of the baptismal pool, fishing them out of their sins, so to speak (see chapter 7).

Noah is often depicted alone on the ark, which is sometimes just a box floating on the waters. He is frequently shown releasing a dove into the sky, or we see the dove with an olive leaf in its beak, a sign of salvation and a reminder of the scene of baptism (see chapter 7). Scripture says, "Again [Noah] sent forth the dove out of the ark; and the dove came back to him in the evening, and behold, in her mouth a freshly plucked olive leaf; so Noah knew that the waters had subsided from the earth" (Gn 8:10–11).

Occasionally, we see Noah and his family offering sacrifice in thanksgiving to God, and in the background is the ark with animals coming out of it. A rainbow, the heavenly sign of God's covenant, is also shown. Concerning the rainbow, whose scriptural meaning, in our time, has been lost and even distorted, we must state again the promise of God: "When the bow is in the clouds, I will look upon it and remember the everlasting covenant between God and every living creature of all flesh that is upon the earth" (Gn 9:16). As such, the rainbow is a reminder of God's promise not to destroy humankind for its sins. It is a reminder, indeed, of God's loving mercy, made manifest in Christ. As St.

Thomas Aquinas says: "Therefore the only-begotten Word of God, true God and Son of God, assumed a human nature and willed to suffer death in it so as to purify the whole human race indebted by sin." The rainbow should stir up in us gratitude for God's mercy, greater love for the Savior, and contrition for our sins, which keep us from receiving his friendship and grace.

Daniel and the Lions

" 'My God sent his angel and shut the lions' mouths, and they have not hurt me, because I was found blameless before him; and also before you, O king, I have done no wrong,'" recounts Daniel 6:22. "Then the king was exceedingly glad, and commanded that Daniel be taken up out of the den. So Daniel was taken up out of the den, and no kind of hurt was found upon him, because he had trusted in his God" (v. 23).

The image of Daniel, often portrayed as a young man, between two lions is found in the catacombs in Rome and carved into early Christian sarcophagi because it is a prefiguration of Christ delivering us from death, which is symbolized by the lions (see

chapter 7). So, when confronted by the dangers of death, or even by the lions of the amphitheater (as the early Christians were), or the lions that stalk us in our time, we Christians are reminded to have no fear but to trust in Christ, our risen Lord, and God, who will save us from eternal death.

The Three Young Men in the Furnace

Also from the Book of Daniel is the story of Shadrach, Meshach, and Abednego, who refuse to worship idols and so are tied up and thrown into a blazing furnace. But the king is astonished to see "four men loose, walking in the midst of the fire, and they are not hurt; and the appearance of the fourth is like a son of the gods." They are rescued from the furnace and the king says: "Blessed be the God of Shadrach, Meshach, and Abednego, who has sent his angel and delivered his servants, who trusted in him, and set at nothing the king's command, and yielded up their bodies rather than serve and wor-

ship any god except their own God" (Dn 3:25, 28).

This again is a prefiguration of Christ delivering souls from death or a sign of the victory of the martyrs who would not succumb to the powers of the world and who are saved by their trust in the one true God. Consequently, the three youths seen standing in an oven, with their hands raised in prayer, is another Old Testament image that is prominent in the Roman catacombs and in early Christian art.

Elijah and the Fiery Chariot

In the Second Book of Kings, we're told that as Elijah and Elisha "went on and talked, behold, a chariot of fire and horses of fire separated the two of them. And Elijah went up by a whirlwind into heaven" (2:11). We sometimes see this dramatic scene in church art, prefiguring Christ's ascension into heaven and also as a precursor of the assumption of Our Lady into heaven. Writing in the fourth century, Saint Epiphanius, bishop of Salamis, thus compares the Blessed

Virgin Mary to Elijah, who he says also "was virgin from his mother's womb, always remained so, and was taken up and has not seen death."

Adam and Eve

Images of the creation of Adam, the creation of Eve, and especially of their succumbing to temptation and reaching out for the forbidden fruit or an apple (see chapter 7) are not infrequently seen in churches. The scene of the Fall of man into sin, however, is always juxtaposed with the obedience of Our Lady at the Annunciation (see chapter 10) or the offering of Christ on the tree of the cross — the New Adam and the New Eve compared with our first parents. As such, Adam and Eve prefigure, or rather anticipate, our redemption.

Saint Irenaeus explains this beautifully in his work *Adversus hæreses*:

> The Lord, coming into his own creation in visible form, was sustained by his own creation which he himself sustains in being. his obedience on the tree of the cross reversed the disobedience at the tree in Eden; the good news of the truth announced by an angel to Mary, a virgin subject to a husband, undid the evil lie that seduced Eve, a virgin espoused to a husband. As Eve was seduced by the word of an angel and so fled from God after disobeying his word, Mary in her turn was given the good news by the word of an angel, and bore God in obedience to his word. As Eve was seduced into disobedience to God, so Mary was persuaded into obedience to God; thus the Virgin Mary became the advocate of the virgin Eve. ... That is why the Lord proclaims himself the Son of Man, the one who renews in himself that first man from whom the race born of woman was formed; as by a man's defeat our race fell into the bondage of death, so by a man's victory we were to rise again to life.

12

Depicting God: The Mystery Made Visible

Having surveyed the Scriptures and the mysteries of salvation made visible in the art that adorns our churches, we can now look, more generally, at the "actors" in the drama of salvation. We begin, of course, with He Who Is: God.

Now, Saint John states simply that "no one has ever seen God; the only-begotten Son, who is in the bosom of the Father, he has made him known" (Jn 1:18). So the notion of depicting God, at first, seems ridiculous. Certainly, were it not for the Incarnation, it would be impossible and even blasphemous to depict God; Muslims and Jews, who reject the Incarnation, are thus consistent in their rejection of attempts to represent God in figurative art. Christianity has also had to struggle with iconoclasm within its own ranks, grappling with a sometimes violent opposition to depicting God. The classic iconoclastic struggle took place in the Byzantine period from 726 to 842, but iconoclasm returned after the Protestant Reformation and, more recently, after the Second Vatican Council, when all too many church sanctuaries were literally whitewashed. Some were even stripped bare of figurative art and visual representations of God, leaving behind vague symbols, abstract forms, and featureless and faceless figures. In each case, there was, arguably, an appeal to the mystery and transcendent simplicity of God, who resists being captured by human artistry, coupled with a fear of the dangers of superstition and idolatry.

And yet the glory of the divine condescension and the "scandal" of the Incarnation of God is found precisely in this fact: that God wills to make himself known to us; that God, desiring friendship with man, should now have a face and a body so that he can be known. Indeed, God is now able to be represented in art, risky though this might be.

But this is the risk of the Incarnation, a risk that Love itself can dare to take. So Saint John says:

> That which was from the beginning, which we have heard, which we have seen with our eyes, which we have looked upon and touched with our hands, concerning the word of life — the life was made manifest, and we saw it, and testify to it, and proclaim to you the eternal life which was with the Father and was made manifest to us — that which we have seen and heard we proclaim also to you, so that you may have fellowship with us; and our fellowship is with the Father and with his Son Jesus Christ. And we are writing this that our joy may be complete. (1 John 1:1–4)

The art of creating images of the Word-made-Flesh and present among us is still called iconography — literally, writing an image, a picture. For Christ himself is the consubstantial "*icon* of the unseen God" (see Col 1:15) who has made God known to us. So St. John Damascene argued that "of old they who did not know God, worshiped false gods. But now, knowing God, or rather being known by him, how can we return to bare and naked rudiments? I have looked upon the human form of God, and

my soul has been saved." For "just as we listen with our bodily ears to physical words and understand spiritual things, so, through corporeal vision, we come to the spiritual. On this account Christ took a body and a soul, as man has both one and the other." Therefore, images of God are right and just and fitting, and they honor the Incarnation of Christ that we depict God-made-Man, and show forth his deeds and his visible mysteries, and those of the saints and even of the angelic realm. St. Germanus of Constantinople argued: "We depict the likeness of his holy flesh in our icons, which we esteem and honor through appropriate reverence, for they remind us of his life-giving and ineffable Incarnation."

These images are written so that our joy in God-with-us, the Incarnate God, may be complete.

In these next few chapters, we shall survey the invisible made visible: how God is depicted, then the angels, and then the sacraments.

The Halo

The sacraments are, in Saint Augustine's formulation, "outward and visible signs of inward and invisible grace." So how might something unseen, such as grace or spiritual things, be shown in art? One way, as we shall see, is by trying to depict light. Scripture tells us that God "dwells in unapproachable light" (1 Tm 6:16), so light is an important sign of the divine presence. In considering the artistic depictions of the Assumption and the Transfiguration in chapter 10, I mentioned the almond-shaped halo of light known as the mandorla, the Italian word for *almond*.

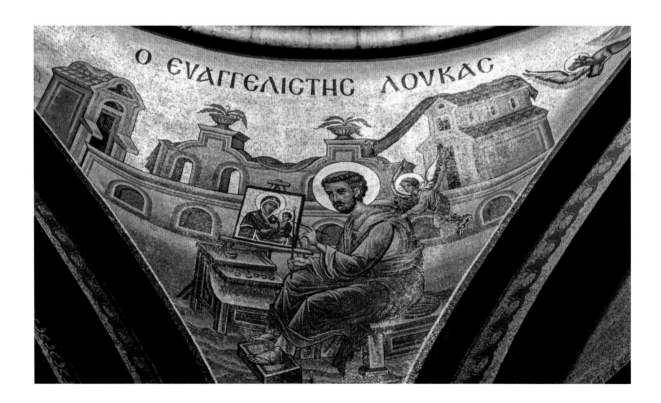

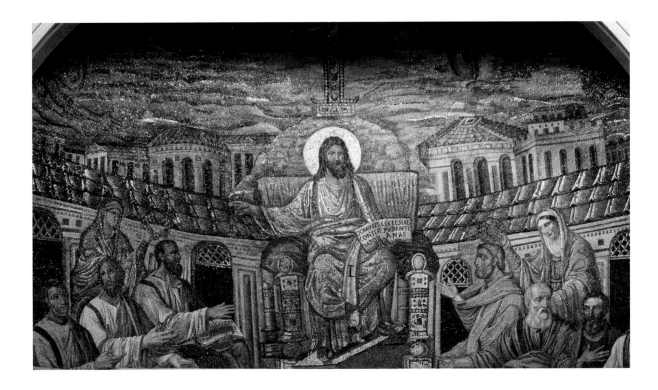

The word *halo* itself comes from the Greek and Latin for "disk," or a ring of light around the sun or the moon. The halo, as an artistic device, whether just a disk around the head (also known as an *aureole*) or surrounding the whole person (called a *mandorla*), is believed to have originated in ancient Buddhist art as a sign of enlightenment. This artistic depiction of light around a person made its way into imperial Roman art, and a golden mosaic halo became a sign of divinity for the Roman gods.

It was only in the fourth century that the halo was adopted in Christian art, as the Church struggled against Arianism, which denied the divinity of Christ. Countering Arianism, the Council of Nicaea specifically declared Christ to be "light from light, true God from true God, consubstantial with the Father," and so this supernatural light was depicted in art, and especially in mosaic, to express the divinity of Christ. Thomas F. Mathews traces the "earliest securely dated example of the aureole" to a mosaic from around 366–384 in the Roman catacomb of Domitilla: Christ is seated in "a circle of light, a zone of supernatural glory, meant to convey the equation of Christ with his Father." Subsequently, the saints also came to be shown with halos, a beautiful way of indicating that the grace of Christ, which redeems and sanctifies the saints, makes us "partakers of the divine nature" (2 Pt 1:4). Christ tells us, "Let your light so shine before men, that they may see your good works and give glory to your Father who is in heaven" (Mt 5:16). Oftentimes, to distinguish Jesus Christ from other persons, a red or gold cross will appear in the aureole of the Savior.

13
The Holy Trinity

We saw in chapter 10 that, at the baptism of Christ, the Holy Trinity is revealed, so artists have sought to depict the Trinity in this scene. But in the first millennium of the Church, there was rightly a reticence to depict God the Father, since "no one has seen the Father except the one who is from God; only he has seen the Father" (Jn 6:46, NIV). God the Father is shown as a hand — pointing downward in blessing from the heavens, surrounded by clouds or angels or sending forth the Holy Spirit in the form of a dove upon the Son.

From the tenth century onward, attempts were made to give the Father a human face, often one that looked like Christ's (see Jn 14:9) but with a long, flowing white beard. Justification for this artistic depiction comes from the description of the "Ancient of Days" in the Book of Daniel: "His clothing was white as snow, and the hair of his head like pure wool" (7:9). Sometimes, the Father has a triangular halo around his head — in general, any shape with three lobes, or three sides, or even three windows together came to be regarded as a symbol of the Blessed Trinity.

In the Middle Ages, a popular representation of the Blessed Trinity, known as the "Throne of Mercy" or *Sedes gratiæ* (seat of grace) developed. God the Father, shown as an older, bearded figure — sometimes with the distinctive papal crown (see chapter 21) and seated on a throne — holds aloft the crucifix or the dying Christ. The Holy Spirit in the form of a dove is seen either between the Father and the Son or somewhere in line with them. This depiction of the Blessed Trinity received support from Pope Benedict XIV in 1745, even though it remains controversial in Orthodoxy and in some parts of the Church in the West to depict God the Father as a human figure.

From the time that God the Father begins to be depicted as the Ancient of Days, we gradually find the hand of God being steadily replaced by an image of a bearded man, crowned and holding the globe and surrounded by an aureole of light or clouds or by angels. This is how

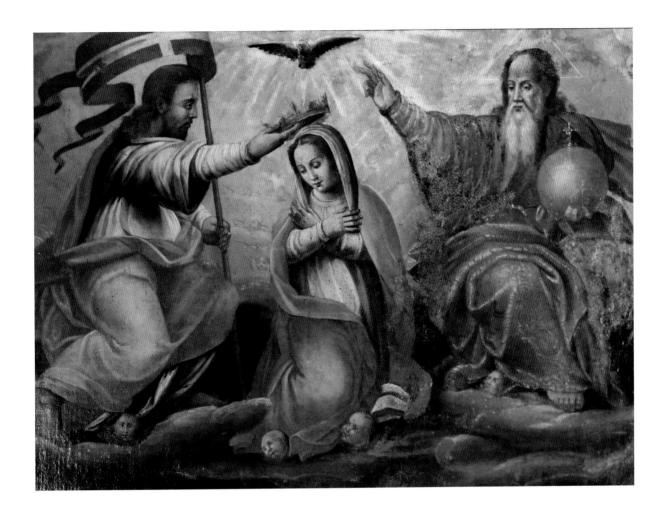

we tend to envisage God the Father — even Michelangelo's famous depiction of *The Creation of Adam* on the Sistine Chapel ceiling follows in this tradition. Then, beginning in the middle of the second millennium of Christianity, images of the Trinity crowning Our Lady also develop, and the Mercy Seat is replaced with the Father as the Ancient of Days, shown in heavenly light next to the Son crowning Our Lady (see chapter 10), and again, the Holy Spirit in the form of a dove hovers between them. Later,

Our Lady is removed from this artistic assemblage, and the Holy Trinity is depicted independently as three Persons — an older bearded man, a younger man, and a dove — surrounded by light or shedding rays upon a globe. In some countries, it has even become commonplace to depict God the Father in this form but alone, just as artists also depict the second and third Persons of the Holy Trinity on their own.

I think that depictions of the invisible Triune God, and especially of the Father, are always going

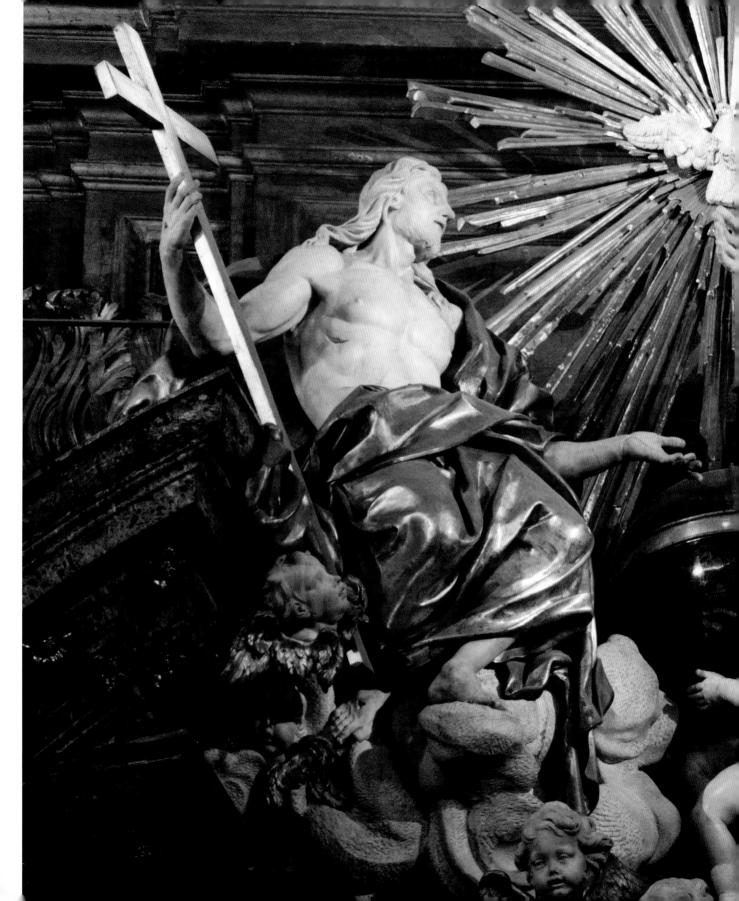

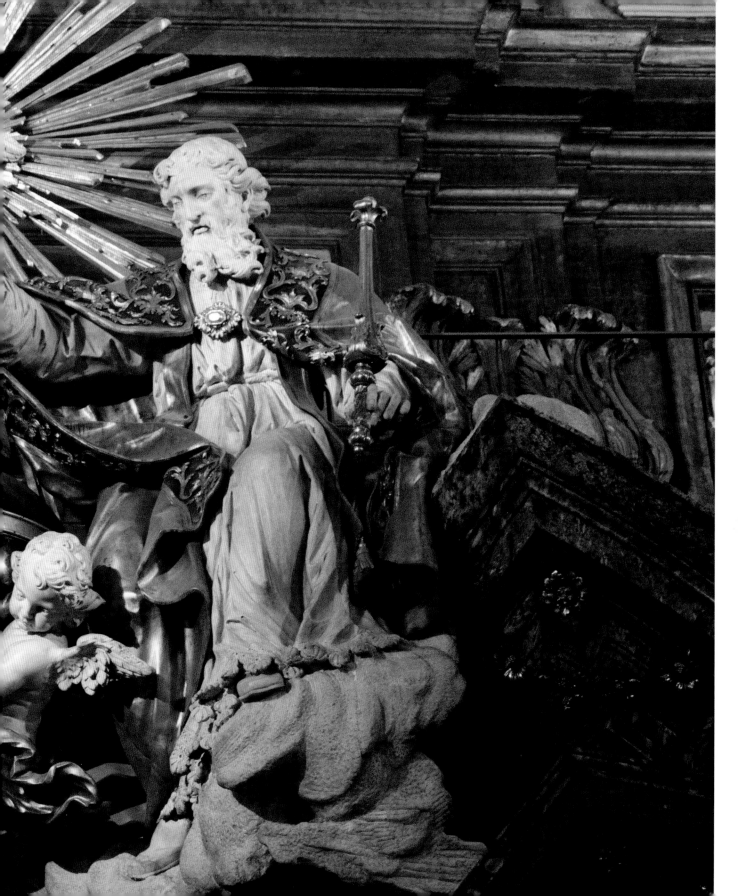

to be difficult and controversial. But this alerts us to the fact that although Christ has deigned to make God known to us so that we can love him better, we must also remember that creatures simply cannot grasp the infinite mystery of God or bring him down to our material human level or conceive of him adequately with our limited intellects. Rather, as St. Thomas Aquinas said, "God is greater than all we can say, greater than all that we can know; and not merely does he transcend our language and our knowledge, but he is beyond the comprehension of every mind whatsoever, even of angelic minds, and beyond the being of every substance" (*Commentary on the Divine Names*, I, 3, 77).

Depictions of God the Son

Crucifix: See chapter 10 on the crucifixion about the emergence of the crucifix in Christian art. Today, the Church's liturgy requires that "a cross, with the figure of Christ crucified" be placed "either on the altar or near it" and that it should be "clearly visible to the assembled people ... so as to call to mind for the faithful the saving Passion of the Lord" (*General Instruction of the Roman Missal*, 308).

In a traditional Roman altar arrangement, this crucifix was at the center of six candles, which, as noted above, burn as a sign of sacrificial love. The cross of Jesus, of course, is the principal sign of God's sacrificial love for mankind, and when placed between six candles, it alludes to the menorah, the seven-branched candlestick that burned in the Jewish Temple as a sign of God's presence on earth (see Ex 25:31-40 for a description). It is also an allusion to the seven golden lampstands in

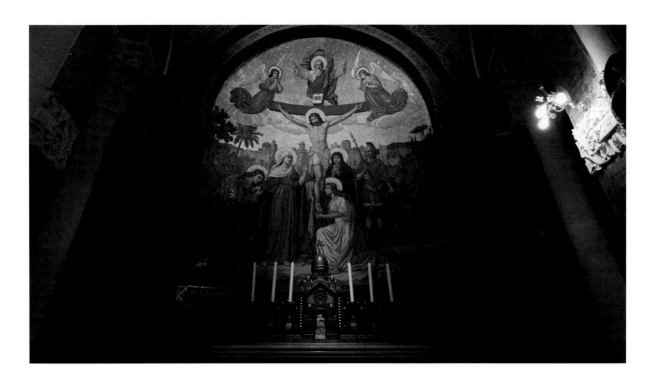

heaven that burn in God's presence as a sign of the prayers of the Church (see Rv 1:12–20).

Eucharist: I have already noted various symbols of the Eucharist that I will briefly list here again: the pelican; the wheat and the vine; the chalice and the manna; the five loaves and two fish. More recently, one will see a Host — that is, the consecrated altar bread — perhaps with the name of Christ on it, and sometimes contained in a monstrance. A monstrance is a gold container in which the Host is displayed for adoration, and it is either in the shape of a sunburst, a tower with spires, or an aureole of light and clouds with little angels.

Sometimes the monstrance with the Host is an attribute of certain saints who are connected with Eucharistic devotion or who have defended the Catholic doctrine of the Eucharist.

Good Shepherd: St. Thomas Aquinas said that God the Son is "the express Image of the Father," so beauty, which is a property of goodness in things that are seen and perceived, has a likeness to the Son, who is the visible image of the unseen God. Indeed, Christ describes himself in Saint John's Gospel as *ho poimen ho kalos*, the beautiful or attractive or good Shepherd (see 10:11). Consequently, images of a shepherd, carrying a sheep on his shoulders, or leading it back to the sheepfold with his shepherd's crook, or protecting it from wolves, or seated and playing a lyre are among the oldest representations of Jesus Christ. Drawing on preexisting Greek and Roman imagery, portrayals of the Good Shepherd are found in the Roman catacombs and continue to be popular in every age. The shepherd leads his flock to safe pasture, just as Christ perennially protects us

from sin and leads us to heaven.

Instruments of the Passion: These symbols of the Lord's passion are derived from the Gospel accounts of the final hours of Christ's life on earth. The relics of these items can be found in Rome and in Jerusalem. The most obvious are the cross, the nails, the crown of thorns, and a reed (see Mk 15:17-19). There is also the seamless tunic of Christ together with some dice (Jn 19:23-24); the cat-o'-nine-tails and the pillar (see chapter 10, "The Scourging at the Pillar"); a reed and a sponge soaked with vinegar (Mk 15:36); the spear that pierced the Lord's side (Jn 19:34); and a ladder for taking the dead Christ down from the cross. To these is sometimes added the purse of Judas Iscariot (see chapter 10, "The Institution of the Eucha-

rist"); the cock that crowed when Peter denied the Lord thrice (see chapter 19), and ropes, a hammer, and pincers. These various items are found either arranged together, or placed on shields, or held by angels as reminders of the Lord's suffering and also as trophies — that is, emblems of the Lord's victory over sin and evil. Scripture says, "Although he was a Son, he learned obedience through what he suffered; and being made perfect he became the source of eternal salvation to all who obey him" (Heb 5:8-9).

Lamb of God: Another scriptural image of Jesus is that of the Passover Lamb (see Ex 12) that is sacrificed for our sins. Saint Paul declares that "Christ, our Paschal Lamb, has been sacrificed" (1 Cor 5:7), and St. John the Baptist, pointing to

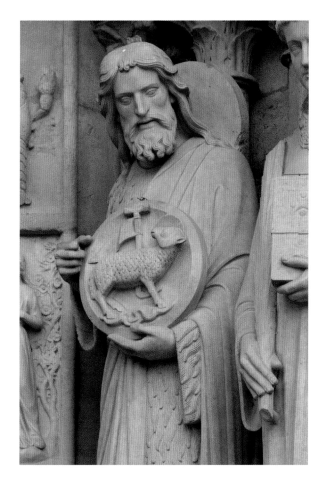

Christ, cries out: "Behold, the Lamb of God, who takes away the sin of the world!" (Jn 1:29). In his vision of heavenly worship, Saint John says that "between the throne and the four living creatures and among the elders, I saw a Lamb standing, as though it had been slain" (Rv 5:6) and the Lamb alone is worthy to open the seven seals of the book of life in heaven (see vv. 7–9).

St. John the Baptist is often depicted pointing at or holding a lamb (sometimes shown with the flag of the Resurrection, a white flag with a red cross, as mentioned in chapter 10). Early Christian mosaics in the Roman basilicas show the Lamb standing in the middle of the apse, often with a halo with a cross (known as a cruciform halo) or lying on a throne. Later depictions show the Lamb of God lying on a book or scroll sealed with seven seals, thus showing that, by his sacrifice, Christ leads us to eternal life.

Name and Titles: Saint John tells us that "Pilate also wrote a title and put it on the cross; it read, 'Jesus of Nazareth, the King of the Jews.'

... And it was written in Hebrew, in Latin, and in Greek" (Jn 19:19–20). Above the figure of Christ on the Cross are shown the letters INRI, which is the Latin abbreviation for this title. The relic of this *titulus* is in the basilica of Santa Croce in Gerusalemme in Rome.

The Holy Name of Jesus is often depicted with the letters *IHC* or, more commonly, *IHS*. The letters form the emblem of the Society of Jesus (Jesuits), and they were used as a logo by St. Bernardine of Siena to spread devotion to the Holy Name. Appropriately, these are the first three Greek letters of the name Jesus. Perhaps due to ignorance of the Greek alphabet, however, the letters have also been said to stand for the

Latin phrase *Iesus Hominum Salvator*, which means "Jesus, Savior of mankind," or even the English phrase "In His service." Neither of these translations, though, can compare to the Holy Name of Jesus itself, written in Greek, the language of the New Testament, and which means "God saves."

Two other Greek letters that stand for the person of Jesus Christ are mentioned in Revelation 1:8: "'I am the Alpha and the Omega,' says the Lord God, who is and who was and who is to come, the Almighty." The A and the Ω are the first and last letters of the Greek alphabet and signify God's eternity. When the paschal candle is blessed, the priest declares: "Christ yesterday and today, the beginning and the end, Alpha and Omega, all time belongs to

him and all the ages." The Alpha and the Omega are seen marked on every paschal candle, and they are often shown in depictions of Christ seated in majesty in heaven or returning in glory; these letters of the Greek alphabet are marked in an open book that he holds in his left hand.

The last Greek letter combination is the Chi-Rho, which is formed from the first two Greek letters (X and P) of the word *Christos* which means "Christ." According to Eusebius, the emperor Constantine had a vision in the year 312 telling him to place the Chi-Rho on his ensign, and he would be victorious in battle. The emperor indeed prevailed against Maxentius at the Milvian Bridge outside Rome and thus came to believe in Christ and eventually converted to Christianity. Constantine subsequently safeguarded the Christian community, gave religious tolerance to Christians throughout the Roman Empire, and, with his mother, Saint Helena, built the first dedicated Christian churches. The Chi-Rho, regarded as a symbol of Christ's victory over death, can be found in the catacombs, on early Christian sepulchers and funerary monuments, on lamps, mosaics, and vestments, and even surmounting the facade of St. John Lateran, the cathedral church of Rome, built on a site that Constantine donated to the pope.

Sacred Heart: In the Middle Ages, devotion to the five wounds of Christ — his nail-pierced hands and feet, and his lance-pierced heart — was fostered by Saint Gertrude and other saints. The five Our Fathers of the Dominican Rosary were said to honor the five wounds of Christ, and a Mass in honor of the five wounds became very

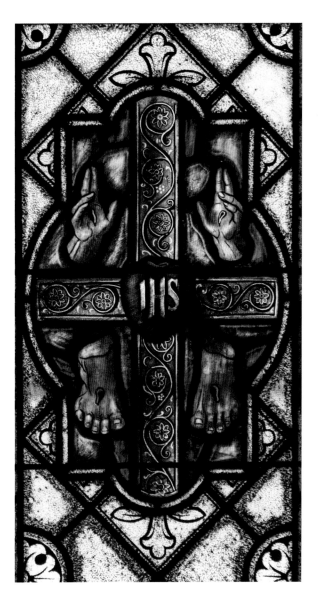

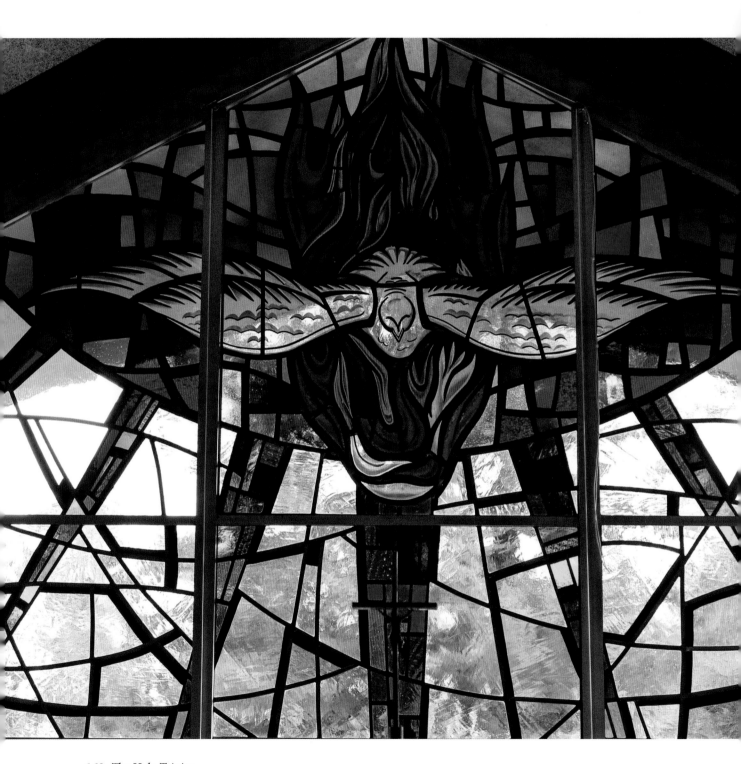

popular in the fifteenth century. The heraldic depiction of the five wounds even became part of the Portuguese flag. The five wounds are thus often depicted on a shield with the pierced heart in the center, and with the two pierced hands above it and two pierced feet below. Sometimes blood drips from the Sacred Heart into a chalice, and the name of Christ might appear in a golden sunburst above the Sacred Heart. In the sixteenth century, this became the emblem of the Pilgrimage of Grace, an attempt by Catholics in the North of England to protest and overturn the Protestant Reformation and the closure of the monasteries under Henry VIII.

In 1674, St. Margaret Mary Alacoque had a vision of Jesus Christ, who revealed to her his heart, wounded by the ingratitude and sins of humanity. She said:

> The Divine Heart was presented to me in a throne of flames, more resplendent than a sun, transparent as crystal, with this adorable wound. And it was surrounded with a crown of thorns, signifying the punctures made in it by our sins, and a cross above signifying that from the first instant of his Incarnation ... the cross was implanted into it and from the first moment it was filled with all the sorrow to be inflicted on it by the humiliations, poverty, pain, and scorn that his sacred humanity was to endure throughout his life and during his sacred passion.

The Sacred Heart shown by itself, according to this vision of St. Margaret Mary, or on an image of the Lord, is always a reminder to us to repent of our sins, to console the Lord with our love and thanks, and to honor him. Pope Pius XII said that "there is no doubt that Christians in paying homage to the Sacred Heart of the Redeemer are fulfilling a serious part of their obligations in their service of God and, at the same time ... they are obeying that divine commandment: 'Thou shalt love the Lord thy God with thy whole heart, and with thy whole soul, and with thy whole mind, and with thy whole Strength'" (*Haurietis Aquas*, 111).

Depictions of the Holy Spirit

The Holy Spirit, as we have seen, is depicted as a dove (see Mt 3:16) or as a living flame (see Acts 2:3; Lk 12:49). Other biblical images of the Holy Spirit are living (flowing) water (Jn 4:13–14), the Breath of God (Gn 1:2), and "a mighty wind "(Acts 2:2). Each of these is depicted in various ways in churches.

Sometimes certain saints are shown with a dove whispering into their ear, a sign of divine inspiration and guidance. As St. Thomas Aquinas explains: "Since by the Holy Spirit we are established as friends of God, fittingly enough it is by the Holy Spirit that people are said to receive the revelation of the divine mysteries" (*Summa contra Gentiles*, IV, 22).

14

Angels

It seems obvious what an angel should look like: a majestic human figure with splendid wings! But Scripture, when describing the angels who interact with us and bring us divine messages — for that is their office and function, to be messengers of God — does not mention that they have wings. In fact, in Scripture, they are often mistaken for human beings. For example, Tobit doesn't realize that Raphael is an angel until he declares his identity (see Tb 12:15-16). Saint Luke describes the angels as men "in dazzling apparel" (Lk 24:4) or "in white robes" (Acts 1:10). Hebrews 13:2 says that "some have entertained angels unawares," for they can appear indistinguishable from human beings. Nevertheless, Hebrews does say they're "strangers," and indeed angelic beings are of a different nature from that of human beings.

To begin with, the *Catechism* tells us that angels are "spiritual, non-corporeal beings" who "have intelligence and will," which are spiritual powers (328, 330). As such, they do not naturally possess fleshly bodies like ours. Gideon, for example, sees an angel appear and then vanish from his sight (see Jgs 6:21). It would be nearly impossible to depict such creatures, or for us to see them at all, were it not for the fact that they make themselves known to us by assuming a humanlike bodily form. As St. Thomas Aquinas says: "Since the angels are not bodies, nor have they bodies naturally united with them ... it follows that they sometimes assume bodies" (*Summa Theologiae*, Ia, q.51, art. 2). And this is the case, then, for the archangels Raphael and Gabriel in the Bible, and Saint Michael, who has been seen by Pope St. Gregory the Great and others. Nevertheless, in none of these cases are these angels described as having wings.

So why are angels almost invariably depicted as *winged* men? First, because Revelation 14:6 says, "I saw another angel flying in midheaven," and we associate wings with flight, even if they're not strictly necessary. Second, angels move at the speed of thought — that is to say, very quickly. Wings — and powerful ones, at that — are a visible expression

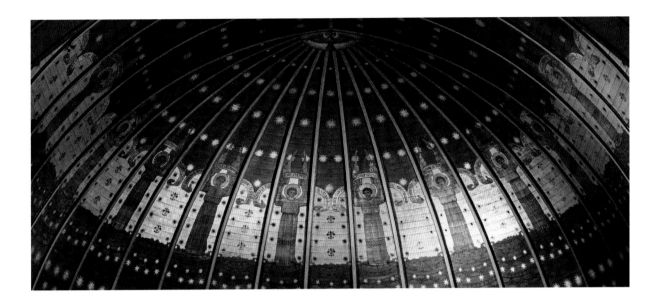

of this superhuman swiftness. Thus Tertullian said: "Every spirit is winged, both angels and demons. In this way, in a moment they are everywhere. ... It is thought that their velocity is divine because their substance is not known." In the cultures around Israel, the messengers of the gods, or celestial creatures, were always thought to be winged beings, and this idea fed the imagination of artists when they depicted the angels. By the fourth century, angels were almost invariably shown with wings, even though this had not been the case in the earliest representations of the Annunciation. St. John Chrysostom gives a theological explanation for the angels' wings, but he agrees with the culture around him that heavenly beings who stand before God's throne needed wings by which to descend to earth and return to the heights: "What do the powers reveal to us by these wings: The exaltedness and ethereality and lightness and speed of their nature. For which reason, Gabriel descends fleet; not that the wings are part of the bodiless power, but that he descends from realms on high and returns to his abode whence he was sent."

We do, in fact, have biblical justification for the angels' wings if we admit the seraphim and cherubim among the ranks of angelic beings, because Isaiah said that the seraphim "each had six wings: with two he covered his face, and with two he covered his feet, and with two he flew" (Is 6:2). Ezekiel also described the cherubim, who bore up the throne of God, as "four living creatures ... [who] had the form of men, but each had four faces, and each of them had four wings." If these highest ranks of angels have wings, perhaps it's not unlikely that the lower ranks, when assuming a bodily form, or at least for the purposes of artistic representation, would also have wings.

The idea of angelic ranks became important in Christianity in the fifth century when Pseudo-Dionysius wrote about a celestial hierarchy comprising nine ranks of angelic creatures, which are derived from Scripture. St. Thomas Aquinas lists them for us, saying, "Dionysius places in the highest hierar-

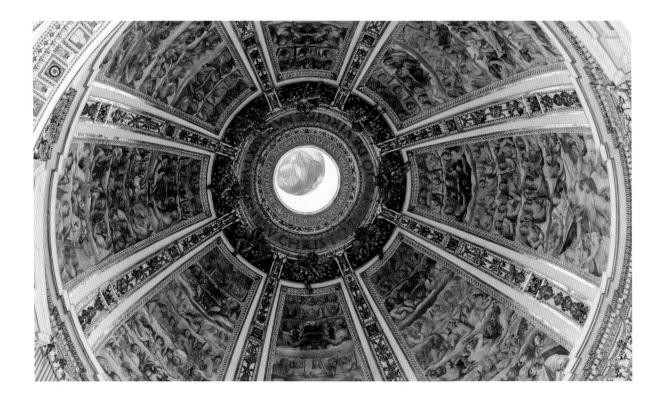

chy the 'Seraphim' as the first, the 'Cherubim' as the middle, the 'Thrones' as the last; in the middle hierarchy he places the 'Dominations,' as the first, the 'Virtues' in the middle, the 'Powers' last; in the lowest hierarchy the 'Principalities' first, then the 'Archangels,' and lastly the 'Angels' " (*Summa Theologia*, Ia, q.106, a.8).

In some churches, it is possible to see these ranks of angels depicted or referred to, and in art it is now universally accepted and even expected that angelic beings be shown with wings as well as halos. Occasionally one will see winged babies, or, even more bizarre, flying babies' heads, and these have been called cherubs or putti. Originally these were pagan Roman forms that found their way into Renaissance Christian art, and they are meant to represent a kind of angelic creature, albeit in a somewhat sentimental manner.

The Church teaches that only three archangels have revealed themselves to us by name: Saint Michael, Saint Gabriel, and Saint Raphael. Their feast is celebrated on September 29. These are the three archangels mentioned in Scripture that we see most frequently in church art, and indeed, the Church has warned that "the practice of assigning names to the Holy Angels should be discouraged, except in the cases of Gabriel, Raphael and Michael, whose names are contained in Holy Scripture."

Saint Michael is shown as a warrior who defeats Satan, the ancient Serpent (see Rv 12:7-9). He is depicted in armor fighting and defeating the Devil, who is another winged but ugly creature, or

sometimes a winged dragon (see chapter 7). Saint Gabriel, as mentioned in chapter 10 on the Annunciation, is shown holding a scepter or a lily or a speech scroll with the words of the Angelic Salutation. Saint Raphael may be shown holding a traveler's staff, or a fish, as he told Tobit to catch a fish and to use its gall to heal his father's blindness (see Tb 6 and 11). The archangel Raphael is also often portrayed with Tobit, depicted as a young man or a boy, and his dog.

Finally, the guardian angels are sometimes depicted in art. We will know them as such when we see images of angels guiding young men or women or sometimes carrying babies in their arms. This is especially poignant when the image commemorates a baby who has died in infancy or *in utero*. The *Catechism* sheds some hope in these sad situations, reminding us that "from its beginning until death human life is surrounded by [angels'] watchful care and intercession. 'Beside each believer stands an angel as protector and shepherd leading him to life.' Already here on earth the Christian life shares by faith in the blessed company of angels and men united in God" (336).

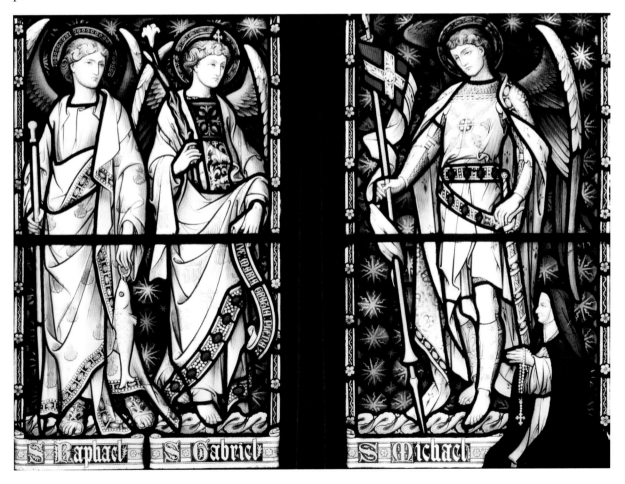

15
The Last Judgment

Having considered how God and the angels are depicted, we can now look at one of the more complex biblical scenes that we might encounter in a church. The Last Judgment used to be painted above the chancel arch in many medieval English churches or carved in a stone tympanum above the entrance of great European churches. One of the most famous depictions of the Last Judgment is in the Sistine chapel in the Vatican, painted by Michelangelo in the sixteenth century.

The purpose of having our final end held before our eyes is to remind us that our daily moral choices and deeds have eternal consequences. Saint Paul reminds us that "we must all appear before the judgment seat of Christ, so that each one may receive good or evil, according to what he has done in the body" (2 Cor 5:10). The Last Judgment scene shows souls rising from their graves, with the just being led by angels and the unjust by demons. Typically, we will find every strata of medieval society, from the lowliest to the exalted, including kings and bishops and popes and monks and nuns, numbered on either side.

Saint Matthew's Gospel states that "when the Son of man comes in his glory, and all the angels with him, then he will sit on his glorious throne" (Mt 25:31), and then all will be brought before him to be judged. Saint Michael is sometimes shown in the middle with a pair of weighing scales, evaluating what we have done. The apostles might also be shown seated on thrones on either side of the Lord "judging the twelve tribes of Israel" (19:28). St. John the Baptist and Our Lady are usually shown immediately next to the Lord, interceding for souls. Sometimes, a host of saintly witnesses are also shown looking upon this scene, and they rejoice to see God's justice done.

In the top section (or on the left side), one may see a depiction of angels leading the righteous into the city of heaven, which is usually shown as a walled city with Saint Peter at the gate. In the bottom section (or the right side), demons might be depicted dragging the repro-

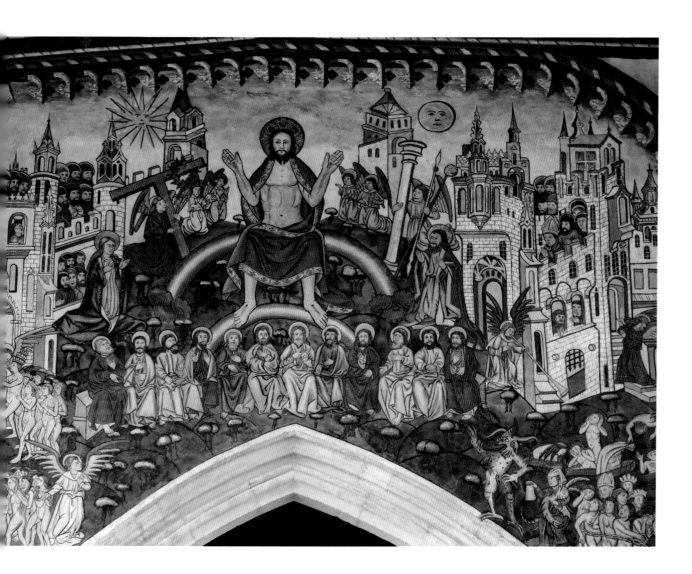

bate souls into hell, usually symbolized by the open jaws of a lion or another monstrous creature. In the Sistine Chapel, the dark chasm of hell is painted directly behind the crucifix on the altar. Hence the cross of our merciful Savior bars the way to hell and saves us from this horrible end if we will but follow Christ and learn the way of the cross with Jesus, the way of love. So, gazing upon this momentous scene and its two ends, we recall the words of St. John of the Cross: "In the evening of life we will be judged on love alone." As the parable of the Last Judgment in Matthew 25:31-46 exhorts us, let us love God by loving and giving of ourselves to the least of our brothers and sisters, for "as you did it to one of the least of these my brethren, you did it to me" (v. 40).

16
The Sacraments

In this final section on the invisible made visible, we shall look at depictions of the seven sacraments in art, for the sacraments are indispensable in the Christian's journey on the way of divine love. As the *Catechism* states: "Christ instituted the sacraments of the new law. There are seven: Baptism, Confirmation (or Chrismation), the Eucharist, Penance, the Anointing of the Sick, Holy Orders, and Matrimony. The seven sacraments touch all the stages and all the important moments of Christian life: they give birth and increase, healing and mission to the Christian's life of faith" (1210).

Baptism, of course, is the gateway to the sacramental life of the Christian, and so the seven sacraments are often depicted in the baptistery or around the font (see chapter 2). Of note are the medieval fonts of East Anglia in England, which are known as Seven-Sacrament Fonts; these octagonal fonts were carved with one of the seven sacraments on each side and with the crucifixion or baptism of the Lord on the eighth side. The sacraments are also often depicted in stained-glass windows in seminaries. In both these fonts and seminary windows, one sees a depiction of the liturgical ceremonies of the Church, so one sees the sacred ministers performing the sacramental rites, whether baptizing an infant, or at the marriage of a couple, or ordaining a priest.

The sacraments are also sometimes depicted by symbols:

- **Baptism** — a shell (see chapter 8), flowing water, and the paschal candle (see chapter 2).
- **Confirmation** — a dove for the Holy Spirit with seven rays proceeding from it, for the seven gifts of the Holy Spirit.
- **Eucharist** — a Host and a chalice, or wheat and a vine (see chapter 13).
- **Penance** — crossed keys showing the Church's power to loose and bind (see Jn 20:23). These are sometimes com-

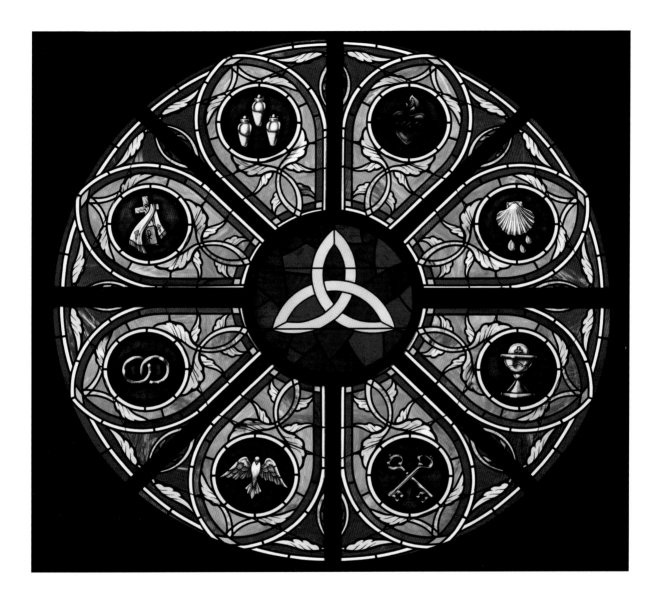

bined with a purple stole (the colored strip of cloth, like a scarf, that the priest wears around his neck as a sign of priestly authority).

- **Anointing of the Sick** — olive branches (because the oils for anointing are made of olives) or a purple stole and a Greek cross (see chapter 8).
- **Holy Orders** — a Host and a chalice and a white stole, or the bishop's hands with a dove.
- **Matrimony** — two rings interlinked.

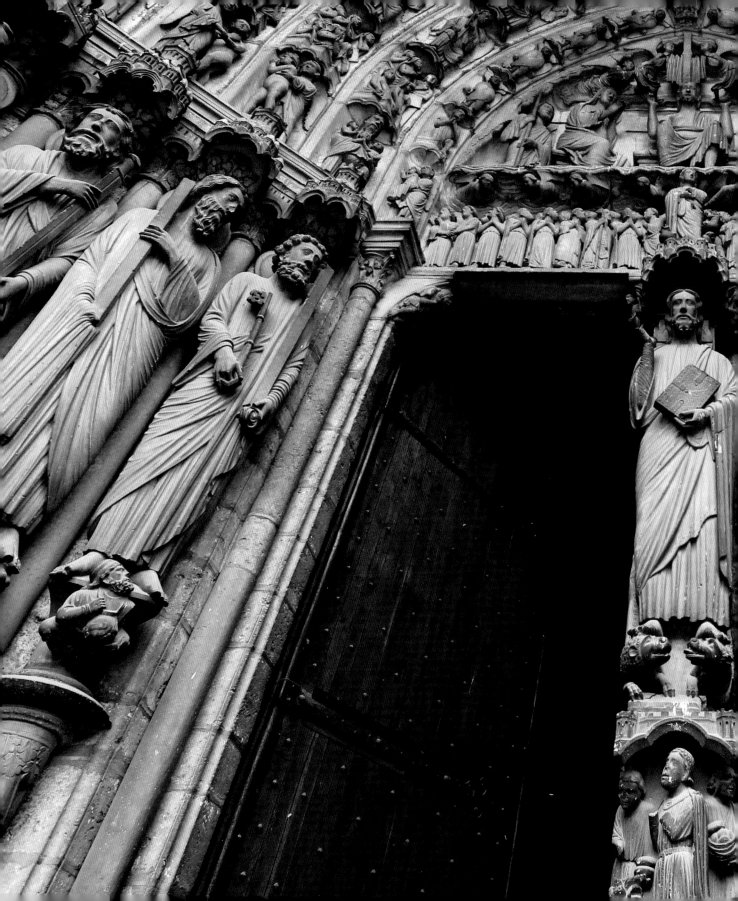

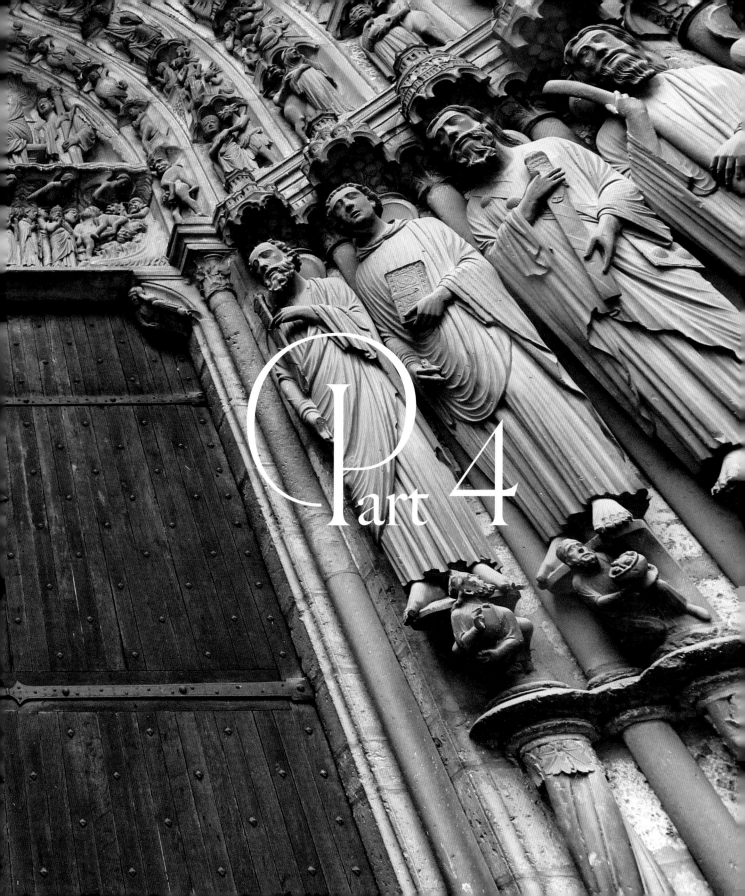

Part 4

17

The Saints: A Great Cloud of Witnesses

Pope Benedict XVI wrote in *Deus Caritas Est* that "the lives of the saints are not limited to their earthly biographies but also include their being and working in God after death. In the saints one thing becomes clear: those who draw near to God do not withdraw from men, but rather become truly close to them." Hence our church buildings often have multiple images of the saints, both on the exterior and in the interior. Outside the church, the saints stand by the doors to welcome us in, and within the church, they line the nave and surround the altar, as a reminder of the great "cloud of witnesses" (Heb 12:1) in the Church Triumphant who surround us and pray for us and are united with us at the Holy Sacrifice of the Mass. Their prayer, together with ours, especially during the Sacred Liturgy, rises before God's throne like incense, according to the vision of Saint John (see Rv 5:8).

It is sometimes objected that asking the saints to pray for us is akin to speaking to the dead, and therefore pointless or even forbidden according to Deuteronomy 18:11. But any Catholic who looks up this verse will be rightly confused. Scripture forbids *necromancy*, which is the ghastly act of summoning the spirits of the dead to consult them about the future. It is forbidden because the dead cannot communicate with us in this way — so when they are being summoned, it is, in fact, deceptive demons who come forth to mislead, entrap, and lead poor souls into sin. Asking the saints to pray for us, seeking the intercession of the righteous who love God, has, as Saint James says, "great power in its effects" (Jas 5:16).

Moreover, it seems to signify a lack of faith in the resurrection of the dead to lump the saints — who, by definition, are in heaven with God and bound to him in charity — with "the dead." Saint Paul, therefore, with great faith in the persistence of the human soul even after death and of the Christian being alive in Christ, the risen Lord, refers to those who have died as having fallen asleep (see 1 Thes 4:13-15); he even declares

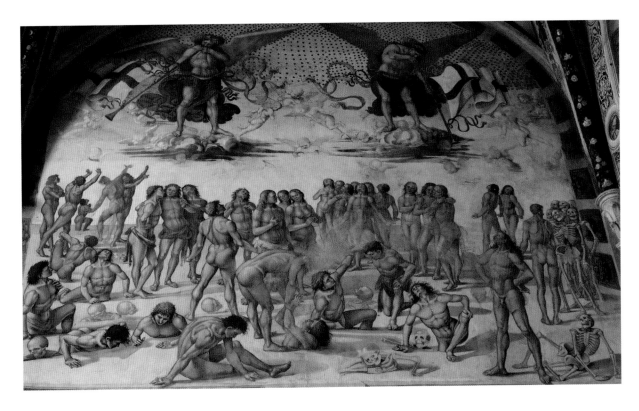

that "my desire is to depart and *be with Christ*, for that is far better" (Phil 1:23, emphasis added). Clearly, Saint Paul does not think that being with Christ means being dead and gone. Rather, Christ is our God, who is alive and risen from the dead, and so we who have been baptized into Christ and who die in Christ have a certain confidence of being with him, the eternal and living God.

Such are the saints to whom we Catholics pray and whose intercession we seek; such are the saints who surround us and whose examples of holy living inspire and teach us; such are the saints to whom we are united by the bond of charity, which is our common life in Christ, vivified by his grace. The *Catechism* teaches that "in the communion of saints, 'a perennial link of charity exists between the faithful who have already reached their heavenly home, those who are expiating their sins in purgatory and those who are still pilgrims on earth. Between them there is, too, an abundant exchange of all good things'" (1475).

It is fitting and good to have images of the saints in our churches, and also depictions of scenes from their lives, to inspire us by their virtue and their good works. Candles are lit before their images as a sign of prayer and as a reminder that we have each been called to shine with good works, too (see chapter 4). The following section of this book will help you identify some of the saints in our churches, and my hope is that you will want to find out more about how they lived, what they wrote, and the ways in which they shone with the light of Christ.

18

epicting Our Lady, Queen of Saints

Mary, Mother of God, is the Queen of All the Saints, Mother of the Church, and Mother of the Redeemed. She is, as an eighth-century Byzantine hymn puts it, "more honorable than the Cherubim, and more glorious beyond compare than the Seraphim" because she is closest to God in her fullness of grace — perfect in charity, ever virgin, and ever without sin, from the moment of her conception. As such, Mary is venerated above all other saints, though, of course, she is never worshiped, for as she herself acknowledges: "My soul magnifies the Lord, and my spirit rejoices in God my Savior" (Lk 1:46–47).

In part 1, in our consideration of the color blue, and in our survey in parts 2 and 3 concerning New Testament scenes and the symbolism of the fleur-de-lis, the lily, and the rose, I said quite a lot about how Mary is portrayed in art — particularly about how Our Lady is clothed and the colors associated with her. Here, I will just touch on Mary's head coverings and crowns, various symbols of Our Lady, and a few popular depictions of Mary derived from Scripture and apparitions. I hope this inspires you to seek out more local devotions to Our Lady and to find out how she is portrayed and how she has appeared to all generations who have called her blessed!

Our Lady's Veil

According to Jewish law, married women were to have their hair covered (see Nm 5:18) whenever they were in public, and to this day, this remains a mark of modesty and chastity for women in the Middle East. Our Lady, most pure and chaste, therefore, is traditionally and fittingly shown with her head covered, and she appeared as such at Tepeyac, Lourdes, and Fátima.

Our Lady is not always shown with her hair covered, however: in many artistic depictions of the Immaculate Conception and of Our Lady's Assumption into heaven (see chapter 10) she is frequently shown with flowing locks of unbound hair. Why? Recall that the Ark of Covenant had been veiled in blue while on earth so that no man might look upon it. Saint John claims, however, that "God's temple in heaven was opened, and the ark of his covenant was seen within his temple" (Rv 11:19), that is to say, presumably uncovered, unveiled. The Ark, as the Fathers of the Church have recognized, is, in fact, a prefiguration of Our Lady, who is described in the next verse of Saint John's Book of Revelation in this way: "And a great sign appeared in heaven, a woman clothed with the sun, with the moon under her feet, and on her head a crown of twelve stars" (12:1). As the Woman of the Apocalypse, therefore, and as the Ark of the Covenant in heaven, Our Lady is shown no longer veiled but, rather, crowned with stars. In 1859, just over one year after she had revealed herself to Saint Bernadette as the Immaculate Conception, when Our Lady appeared to Adele Brise in Champion, Wisconsin, as the Queen of Heaven, she was *not* veiled (despite recent artistic renditions of the apparition). The earliest written account of this apparition states simply that "the beautiful lady [was] clothed in dazzling white, with a yellow sash around her waist. Her dress fell to her feet in graceful folds. She had a crown of stars around her head, and her long golden wavy hair fell loosely over her shoulders." Clearly, Our Lady's hair is a feature of this apparition, in which she appears like the dazzling Woman of the Apocalypse, unveiled as we see in many artistic renditions of the Immaculate Conception (especially in the Spanish artistic tradition) and of Our Lady assumed into heaven.

There is perhaps another reason for this: Young maidens in the Jewish custom did not have to cover their hair, and indeed, according to the Mishna, a woman who went to her wedding with her hair uncovered was giving a sign that she was a virgin. We

could say that depictions of Our Lady with her hair unveiled is a reminder of her maidenhood, her perpetual virginity, and that she is the embodiment of the Church, whom Christ by his grace has purified and sanctified to become the Bride who is "without spot or wrinkle ... holy and without blemish" (Eph 5:27; see Rv 19:7–8).

Our Lady's Crown and Stars

Mary has long been regarded as the Woman of the Apocalypse who is accordingly crowned with twelve stars. Saint Bonaventure worked out in detail how the twelve stars correspond to the pre-eminence of the Queen of Heaven: they stand for Our Lady's sinlessness; her supreme purity; her fullness of grace; her perfect knowledge of God as far as creatures can know God; her perfection of charity and the actual living out of that charity; her

exaltation over all other creatures; and her exalted dignity. The final four stars refer specifically to the graces of the divine motherhood — namely, that she gave birth without pain; that she is both ever virgin and a mother; that she is motherly dignity at its highest because she gave birth to the Son of God; and finally, that she is not only the mother of God in the flesh but is the mother of all redeemed humanity in the order of grace.

The twelve stars may also be a reference to the twelve tribes of Israel, for Our Lady is the perfect "Daughter of Zion." The liturgy of the Church thus applies these words of Judith 15:9 to her: "You are the exaltation of Jerusalem, you are the great glory of Israel, you are the great pride of our nation!" Mary is Queen of the Apostles, and so the twelve stars stand for the apostolic Church as well.

Incidentally, Byzantine icons of Our Lady also

feature three stars around her: one on each shoulder and one on her forehead, indicating that Mary was a virgin before, during, and after she bore Christ in her virginal womb.

One may see images, statues, and icons of Mary with crowns that are modeled on earthly royal crowns, and she may hold other regalia of earthly royal dignity. This is fitting because Mary is, as Saint Germanus says, "Queen of all those who dwell on earth" on account of Christ's having entrusted humanity to her care and protection. Some Catholic monarchs and governments, such as in Poland, have specifically entrusted their realm to Mary, acclaiming her as their true queen. At times, the pope canonically crowns certain images of Our Lady as a sign of honor and to elevate devotion to a specific local image of Mary for the good of the universal Church.

The Enclosed Garden

An antiphon from the Office of the Immaculate Conception that is derived from the Song of Songs 4:12 declares: "Thou art an enclosed garden, Mother of God: an enclosed garden, a fountain sealed up: rise, make haste, my beloved." This is another beautiful image of Mary's perpetual virginity, depicted as a walled garden full of life and fecundity within but intact and sealed off for all except God. The walled garden, whether in art, or as a feature of a cloistered community of nuns, or within a church precinct, is thus a reference to Our Lady, as well as the beauty of consecrated virginity. As St.

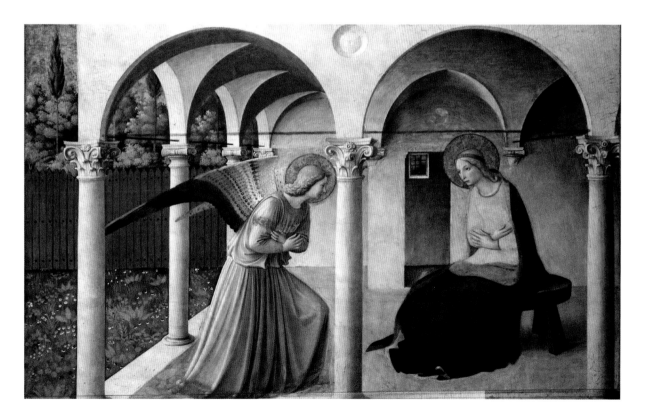

Hildegard of Bingen says in one of her antiphons for the feast of virgin saints: "In you the King can glimpse himself, for in you he sealed once all the ornaments of heaven, where too you are the lushest garden, the fragrances of all its ornaments."

The Litany of Loreto

A litany, as the Vatican *Directory on Popular Piety* states, consists of a "stream of prayer characterized by insistent praise and supplication." The most well-known of the Marian litanies is the ancient one associated with Loreto, where the Holy House of Mary is enshrined. Among the titles given to Our Lady are thirteen invocations drawn from Old Testament imagery, such as "Mystical Rose," "Tower of Ivory," and "Ark of the Covenant." In Marian shrines and chapels and in some depictions of Our Lady, one will see these titles from the Litany of Loreto being used as symbols for the Blessed Virgin Mary.

Star of the Sea

St. Thomas Aquinas, following the tradition of the Fathers of the Church, observes that "it is right that her name is Mary, which means star of the sea [*stella maris*], because, just as sailors are guided by a star to port, so too Christians are guided by Mary to glory." Hence the *stella maris* is one of the symbols of Our Lady that we encounter in our churches.

Marian Monogram

Like the IHS monogram of the Holy Name of Jesus (see chapter 13), Our Lady's name is also often depicted as a crowned M or MRA, an abbreviation of her name in Latin, Maria. This is sometimes surrounded by a Rosary, or it can be embellished in other ways, such as with flowers.

Roses and Rosaries

As mentioned in chapter 7, many flowers have come to be associated with Our Lady, such as the pure-white lily or the sharp-tipped fleur-de-lis, or the marigold with its Marian name. The rose, however, is preeminently the symbol of Our Lady, as we also have seen, and as mentioned in the Litany of Loreto.

Despite their initial reticence because the rose was associated with Aphrodite and other pagan deities, the Fathers of the Church, from the mid-fourth century onward, began to see the rose, regarded as the most perfect and beautiful of flowers, as a symbol of Our Lady. Saint Ambrose and the fifth-century poet Coelius Sedulius both compare Our Lady as a rose *without thorns* to Eve who, because of sin, was like a thorny rose; it was believed that originally, in the Garden of Eden, roses would have been thornless. St. Bernard of Clairvaux thus wrote in the eleventh century: "Eve was a thorn,

wounding, bringing death to all; in Mary we see a rose, soothing everybody's hurts, giving the destiny of salvation back to all." In medieval England, beautiful poems were written in the fifteenth century about Mary as the mystical rose tree through whom Christ was born. For example, "Of a rose, a lovely rose, and of a rose I sing a song. ... The rose is called Mary, heaven's queen, of her bosom a Blossom sprang."

As I have noted, the chivalric garland of flowers offered by knights to their ladies developed in medieval Marian devotion into a garland of roses, or *rosarium*. Thus the Rosary is often seen as a garland of spiritual roses offered to Our Lady, for our prayers and meditation on the saving work of Jesus Christ are pleasing to her and honor her divine ma-

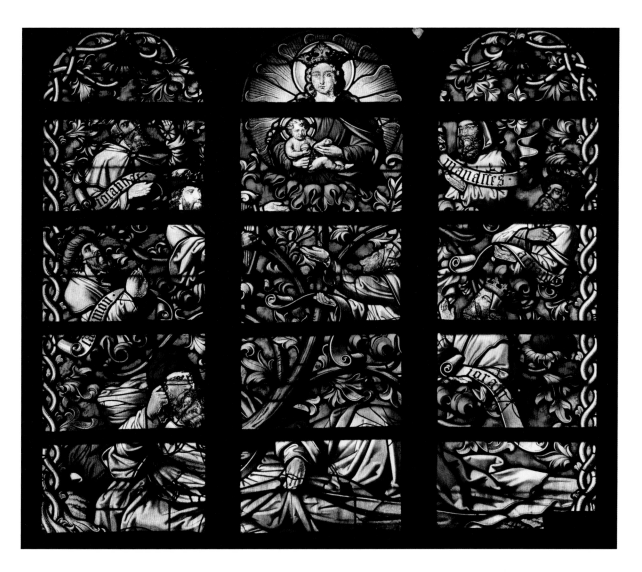

ternity. The Rosary is first, however, Mary's gift to us, her children, for our salvation. Our Lady is thus often shown holding out a rosary, urging us to use it and to pray it. Some of the most powerful images I have seen show the angels with rosaries lifting souls out of the fires of purgatory. (Depictions of people in a blazing fire, with their hands raised in supplication, are *always* images of purgatory, in which we are purified by the fires of divine love; see CCC 1031.)

St. Louis-Marie Grignon de Montfort wrote *The Secret of the Rosary*, a beautiful meditation on the Rosary in which each meditation and story about the rich history of the devotion is called a rose that he prays "will bring true fragrance into your lives — but above all may it save you from the danger that you are in. Every day unbelievers and unrepentant sinners cry: 'Let us crown ourselves with roses.' But our cry should be: 'Let us crown ourselves with roses of the most holy Rosary.'" Through devotion to the Rosary, and faithfully seeking the intercession of Mary, the Mystical Rose, we shall "receive three crowns from Jesus and Mary. The first is a crown of merit during our lifetime, the second, a crown of peace at our death, and the third, a crown of glory in heaven."

Immaculate Heart of Mary

Simeon prophesied, "A sword will pierce through your own soul also" (Lk 2:35). The symbol of a heart, sometimes winged, pierced with a sword, became a popular symbol of Our Lady in the Middle Ages. Sometimes the heart of Mary is pierced with seven swords, which stand for the Seven Sorrows of Mary, a scriptural devotion promoted by the Servites and renewed by Our Lady at Kibeho (Rwanda).

More often, though, the Immaculate Heart,

whether shown by itself or on an image of Our Lady, will be a heart ablaze with love, perhaps with a ring of roses and lilies, and always with a single sword piercing it. This symbol of Mary reminds us of Our Lady's beauty and perfections, her immaculate purity, and her suffering for sinners.

It should be noted, however, that when Our Lady appeared to Sr. Lúcia of Fátima in 1925, she told Sister Lúcia that her Immaculate Heart was "surrounded with thorns with which ungrateful men pierce Me at every moment by their blasphemies and ingratitude." It is sometimes shown as such in art, especially when depicting Our Lady of the Rosary of Fátima. We can console Our Lady, and remove these thorns from around her heart, through acts of devotion, thanks, and love, consecrating ourselves to her Immaculate Heart. In doing so, Pope Francis said that we place "in that pure and undefiled heart, where God is mirrored, the inestimable goods of fraternity and peace, all that we have and are, so that she, the Mother whom the Lord has given us, may

protect us and watch over us."

Pietà

Scripture tells us that Jesus was taken down from the cross and then buried in the newly hewn tomb of Joseph of Arimathea (see Lk 23:53). Devotional art has long sought to imagine this scene, which is so briefly recounted in the Bible. Our Lady is shown in art weeping as her Son is taken down from the cross, and then she cradles the dead Jesus in her arms, and the words of Mother Jerusalem become hers, she who is the Daughter of Zion: "Is it nothing to you, all you who pass by? / Look and see / if there is any sorrow like my sorrow / which was brought upon me" (Lam 1:12). Images of Mary holding the corpse of Jesus have come to be called *La Pietà*, which is Italian for "pity" or "compassion," because they invite us to share in Our Lady's sorrow and suffering. At the same time, though, for many parents who have had to bury a child, this is a powerful devotional image of Christ and his blessed mother sharing in the tragedy of our human existence, suffering with us: "Pray for us, O Virgin most sorrowful, that we may be made worthy of the promises of Christ."

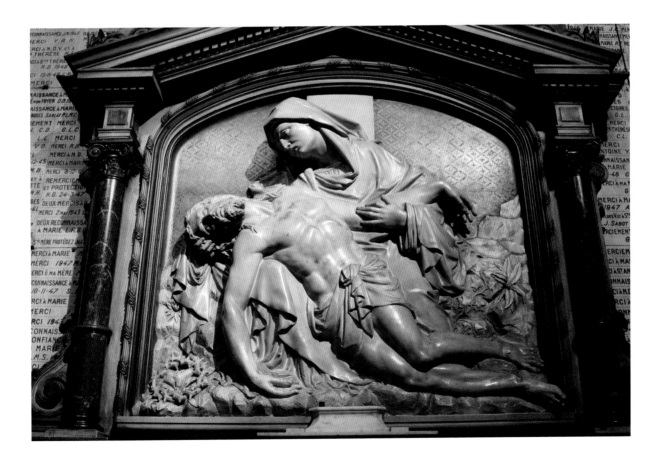

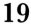

19

Depicting the Apostles and Evangelists

The Roman Canon lists the apostles in this order: Peter and Paul, Andrew, James, John, Thomas, James, Philip, Bartholomew, Matthew, Simon and Jude, and Matthias. Usually each of these apostles is shown with the instrument of his martyrdom, just as Christ is shown with the cross and other instruments of his passion. Saint John, of course, wasn't martyred, and we saw in chapter 7 that he is often symbolized by an eagle. Each of the evangelists, in fact, has his own symbol.

Matthew, Mark, Luke, and John, the writers of the four canonical gospels, are each represented by one of four "living creatures" that surround the throne of God, according to the vision of Ezekiel 1:4–14. Specifically, these winged creatures are said to have "the face of a man in front ... the face of a lion on the right side ... the face of an ox on the left side, ... the face of an eagle at the back" (1:10). The Fathers of the Church attributed one of these faces to each of the four Gospel writers, and it is Saint Jerome's interpretation that has become the most authoritative, perhaps because he is the foremost translator of the Scriptures into Latin. These four living creatures appear either alone, as a symbol of a particular Gospel, or with one of the evangelists, who is shown writing or with a pen or a quill. As we shall see, Matthew is given the man, Mark the lion, Luke the ox, and John the eagle.

The feast of Saint Peter and Saint Paul is on June 29, and these saints, the patrons of Rome and the princes of the Church, are very often depicted together in our churches. As the liturgy proclaims: "Peter the Apostle, and Paul the teacher of the Gentiles, these have taught us your law, O Lord." It is remarkable that the portraits of Saint Peter and Saint Paul in art have been stable and consistent since as early as the fourth century, the date of the earliest surviving portrayal of these

Saint Peter

apostles. Peter, the shorter of the two, has a rounder face, curly hair (though sometimes he's shown balding), and a shorter beard; Paul has a longer face, a prominent forehead, and a long, tapering beard. Nevertheless, as with all the saints, we can identify them with more certitude through scenes from their histories or through attributes —items associated with their lives and works.

In Matthew 16:19, Jesus entrusts his authority to Saint Peter and his successors, the popes, saying: "I will give you the keys of the kingdom of heaven, and whatever you bind on earth shall be bound in heaven, and whatever you loose on earth shall be loosed in heaven." The crossed keys are a symbol of Saint Peter and papal authority, and he is usually shown carrying them, and sometimes wearing a papal crown (see chapter 21).

Sometimes Saint Peter is represented by an inverted Latin cross (see chapter 8). Tradition holds that he was crucified, but he did not consider him-

self worthy to die in the same way as the Lord — and so he asked to be crucified upside down!

As mentioned in chapter 7, the rooster is another symbol of Saint Peter (see Mt 26:34), and it can be shown with three teardrops, a sign of Peter's repentance for thrice denying the Lord (Mt 26:75).

Finally, Saint Peter will often be shown receiving a shepherd's crook, also known as a crozier, from the risen Lord. This is the mark of Saint Peter's rehabilitation after the Resurrection and his pastoral authority over the universal Church, for Jesus tells him, "Feed my sheep" (Jn 21:15–17.)

Saint Paul

The conversion of Saint Paul (who, unlike the other apostles, was called by Christ after his resurrection) is recounted in three distinct accounts in the Book of Acts. The feast of the Conversion of Saint Paul is celebrated in the Church's liturgy on January 25. Artistic depictions of this scene can be quite dramatic and often show Saint Paul falling off a horse (although no horse is mentioned in the biblical account) and a bright light shining from heaven, or sometimes Jesus will be shown in the clouds above: "As I made my journey and drew near to Damascus, about noon a great light from heaven suddenly shone about me. And I fell to the ground and heard a voice saying to me, 'Saul, Saul, why do you persecute me?' And I answered, 'Who are you, Lord?' And he said to me, 'I am Jesus of Nazareth whom you are persecuting.'" (Acts 22:6–8).

Saint Paul is depicted carrying a sword because tradition holds that he was beheaded in Rome, a privilege accorded him as a Roman citizen (see Acts 22:27). He might also be shown holding a book or a scroll because of his many writings,

which form the bulk of the New Testament.

Saint Andrew

Saint Andrew, the brother of Saint Peter and the first to be called by Christ, is identified by the Saltire cross (see chapter 8) because he, too, was crucified, but spread-eagled on an X-shaped cross in Patras, Greece. His feast day is November 30.

St. James the Greater

Nicknamed "son of thunder" alongside his brother John by the Lord (see Mk 3:17), Saint James, the son of Zebedee, is called "the Greater" because he is said to have been taller than the other apostle who shared his name. Saint James was the cousin of Jesus Christ and also the first apostle to be martyred in Judaea by Herod Agrippa. His relics were transferred to northwestern Spain, where they are enshrined in Santiago de Compostela. Because of the many pilgrimages to this site, the traveler's staff, with a gourd for carrying water, came to be associated with Saint James. He is also depicted with a broad-brimmed traveler's sun hat, decorated with the scallop shell (see chapter 8), the symbol of the

pilgrim who had made it to the coast of Galicia in northwest Spain, where these shells are plentiful. These shells became souvenirs or proof that one had journeyed to the "world's end" and are a symbol of Saint James himself. His feast day is July 25.

Saint John

As mentioned in chapter 7, Saint John's symbol as an evangelist is the eagle because his writing soars to the heights of heaven — his Gospel opens with the divinity of the Eternal Word, who became man and "dwelt among us" (Jn 1:14). Saint John might be shown writing his Gospel with an eagle nearby. In the Gospel, he is also called "the disci-ple whom [Jesus] loved" (Jn 19:26), so he is some-times known as the "beloved disciple" and might be shown with his head lying on the Lord's breast at the Last Supper (see 13:23). Saint John, always depicted as a younger man without a beard, and often with long, flowing hair, is sometimes shown standing beside the cross of Christ with Our Lady, who is entrusted to his care. Tradition holds that Our Lady and Saint John lived in Ephesus after Christ's ascension.

Saint John is also known as St. John the Theo-logian or "the Divine" (an old term for students of divinity —that is, theology), the visionary author of the Book of Revelation. In this context, he is some-

times shown writing, with an eagle in view, and often with a vision of the Woman of the Apocalypse (see chapter 18) in the heavens or of the heavenly city of Jerusalem (see Rv 21:1–2).

Saint John was the only apostle not to have suffered martyrdom, so he is shown holding not the instrument of his death but the instrument of his deliverance from malice — a chalice with a small snake or a little dragon emerging from it, which are symbols of poison and death (see chapter 7). According to the *Acts of St. John the Evangelist*, Aristodemus, high priest of Artemis, challenged Saint John to drink from a poisoned cup. Saint John prayed that God would neutralize the poison, which he drank safely, and at last Aristodemus and the onlookers converted to faith in Christ. A tradition has arisen of blessing wine on Saint John's feast day, December 27: "As the blessed John drank the poisoned potion without any ill effects, so may all who today drink the blessed wine in his honor

be delivered from poisoning and similar harmful things."

Saint Thomas

Sometimes known as "Didymus," a Greek word meaning "the Twin," Saint Thomas was the first apostle explicitly to call Jesus "my Lord and my God" (Jn 20:28) when he saw the risen Lord, one week after Christ had appeared to the other apostles. This scene, in which Saint Thomas, who had been unbelieving, puts his finger into the wounded side of the Risen Christ, is often depicted in art.

Saint Thomas is sometimes shown kneeling in prayer by the empty grave of Mary or looking up into heaven as Our Lady drops her girdle (see chapter 10 concerning the Assumption).

Saint Thomas is believed to have brought the faith to India, where he was martyred by being speared and where his relics remain. The spear is one of his symbols, together with a carpenter's square because of a legend that an Indian king had sought an architect who could build him a Western-style palace. The apostle, seeing this as an opportunity to preach the Gospel, volunteered his services but gave the money to the poor and told the king that his palace would be in heaven (see Jn 14:2). The king apparently was converted by this work of charity and Christian hope. Saint Thomas's feast day is July 3.

St. James the Lesser

Thought to be the shorter in stature of the two Jameses, and thus called "the Lesser," Saint James is identified as the son of Alphaeus, and his mother is thought to have been Mary of Clopas, one of the women at the foot of the Cross (see Jn 19:25). As such, he is thought to have been a cousin of Jesus

Christ, to whom the risen Lord appeared (1 Cor 15:7). The tradition is that James the Lesser became the first bishop of the Church in Jerusalem. Saint Paul refers to him as one of the "pillars" of the Church community (Gal 2:9). He was martyred under Herod Agrippa in Jerusalem by being stoned and then clubbed to death, and afterward his body was sawn into pieces. Hence his symbols are a saw or a fuller's club, which looks like a large, roughly hewn baseball bat or golf club. His feast day is May 3, observed together with Saint Philip's, because their relics were brought to Rome and placed together in the Church of the Twelve Holy Apostles.

Saint Philip

The name of this apostle, and various incidents in the Gospel, suggest that Saint Philip was a Greek speaker who ministered to Greek pilgrims coming to Jerusalem. Saint John's Gospel tells us that before Christ multiplied the five loaves and the two fish to feed the five thousand, "Jesus said to Philip, 'How are we to buy bread, so that these people may eat?' This he said to test him, for he himself knew what he would do" (Jn 6:6). The loaves of bread,

Saint Bartholomew

Perhaps because of its dramatic potential, Saint Bartholomew's martyrdom has captured the imagination of many artists, including Michelangelo — who depicts his own face in the drooping skin held by this apostle in the painting of the Last Judgment in the Sistine Chapel. According to tradition, the apostle was flayed alive in Armenia, his skin separated from his body. His relics now rest in the basilica of Saint Bartholomew on Tiber Island in Rome. His symbol is not only his flayed skin but also a knife used for skinning animals. His feast day is August 24.

Saint Matthew

A Jew who worked for the Roman occupiers as a tax collector, Saint Matthew repented when the Lord called him: "As Jesus passed on from there, he saw a man called Matthew sitting at the tax office; and he said to him, 'Follow me.' And he rose and followed him" (Mt 9:9). Therefore, bags of money are a symbol of Saint Matthew.

Saint Matthew is also one of the evangelists, so he might be shown writing or with a book, and, as noted above, one of the four living creatures around God's throne has been assigned as his symbol: a winged man because Matthew's Gospel opens with the genealogy of Christ, that is, the human forebears of the Messiah. The winged man is often said to be an angel, but this is incorrect, and it would not be fitting when, in fact, Matthew begins his account of Christ's life by speaking about the wonder of God's becoming man in a human family and context.

Saint Matthew is reported to have been martyred in Ethiopia, killed with a hatchet while offering the Sacrifice of the Mass. His relics are in the cathedral in Salerno, Italy, and his feast day is September 21.

usually depicted as white disks, are used as a symbol of Saint Philip. These are usually combined with a Latin cross (see chapter 8) because he was thought to have been crucified at Hierapolis in modern-day Turkey. His feast day is May 3.

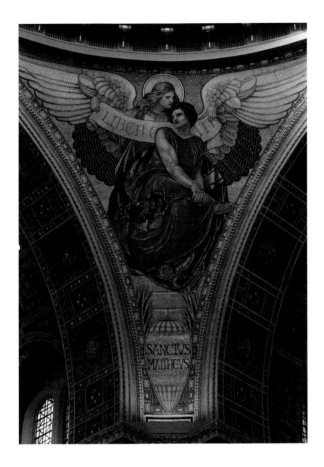

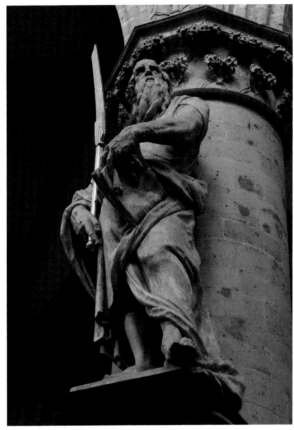

Saint Simon

The martyrdom of Saint Simon, sometimes called "the Zealot" to distinguish him from Simon Peter, is probably the most horrifying: he is said to have been sawn in half, lengthwise! Saint Simon's attribute, therefore, is a long, two-handled saw. A tamer set of symbols for him is a fish and a book because he was a fisher of men and a preacher, but this seems rather generic to me. Saint Simon's feast day is October 28, celebrated together with Saint Jude's, perhaps because they had been missionaries together.

Saint Jude

Known as St. Jude Thaddeus and widely loved as the "patron of lost causes," Saint Jude is the last of the apostles to be named in Scripture, and the Letter of Jude is attributed to him. He is shown holding an axe, with which he was killed in Roman Syria, modern-day Lebanon.

Another symbol of the apostle is a ship sailing on the waves, maybe because he traveled across the seas with the Good News. Hence some statues show him holding a traveler's staff. A flame above his head recalls Pentecost (chapter 10) and the flame of charity that drove the apostles to bring the

Gospel to all nations.

All who go forth as missionaries must bring Christ to others and so must have Christ imprinted on their souls through grace. To show this, Saint Jude is often depicted holding a medallion with the face of Jesus on it. Some say this is a reference to a miraculous healing effected by an imprint of Christ's face, which Jesus himself sent to King Abgar of Edessa. It seems to me more fitting, however, that the medallion recalls that all of us Christians are called to become icons of Christ, called to "build yourselves up on your most holy faith; pray in the Holy Spirit; keep yourselves in the love of God; [wait] for the mercy of our Lord Jesus Christ

unto eternal life" (Jude 1:20–21). Saint Jude's feast is on October 28.

Saint Matthias

"And [the apostles] prayed and said, 'Lord, you know the hearts of all men, show which one of these two you have chosen to take the place in this ministry and apostleship from which Judas turned aside, to go to his own place.' And they cast lots for them, and the lot fell on Matthias; and he was enrolled with the eleven apostles" (Acts 1:24-26). Matthias is thought to have been martyred with an axe while preaching the Gospel; hence his symbol is an axe placed on an open book of the Gospels. His feast is on May 14.

St. Mark the Evangelist

Believed to have been one of the seventy disciples mentioned in Luke 10:1, Saint Mark, according to tradition, founded the Church in Alexandria, Egypt, where he is honored as the first bishop and the "Apostle to Africa." He is almost always shown writing his Gospel, and his symbol is a winged lion because his Gospel begins with the voice crying in the wilderness who prepares the way for the Lord (see 1:3) — likened to a lion roaring in the African desert. The relics of Saint Mark are in Venice, in the basilica named after him, and the winged lion is the symbol of the Venetian republic. Saint Mark's feast day is April 25.

St. Luke the Evangelist

Saint Paul refers to Saint Luke as "the beloved physician" (Col 4:14). Saint Luke's Gospel has stories about the birth and early years of Christ that no other Gospel contains. Hence some believe that Saint Luke knew the Blessed Virgin Mary and had learned from her those stories, which he then committed to writing.

Saint Luke is also credited with having been a painter, and apart from the portrait of Our Lady that he gives us in his Gospel, he is said to have painted an icon of Mary. There is a tantalizing theory that the ancient encaustic icon known as the *Advocata*, which is safeguarded by the Dominican nuns in Rome and which had been moved by Saint Dominic from their original convent of San Sisto Vecchio in Rome, can be traced to the icon of Our Lady painted by Saint Luke. Radiocarbon tests have dated it to the first century AD, and its style of portraiture is from Syria, where Saint Luke came from.

Saint Luke is thus often depicted painting an icon or writing his Gospel. The symbol assigned to him is the winged ox because Saint Luke's Gospel begins with the priesthood of Zechariah and opens in the Temple, where the ox was offered to God in sacrifice by the Jewish priesthood. The skull of Saint Luke is in Prague, and his feast day is October 18.

20

Seeking the Saints in Art

The saints are often depicted through carved stone and wood statues, sometimes polychromed, and they might be found lining the nave of a church, or around the altar, or in the reredos. Often, the angels and saints are painted or pieced together with mosaics on the walls, especially around the sanctuary, and indeed, in an Eastern-rite church, painted iconography covers every surface of the interior of the church — quite a magnificent sight to behold. Of all the forms of art that are used to represent the saints and their lives, however, I am most attracted to stained-glass windows. My personal interest in photographing churches began with stained-glass windows. I thought that these colorful images of the saints and of the lives of Our Lord and Our Lady would be attractive in catechetical presentations for children; I had just finished a year of teaching primary-school children in a Dominican mission in the Philippines at the time. As I have said, however, as I looked at the beauty of our churches with my friends, I began to realize that these wonderful windows and works of art needed decoding. Thus began my daily discipline of sharing these photos online, always in tandem with the Church's liturgical year and Scripture readings, coupled with some explanation of the symbolism and how the saints could be identified. This book is derived from that daily practice.

As I recalled in part 1, Pope Benedict XVI, when he visited St. Patrick's Cathedral in New York City, observed that stained-glass windows come alive when the light passes through them, and we who are inside the church building beholding this then understand what it means to be called into the communion of the Church, gathered into the Body of Christ. Each of us, called in Baptism to be saints, has thus been invited by the Lord to become "flooded with grace, resplendent in beauty, adorned by the manifold gifts of the Spirit." So, for me, the saints are most fittingly portrayed in stained-glass windows because, like those windows, these holy men and women, the friends of God, bring beauty

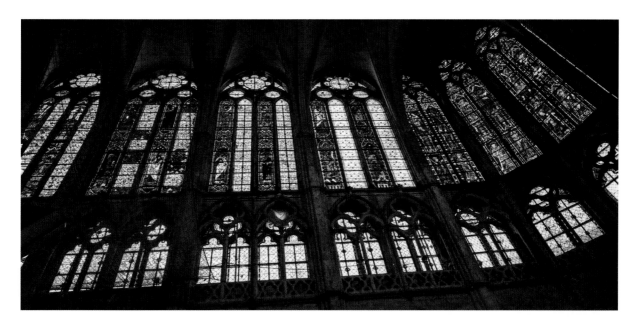

and color to the otherwise bland and even dark edifice of the world. The saints are resplendent with their good works because they are transfigured by the light of God's grace at work in their humanity. As Jesus says in Matthew 5:16, those who see their beautiful deeds, their good works, will give glory to God and will raise a cry of joy and thanks to the One who is, in Hopkins's words, "beauty's self and beauty's giver." Only in this sense shall Beauty indeed save the world, as Dostoyevsky writes.

So how do we identify the saints in sacred art? As we saw with Saint Peter and Saint Paul, sometimes we have particular portraits of the saint that are handed down in tradition, and, as with every human person, we can first identify them by their faces. This is especially true of modern saints whose likeness we may have seen in photographs, such as St. Pius X, St. Thérèse of Lisieux, and St. Teresa of Kolkata. The vast majority of the saints we encounter, however, will not be from the previous century.

Another way, then, in which we commonly identify people, is by their clothing. As such, learning to recognize the religious habits worn by monks, friars, and nuns (known collectively as consecrated religious persons), and also some of the clothing worn by bishops and priests, will be very helpful. But we might look at a group of Dominican friars all in their distinctive black and white habits and wonder: How do we distinguish between them?

Learning the attributes of the saints is vital. These little symbols are like emojis or logos that point to something associated with a particular saint, his works, a miracle or vision perhaps, or his martyrdom and death, or a well-known aspect of his life. In newer churches, the images of the saints often have labels, which can be a great help. But in the past, when people were generally less literate, the attribute of a saint was a vital visual clue that helped people to identify the saint by recalling his or her stories. But of course, these made no sense if one was not already familiar with the stories and works of that saint. Similarly, as I have stressed, if we are not familiar with the Scriptures, then the art and symbolism of a church will remain closed off to

us, just as I might feel when I visit a Hindu temple, or indeed, look at a wall of Egyptian hieroglyphics! As Saint Jerome states, "Ignorance of the Scriptures is ignorance of Christ."

Therefore, to really enjoy your church visits, let the art that you find before you become an invitation for you to discover its meaning. Read the Bible, find out more about the lives of the saints, and thereby grow in your friendship with Christ, with Our Lady, and with the holy men and women who have befriended God and who have reflected his glory even while on earth. And then recall that the light of faith and the light of divine grace that shone through these persons is shining through us as Christians too. We just need to make sure we become transparent to God's grace, windows for him to shine his light through into our lives, our homes and communities, and into this dark world: "But he who does what is true comes to the light, that it may be clearly seen that his deeds have been wrought in God" (Jn 3:21).

In these final chapters, we shall look at the attributes of the saints. We will begin with looking at the general clothing of the saint, so that we can make some basic distinctions about the vocation or Christian state of life of that saint: Is this person a layperson or ordained, a religious or not, married or not? After considering this, as I have done previously when we looked at symbols in a church building, I shall divide the attributes of the saints into those that are living and those that are nonliving objects and instruments associated with the saints, again arranged alphabetically.

21

Halos and Habits

In my discussion of halos (chapter 12) we saw how these have become a common symbol of the saints and angels participating through sanctifying grace in the divine light of God. So when looking at a human figure in church art, first seek the halo. If there isn't one, then you're probably not looking at an image of a canonized saint but maybe someone else, such as a bishop who founded the local church, or a religious sister who taught in the local schools, or a secular leader of the local community, or the benefactors of the church. Someone who is not yet canonized may be shown with aureoles of light or a square-shaped halo around his or her head, but this is more notable as an exception than a norm.

Once you have ascertained that you're looking at a saint, then look at what the saint is wearing. Colorful robes with toga-like drapery would suggest that he is not a consecrated religious nor likely a cleric. Bear in mind, though, that you might be looking at a depiction of the saint before he entered religious life or was ordained, such as St. Martin of Tours, who was a soldier and eventually became a bishop. Saint Martin is often shown dividing his red cloak with a sword and giving half of the cloak to a beggar.

The clothing traditionally worn by consecrated religious is based on the clothing adopted by their founders, or (as in the case of the Dominicans, for example) revealed by Our Lady or another saint. Clothing worn by monastic communities of men and women roughly before the sixteenth century tends to have three parts. First, there is an ankle-length garment with long sleeves, called the tunic. Over this is a kind of apron that sits on the shoulders, hanging loosely in the front and in the back. Because it sits on the shoulders it is called a *scapular*, from the Latin word for *shoulders*. Many Catholics are familiar with the two small pieces of cloth connected by colored cord that is also called a

scapular — these sacramentals are derived from the monastic scapular and are essentially a miniature version. Often, especially in older religious orders, the scapular has a hood attached to it. Sometimes, though, the hood is part of a third piece of clothing that is connected to a short shoulder cape and is worn over the tunic and the scapular. The hood is called a *capuce*, which is Italian for *hood*. Capuchin Franciscan friars are so called because, in distinction from other Franciscans, they wear a prominently long pointed hood that comes down almost to the waist.

Women religious do not wear hoods; their head covering is a veil — usually black, worn over a white linen layer that can be fitted tightly around their head. If the veil is white, this usually indicates that the nun is a novice — that is, in her initial stage of formation and still new to the religious life. In all the descriptions below, the hood can be duly replaced with the black or white veil for women. Before the Reformation, the most distinctive headdress for a nun came from the Order of St. Bridget of Sweden, who gave to her nuns a Crown of the Five Holy Wounds, which they wore over their black veils. This is a white cross on the top of their head with five red circles on the joints of the cross.

Male religious from medieval monastic communities also had a tonsure, a distinctive way of

shaving the center of the head and leaving just a ring or a crown of hair. A tonsure would identify the person we're looking at as a monk or a friar even if he were not in his distinctive order's clothing (for example, in a Last Judgment scene). The monastic hood served to cover this tonsure for added warmth.

Finally, to ward off the elements and for warmth, a cloak that covers the hood (but not the veil) and encloses the whole person may also be worn over the other layers, although it is often worn for ceremonial reasons and not merely practical reasons. Altogether, the full set of clothing worn by a member of a religious order is called a *habit*, which comes from the Latin word for *clothes*.

The color of the tunic, scapular, and capuce are usually the same, and in the traditional orders, they tend to be black, white, gray, or light brown. Recall that color was a special commodity, and so were dyes for fabrics. Therefore, religious wore habits in colors derived from the colors of undyed sheep's wool that was easily available to them. Gray comes from a combination of unsorted black and white wool and was probably the cheapest, which is why the first Franciscans wore gray, a reminder of ash and our mortality. The brown that we tend to associate with the Franciscans only came about in 1895, and the Capuchins adopted brown only in 1912. Nevertheless, most depictions of Franciscan saints, especially since the First World War, show

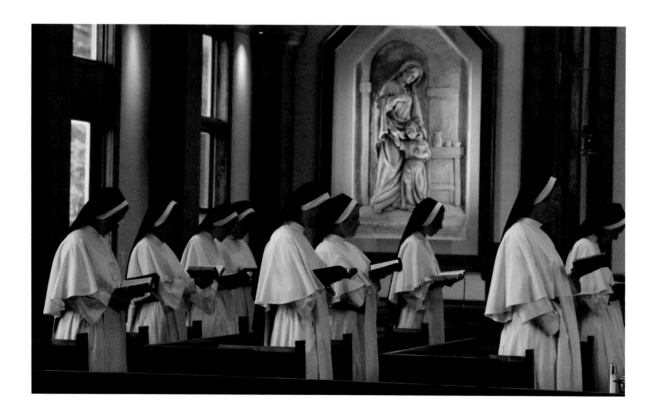

them dressed in brown. The order that has always had a brown habit is the Carmelites. Sheep's wool can also have a reddish-brown tinge, and this color was favored by the Carmelites because it reminded them of the wood of the Cross.

Before the age of industrial dyes, there would have been some variation in the color of these habits. The Dominicans, who wear a black cloak (known as a *cappa*), initially had so much brownish red wool mixed in with their black wool that they were sometimes mistaken as "red friars"! Bl. Humbert of Romans, fifth master of the Dominican Order, made this observation in his commentary on the Constitutions of the Order from the 1250s: "One has a black cappa, another brown, another gray ..." He set about to try to reduce this variation and to make the colors more uniform. Wool could be cheaply dyed black with soot or made more white with bleach or fuller's alkali. In England, the color of the cloak that covers the habit has been used by the laity to identify the different orders, although it does lead to profound confusion when the cloaks are not worn, such as in the summer months.

Of the older religious orders that you'll encounter in art, these are the habits you'll see most frequently; where necessary, I have described other habits under the list of attributes. What follows are the names of these orders according to the terms coined in medieval English usage.

Black Monks — Benedictines, the most venerable of religious orders in the West. As the name implies, these monks are dressed entirely in black, and their name comes from St. Benedict of Nursia, the patriarch of Western monasticism.

White Monks — Cistercians, a reform of the Benedictine life. Orders who wore white were aligned to this reform for a simpler and more aus-

DOCTOR VERITATIS

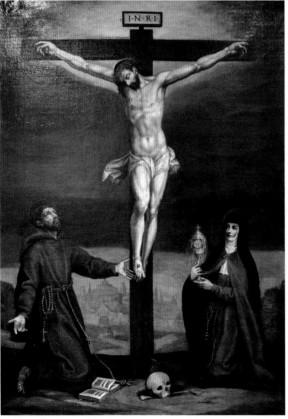

tere religious life and were initially set up in distinction from the old Benedictine abbeys. Apart from the Cistercians, there are the Trappists (a later, stricter reform of the Cistercian life), and then other monastic orders, such as the Camaldolese and the Carthusians, who all wear white monastic habits. The names of these orders are derived from the place names of their principal abbeys.

Black Friars — Dominicans, named after St. Dominic of Caleruega, their founder. The friars emerged in the thirteenth century in response to the rise of urban life and universities. Unlike the monks, who were tied to the land and live in one abbey for their whole lives, the friars moved around cities (thus they are called itinerant preachers), and they moved from one priory to another. Because they did not own lands and could not earn a living from the land, they had to beg for their food and living (thus they are also called mendicants). Black Friars wear a black cloak and hood over a white habit consisting of a white tunic, a scapular, and a capuce. We should note that for most of their history, the nonordained friars, also known as lay brothers, wore a black scapular and capuce over their white tunic. Dominican saints also wear a rosary from the left side of their belt, although this is not always visible.

Grey Friars — Franciscans, named after St. Francis of Assisi, their founder, a contemporary of Saint Dominic. Dominicans recognize Saint Francis as their "holy father" because the itinerant and poor life of a mendicant friar originated from him. The Franciscans have many branches of men and women, as each branch tried to imitate Saint Francis's ideals more closely. Not all wear a scapular, but some have a capuce. Their habit is usually a simple tunic and hood, bound by a rope cord with three

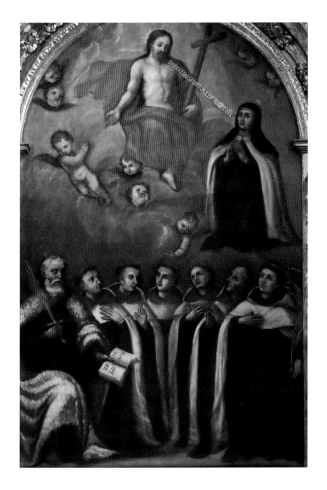

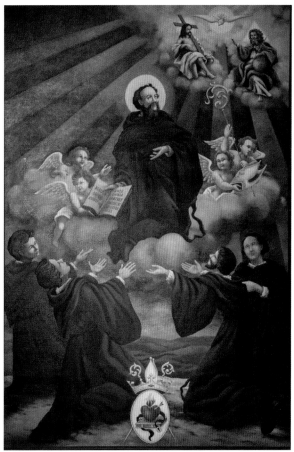

knots hanging from it, representing the vows of poverty, chastity, and obedience. This habit is gray or dark gray (almost black) or brown. As noted above, the Capuchins are distinguished by a long brown hood, and the men also grow long beards. They might also be shown wearing a short brown cape.

White Friars — Carmelites, so called because they pattern their contemplative lives after a group of hermits inspired by the Jewish prophet Elijah, who lived on Mount Carmel in the Holy Land.

Their habit looks like the Dominicans', except they have a brown habit, scapular, and capuce, covered by a white cloak and hood. The reformed Carmelites, founded by St. Teresa of Ávila, wear sandals instead of shoes, but this is not always visible in artistic depictions of Carmelite saints.

Austin Friars — Augustinians, so called because they follow the Rule of Saint Augustine. Their habit consists of a black tunic, a scapular, a large shoulder cape with a hood, and a long leather belt to gather their tunic under the scapular.

Newer Habits

Since the Protestant Reformation and in the modern era, religious congregations are noncontemplative or cloistered, but have active apostolates in the world. Generally speaking, male religious congregations wear a cassock, which is a long black robe with long, close-fitting sleeves worn by all nonmonastic priests. We are familiar with the pope's white cassock, and different-colored versions of the cassock pertain to different ranks: red for a cardinal, purple for a bishop, and black for priests and deacons.

Sometimes priests are portrayed wearing a surplice over a black cassock; a surplice is a knee-length white tunic with loose, flowing sleeves. If this garment has tight sleeves and is embellished with lace, it is called a *rochet* and is worn by prelates. St. Francis de Sales is often shown wearing a rochet over a purple (or uniquely blue) cassock, and with a matching shoulder cape and a pectoral

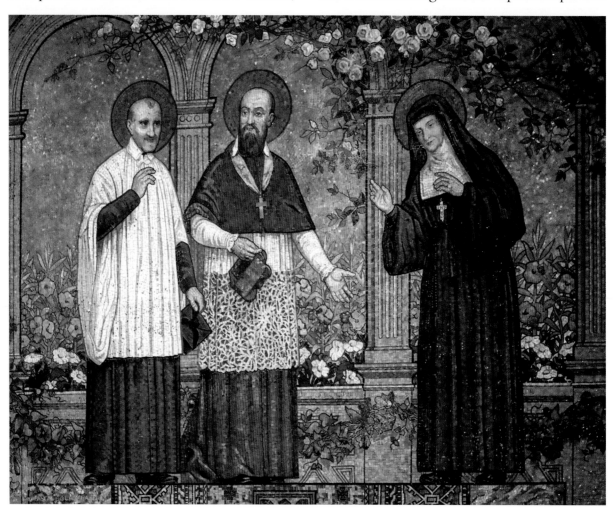

cross. This is the formal attire of a bishop, and the pectoral cross is also worn by abbots, abbesses, and some nuns. A bishop, abbot, or abbess may also be shown holding a crozier (see chapter 19).

The stole, as already mentioned, is a long band of fabric that may be worn over the surplice. When it is shown hanging loosely around the neck, it is the garment worn by priests and bishops when preaching and celebrating the rites of the sacraments. For example, St. Francis Xavier, a Jesuit missionary, is often shown in cassock, surplice, and stole because he was an impressive missionary preacher and baptizer of thousands. Sometimes, the collar of a cassock is embellished with two white or black linen bands, said to symbolize the tablets of the commandments, which was worn by clergy in seventeenth-century France (as in the case of St. John Vianney). Later, the cassock might have a logo emblazoned on the chest, such as the Passionist emblem, or a rosary might be worn from the waist, as with Redemptorists.

Women religious typically wore long black ample garments and black veils (or white, for a novice), with a white linen wimple that went around the head and neck under the veil. They often also wore an ample white bib, and over this a crucifix or some other emblem of their congregation. Some religious sisters had rather striking starched linen head coverings that originated from the headgear of peasant women in the regions where their congregations were founded. The most famous of these is the Daughters of Charity cornette, as was worn by St. Catherine Labouré with a bluish-gray dress. Others, such as St. Elizabeth Ann Seton, wore a black bonnet with a ruffled edge or, like St. Frances Xavier Cabrini, tied their bonnets with a large black bow.

Blue is a popular color added in modern times

to the color palette of habits, particularly as a mark of Marian devotion. The form of modern religious habits has also changed to include other non-European cultures. The most famous of all is the white sari with blue edging worn by St. Teresa of Kolkata and her congregation.

Vestments and Crowns

Finally, we need some basic knowledge of indicative vesture worn by prelates and clergy and European royalty. The **papal crown**, also called the *triregnum*, is a beehive-shaped headgear with three crowns (or tiaras) encircling it, topped with an orb and a cross. It is still seen on the flag of the Vatican City State and is frequently used in church art to indicate a saintly pope or as a sign of papal or even supreme authority; God the Father is often shown wearing a papal crown!

A **miter** is the distinctive arch-shaped, pointed headgear worn by a bishop, although older styles are less pointed, less tall, and might look like two small linen mounds on his head. Miters may also be worn by abbots. An Eastern bishop

wears a miter that looks like a smaller version of the papal crown, but without the three tiaras. Occasionally, certain saints, such as Saint Bruno, are shown turning away from a miter that has been thrown down to the ground, a sign that the saint rejected the episcopal office.

A cardinal will often be shown in art with a red **galero**, which is the traditional broad-brimmed hat sometimes with cords and tassels hanging down the sides. In heraldry, bishops have green galeros.

The Mass vestment worn by all priests is the **chasuble**, which means "little house" because it envelops the priest like a poncho. The later development of the chasuble is a more streamlined garment, like a fuller scapular, which has had its ample folds cut away so that the priest's arms are unencumbered. Either form of chasuble tells us that the saint we're looking at is a priest. Likewise, the stole is a sign of priestly authority, usually worn under the chasuble. If it is visible in older depictions, it is crossed over the chest if worn by a priest or left hanging loose if worn by a bishop,

unless it is worn over a surplice, as mentioned above.

Deacons are typically shown wearing a **dalmatic**, which is shaped like an oversized T-shirt with ornamented bands and tassels on it. A deacon wears a stole suspended from his left shoulder and stretching diagonally across his body. In the Eastern church and in icons, a deacon is shown wearing his stole on top of his dalmatic, and usually he holds the stole in his right hand. It is not unusual to see angels dressed as deacons because angels, like deacons, are servants of God who minister in the Divine Liturgy.

Last of all, we should take note of the **circlet of gold** (see chapter 8) that is the royal diadem or crown worn by royalty. Sometimes a saintly abbess or a nun who was also a princess is shown wearing a crown. Likewise, some sainted kings, queens, and princes are shown crowned or setting aside their crowns. Note, however, that sometimes saints (particularly martyrs) are shown holding one or several crowns as a sign of their victory over death, as a sign of their chastity, or as a sign of learning. As Saint Paul says: "I have fought the good fight, I have finished the race, I have kept the faith. From now on there is laid up for me the crown of righteousness, which the Lord, the righteous judge, will award to me on that Day" (2 Tm 4:7–8).

22

Flora and Fauna

*"Let man and beast appear before him,/
And magnify his name together."*

— Christopher Smart, "Iubilate Agno"

Birds

Saint Bonaventure, in his biography of St. Francis of Assisi, wrote that Saint Francis approached a flock of birds and exhorted them to give thanks to God for the gift of carefree flight and that "none of them moved from the spot until the man of God made the sign of the cross and gave them permission to leave; then they all flew away together."

Pig or Boar

The pig is associated with Saint Anthony, the third-century abbot and hermit of the Egyptian desert who is considered the father of monasticism. He is also shown with a traveler's staff surmounted by a tau cross (see chapter 7) or a bell (see below). Some people think the pig is a symbol of vice which St. Anthony combated and overcame in the desert. It is more likely, however, that the pig comes from a papal privilege granted to the eleventh-century Hospitaller Order (religious who ran hospitals for the sick and dedicated to Saint Anthony). They were given permission by the pope to let their pigs roam freely in towns scavenging for scraps. A bell was hung around their necks as a sign that they belonged to the order, and the pigs' lard was used by the monks for their medical ointments. The order was suppressed during the French Revolution, but the association of Saint Anthony with pigs remains, so he is patron of domestic and farm animals, and a blessing of stables and farm animals may be imparted on his feast day (January 17).

Children

Saints who ministered to children and their spiritual development, and who dedicated their lives to educating them in Christian virtue, are often shown with children around them. Some examples are:

- St. Vincent de Paul, the French "Apostle of Charity" who began in 1617 to bring food and clothing to poor families in the slums of Paris and to the slaves aboard ships.
- St. John Baptist de La Salle, who is dressed in a cassock with two white linen strips of fabric and who founded in the 1680s the Brothers of the Christian Schools, the first institute of consecrated laymen devoted to Christian education and the formation of teachers.
- St. John Bosco, who founded the Salesian Congregation in 1873 for the education of poor street children in Italy.
- St. Elizabeth Ann Seton, shown in her distinctive habit for her new Congregation of Sisters, who in 1809 established the first Catholic girls' school in the United States.

The portraits of these saints have all remained stable

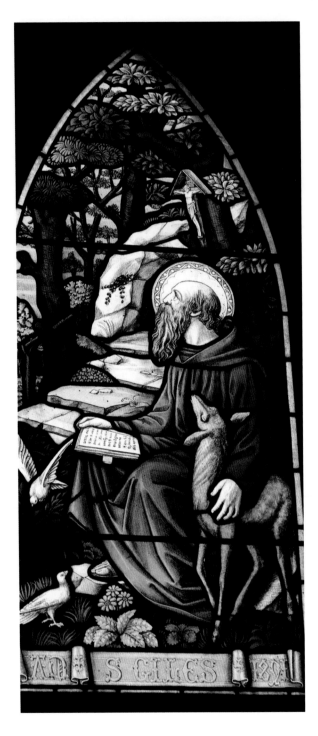

in art, and so these saints are quite easily recognized.

Relating to St. Vincent de Paul's mission to galley slaves, we can add two saints who strove for the liberation of Christian slaves from Muslim pirates and have also been depicted with freed children or grown men and women: the Jesuit St. Peter Claver and the Mercedarian St. Peter of Nolasco. Finally, there is also the patron saint of children, the bishop of Myra Saint Nicholas, who is often depicted alongside three boys in a wooden tub because he rescued them from an untimely death.

Deer

Saints associated with the woodlands are often shown with deer — in particular, the abbot Saint Giles, who was also a hermit. It is said that he drank the deer's milk and that, on one occasion, took an arrow in his knee to protect the deer, which a hunter had been chasing, and was rendered lame for the rest of his life. He is a patron of those with physical disabilities.

The patron saint of hunters, Saint Hubert, is often shown beholding the vision of a deer with a shining crucifix between its antlers. This vision, received on Good Friday, moved Hubert to repent and return to a good Christian life. He eventually gave up his wealth and titles and became the first bishop of Liège in France. His story resembles that of an earlier saint, Eustachius (known before his baptism as Placidas), a second-century Roman soldier who converted to Christianity after seeing a vision of a stag with a cross between its antlers. The German digestif known as Jägermeister (master of the hunt) has the deer with the radiant cross as its logo, directly inspired by the legend of Saint Hubert, after whom the drink is named.

Dog

The earliest biography of Saint Dominic, founder of the Order of Preachers, recounts that "before his mother conceived him, she saw in a vision that she would bear in her womb a dog who, with a burning torch in his mouth and leaping from her womb, seemed to set the whole earth on fire." The image of a barking dog had been associated with the ministry of preaching, warning against the wolves of heresy and protecting the Lord's flock from dangers. The dog with the blazing torch, a symbol of charity and the light of truth, became a symbol of Saint Dominic and his Order, the Dominicans; in Latin, *Domini canes* means "dogs of the Lord."

A dog bringing bread to a man shown in pilgrim's garb indicates Saint Roch, a fourteenth-century Frenchman who was a Third Order Franciscan. On pilgrimage to Rome, he cared for plague victims on the way and healed them. Eventually he succumbed to the illness in Italy, where he was cared for by a dog that brought him food. He is a patron of plague victims and of dogs.

Donkey

A beautiful story of Eucharistic devotion involves the Franciscan Saint Anthony, who was born in Lisbon, Portugal, but is buried in Padua, Italy. To prove to unbelievers that Jesus is present, Body, Blood, Soul, and Divinity, in the Eucharist, Saint Anthony once led a donkey that had not eaten for three days to the Eucharist. Perceiving that this was not mere bread, the hungry donkey did not eat it but knelt before the Eucharist.

Dove

As the predominant biblical symbol of the Holy Spirit, the dove, when it is seen hovering around a

saint, is a sign of divine inspiration, usually found in images of popes and Doctors of the Church.

If you see a dove whispering into the ear of a pope, that will usually be St. Gregory the Great, one of the four great Western Doctors of the Church, along with Saint Jerome, Saint Ambrose, and Saint Augustine.

If the dove is seen hovering around a Dominican friar with a sunburst (see below) on his chest,

preaching in Llanddewi Brefi, and a white dove alighted on his shoulder.

Saint Scholastica, Benedictine abbess and sister of Saint Benedict, is also shown with a dove because at the time of her death, Saint Benedict saw her soul rise like a dove to heaven; doves are ancient symbols of souls, as noted in chapter 7.

St. Teresa of Ávila, the great Doctor of the Church who reformed the Carmelite Order, is also shown with the dove hovering near her as she writes her treatises on spiritual theology.

Some saints have names that mean "dove" — such as the abbot of Iona and co-patron of Ireland, Saint Columba (Colmcille), who, in addition to being depicted with a dove resting on his shoulder, may be shown with a crozier. His black habit helps distinguish him from Saint Columbanus (Colmán), a white-clad monk and missionary abbot who traveled across the Alps and is buried in Bobbio, Italy.

Dragon

As mentioned in chapter 14, the dragon is shown being slain by St. Michael the Archangel. However, as a symbol of the Devil, the dragon is also shown being slain or chained up by various other saints:

Saint George is shown dressed in armor and often with his flag — a red cross on a white field — as he slays the dragon with his lance. Sometimes he can be confused with Saint Michael, so look out for the archangel's wings!

St. Margaret of Antioch was a popular saint in the Middle Ages because she was invoked for help with childbirth. A third-century virgin martyr born to pagan parents, Saint Margaret is shown emerging from the mouth of the dragon or defeating it with a cross.

that saint is St. Thomas Aquinas. He is called the "Common Doctor" of the Church because he is the one theologian whom all Catholics should have in common as their teacher.

If the dove is resting on the shoulder of a bishop, especially one standing on a small mound, that may be Saint David. The ground miraculously rose so that he could be elevated and heard while

Eagle

As mentioned above, the eagle is a symbol of the evangelist Saint John and of the virtue of contemplation of the higher things of God.

Fish

Saint Anthony, the miracle-working Franciscan friar who is popular as the patron of lost items, once tried to preach to heretics but they refused to hear him. So he

> went to the seashore, saying, "Because you show yourself unworthy of God's word,

behold, I turn to the fishes so that your unbelief may be shown up more clearly." As he spoke of God's care for those creatures that live in the waters, a shoal of fish swam near to the bank, partly thrusting themselves out of the water and appearing to listen carefully. At the end of his sermon, the Saint blessed them and they swam away.

Seeing this miracle, the heretics repented, listened to Saint Anthony's teaching, and returned to the fullness of the Catholic Faith.

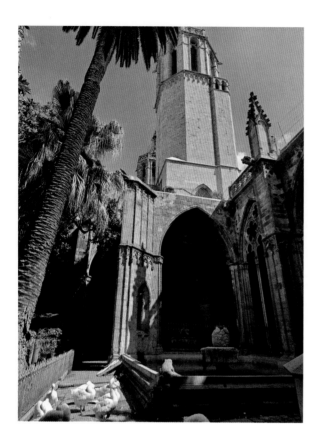

A fish with a ring in its mouth is a symbol of the patron saint of Glasgow, Saint Kentigern (or Mungo), who was the first bishop of that Scottish town. The story is that a Scottish queen had been framed by her husband, the king, who accused her of having given her wedding ring to her secret lover. In fact, the king had thrown it into the river so that he could accuse her falsely and then be rid of her. The queen appealed to Saint Kentigern for help, and he prayed and caught in the river Clyde a fish that had the queen's ring in its mouth.

Geese

Geese have been associated with Saint Martin, who hid to avoid becoming a bishop — but the geese honked and gave away his location when the pious laity and clergy of Tours came looking for him!

Geese are also associated with Saint Dunstan, a Benedictine bishop, and St. Alphege of Winchester, who was once distracted during Mass by the smell of goose being roasted, and afterward swore off meat for the rest of his life.

Geese have, since Roman times, been employed to guard shrines and holy places. The patron saint of Barcelona, Saint Eulalia, a young Christian girl, was martyred on a Saltire cross (see chapter 8) in the early fourth century. At her death, a flock of white geese descended to protect her body from desecration, and many people were converted by this miracle. To this day, geese are kept in the courtyard at Barcelona Cathedral to guard the nearby shrine of Saint Eulalia.

Incidentally, in the Celtic tradition, the Holy Spirit is represented not by a white dove but by the powerful white goose.

Lamb

The name of Saint Agnes, a teenage virgin martyr of Rome who was executed around AD 304, sounds like *agnos*, meaning "pure" in Greek, and *agnus*, meaning "lamb" in Latin. As such, she is often depicted holding a pure white lamb, the symbol of her sacrificial love and her innocence. She is one of five virgin martyrs who are named in the Roman Canon, the so-called First Eucharistic prayer of the Mass, and on her feast day (January 21), lambs are blessed by the pope. The wool from these lambs is used to weave the pallium, a kind of woolen scarf embroidered with crosses that is worn by the pope and archbishops.

As mentioned in chapter 13, the lamb is also a

preeminent symbol of Christ, and St. John the Baptist is often shown with the Lamb of God.

Lion

Saint Jerome is one of the four earliest Western (or Latin) Doctors of the Church. He translated the Bible into Latin between AD 383 and 404 while living in Bethlehem, and he served as secretary to Pope Damasus I in Rome. Jerome is often shown anachronistically in the red robes of a cardinal, or with a red galero, the cardinal's hat, nearby. His more splendid attribute, however, is a big cat — a lion! It is said that Saint Jerome befriended the lion when he was a hermit in the desert by removing a thorn from its paw, and the grateful beast stayed with him like a pet.

As mentioned in chapter 19, the winged lion is also a symbol of the evangelist Saint Mark and of Christ, as well as a symbol of death (see chapter 7).

Lily

As noted in chapter 7, the white lily is a symbol of purity and chastity. In particular, Hosea 14:5 says that the righteous of Israel "shall blossom as the lily," and there is a legend of a blossoming lily associated with the paradigmatic just and righteous man of Israel: Saint Joseph. The *Golden Legend* recounts that when suitors came forward to seek the Virgin Mary's hand in marriage, the priests of the Temple asked all the eligible men of the house of David to lay their walking staffs on the altar. They prayed, and Saint Joseph's staff blossomed; some add that a dove emerged from it, a sign of the Holy Spirit. Thus Saint Joseph was found worthy to become the spouse of the Virgin Mary, to safeguard her perpetual virginity and to protect the infant Son of God. Saint Joseph, the "most chaste spouse," is almost always seen holding a staff with lilies, a sign of his chastity. Another symbol of Saint Joseph is the carpenter's square, and he is sometimes shown working with wood as a carpenter.

Other saints are shown holding lilies as a symbol of their chastity, such as the Dominican saints Dominic and Catherine of Siena; the Jesuit scholastic St. Aloysius Gonzaga; the Augustinian St. Nicholas of Tolentino; and the Franciscan St. Anthony of Padua.

Finally, St. Kateri Tekakwitha, who is called the "Lily of the Mohawks," is often depicted with lilies as a sign of her vow of perpetual chastity, which she made to Christ at the age of nineteen. Saint Kateri is one of a significant number of saints who died at the age of twenty-four.

Otter

St. Cuthbert of Lindisfarne, a seventh-century abbot and then bishop, was known to wade into the waters around the Northumbrian island of Lindisfarne, and he would retreat to little islands farther away from the shore in search of solitude. The Venerable Bede recounts that when Saint Cuthbert knelt on the beach to pray, "two otters bounded out of the water, stretched themselves out before him, warmed his feet with their breath, and tried to dry him with their fur. They finished, received his blessing, and slipped back to their watery home." The otter is the cuter of the two symbols associated with Saint Cuthbert — the other, more common in art, is the head of Saint Oswald, king and martyr of Northumbria, who was beheaded and buried with Saint Cuthbert.

Ox (or Cow or Bull)

As mentioned in chapter 19, the winged ox is a symbol of the evangelist Saint Luke.

Palm Branches

As previously mentioned, the palm branch is an ancient symbol of life and victory, and so Christian martyrs are almost always shown holding palm branches. A palm branch, then, indicates that the saint we're looking at has shared in Christ's victory over suffering and death and that he or she now reigns with Christ, who is the Lord of the living. The palm branch is often matched with another attribute, as well as the habit, to help us identify which martyr we're looking at.

Rat or Mouse

St. Martin de Porres, the Dominican brother who lived in Lima, Peru, from 1579 to 1639, was known for his healing gifts and his compassion and charity. The Dominican friars of the Province of St. Martin de Porres in the United States tell the story well:

> It is told that the prior, who objected to rats, ordered Martin to set out poison for them. Martin did as he was told, but he was very sorry for the rats. He went out into the garden and called softly and out came the rats. He reprimanded them for their bad habits, telling them about the poison. He further assured them that he would feed them every day in the garden if they would refrain from annoying the prior. This agreed upon, he dismissed the rats and forever after, so the stories go, there was no more trouble with rats at Holy Rosary Convent [in Lima, Peru].

scapular or a hood. Saint Martin is also depicted with other domestic animals along with the rats and with a broom (see chapter 23).

Raven

Ravens, as we have seen in chapter 7, have a biblical significance, and they are also associated with the saints. St. Benedict of Nursia, the father of Western monasticism, is often shown with a raven with bread in its beak. St. Gregory the Great tells the story in his *Dialogues* of how "at dinner time, a crow daily used to come to [St. Benedict] from the next wood, which took bread from his hands." One day, someone tried to poison Saint Benedict, and the saint was warned of this. He threw the poisoned loaf to the raven, saying: " 'Take it up without fear, and throw it where no man may find it.' At length, with much ado, the crow took it up, and flew away, and after three hours, having dispatched the loaf, he returned again, and received his usual allowance from the man of God."

Ravens also came to protect the body of St. Vincent of Saragossa from being devoured by wild animals, so he is sometimes depicted with ravens and dressed in the dalmatic of a deacon (see chapter 23). Martyred in 304, Saint Vincent is the protomartyr of Spain.

Roses

St. Elizabeth of Hungary, as mentioned above, is sometimes shown with roses spilling out of her bread basket.

St. Juan Diego, visionary of Our Lady of Guadalupe and hermit, is often depicted with roses spilling out of his cloak, or *tilma*, on which Our Lady left a miraculous imprint of herself in 1531. This miraculous tilma caused the conversion of the Aztecs, the

It should be noted that Saint Martin is almost always shown wearing the former habit of the nonordained friars (also known as lay brothers) of the order: a white tunic, a black scapular, and a black capuce with a black cape. It is now shown by Dominican historians, however, that Saint Martin was, in fact, a *donado* of the convent and would not have worn a

largest single wave of conversions in Christian history, and the sacred tilma itself remains in pristine condition in Mexico City in a Marian sanctuary that is the most visited in the world. Pilgrims go on their knees to offer roses before this miraculous image of Our Lady. The tilma, of course, is always represented as a symbol of St. Juan Diego.

St. Rose of Lima, a Dominican tertiary who lived in Peru from 1586 to 1617, is sometimes shown with a crown of roses or holding roses to help distinguish her from other Dominican women saints. Among the roses in her arms might be an image of the baby Jesus because of a beautiful story that Our Lady appeared to Saint Rose and let her hold the infant Christ. Saint Rose is the first canonized saint of the Americas.

St. Thérèse of Lisieux, Carmelite nun and Doctor of the Church, is one of those young saints who died at the age of twenty-four. As she lay on her deathbed in the convent, she reflected: "After my death, I will let fall a shower of roses. I will spend my heaven doing good upon earth. I will raise up a mighty host of little saints. My mission is to make God loved." She is thus often depicted with roses falling from her hands.

Shamrock

As mentioned in chapter 7, the shamrock indicates Saint Patrick, who used this symbol of the Blessed Trinity to teach the Irish people about the mystery of the Triune God.

Spider

The *Life of St. Norbert* recounts that, one evening, St. Norbert of Xanten had been celebrating Mass in the crypt of a church:

After the Lord's Body and Blood had been consecrated, a large spider fell into the chalice. When [St. Norbert] saw it he was shocked. Life and death hovered before his eyes. But lest the sacrifice suffer any loss he chose rather to undergo the danger and consumed whatever was in the chalice. When the service was finished, believing he was going to die, he remained before the altar and commended his awaited end to the Lord in prayer. Then he was disturbed by an itching in his nose. He scratched it, and soon the spider was expelled by a sudden fit of sneezing.

This example of Eucharistic devotion is commemorated in art by images of the founder of the Norbertines holding a chalice, perhaps with a spider emerging from it!

Swan

The English bishop Hugh of Lincoln, who had been a Carthusian monk, is often shown with a swan that the bishop had encountered during his retreats into the quiet of Stow Park, near the town of Lincoln. This swan followed Saint Hugh for fifteen years, protected him from unwanted attention, and was fed by the saint until he died.

Weasel

On one of his preaching journeys, a weasel caught the eye of Bl. Jordan of Saxony, second master of the Order of Preachers, and he saw it scurry into a hole. He bent down and said, "Beautiful animal, come out, so that we can look at you." Immediately it came to the opening of the hole and fixed its eyes on him. Blessed Jordan then lifted its forefeet with one hand and, with the other, petted the weasel's head and back; all this the weasel accepted. Then he said to it, "Now go back into your hole and may your Creator be blessed."

Whale

As mentioned in chapter 11, the whale (or a monstrous fish) is associated with the prophet Jonah.

The whale is also seen in images of Saint Brendan, who is the patron saint of the U.S. Navy and of mariners and divers. According to the medieval *Voyage of Saint Brendan*, this sixth-century Irish monk and abbot — a tireless missionary throughout Ireland, Scotland, Wales, and Brittany — traveled in a small boat to Newfoundland. He and his companions stopped on an island to celebrate Mass on Easter Sunday only to discover that they had stepped onto the back of a whale (or some say a sea turtle)!

Wolf

In 1220, when St. Francis of Assisi was living in Gubbio, a two days' walk north of Assisi, a wolf began attacking the livestock and then also the townsfolk. Saint Francis approached the wolf, made the Sign of the Cross, and said:

Brother wolf, thou hast done much evil in this land, destroying and killing the creatures of God without his permission; yea, not animals only hast thou destroyed, but thou hast even dared to devour men, made after the image of God; for which thing thou art worthy of being hanged like a robber and a murderer. All men cry out against thee, the dogs pursue thee, and all the inhabitants of this city are thy enemies; but I will make peace between them and thee, O brother wolf, if so be thou no more offend them, and they shall forgive thee all thy past offenses, and neither men nor dogs shall pursue thee any more.

The wolf bowed its head and complied, and so peace was restored by Saint Francis. This story and those told above show the men and women of God bringing harmony and peace to our relationships with the natural world and its wonderful beasts. As Pope Francis said, citing the bishops of Japan: "To sense each creature singing the hymn of its existence is to live joyfully in God's love and hope."

23

Objects, Body Parts, and Instruments

O sweet wood, O sweet nails / That bore his sweet burden / Which alone were worthy to support / The King of Heaven and Lord.

— St. Venantius Fortunatus, "Pange Lingua Gloriosi Proelium Certaminis"

Anchor

The anchor is the attribute of St. Clement of Rome, the fourth pope and bishop of Rome, who was martyred by being tied to an anchor and thrown into the sea, about AD 99. He is often shown in papal vesture and with a prominent anchor.

Arrows

Saint Sebastian, patron saint of archers and athletes, was a Roman soldier who was martyred under Diocletian, about AD 288. Because he would not renounce his Christian faith, he was first shot with arrows, then beaten to death with clubs. The arrow has become his symbol; he is also patron of plague victims, for which the arrow is a symbol of pestilence and illness.

Saint Edmund, king of East Anglia, was martyred in 869 by being tied to a tree and shot with arrows by pagan Vikings who had invaded his kingdom. In heraldry, Saint Edmund is represented by two crossed gold arrows passing through a golden crown on a blue field.

Beehive

Saint Ambrose was such an eloquent preacher that many were moved

to conversion by his words. Saint Augustine, for example, said that "his energetic preaching provided your people with choicest wheat and the joy of oil and the sober intoxication of wine. ... I hung keenly upon his words ... as I stood there delighting in the sweetness of his discourse." On account of his eloquence, Saint Ambrose is shown with a beehive, for the sweetness of his words and according to the legend that when he was born, a bee alighted on his lips and left behind a drop of honey. Saint Ambrose is one of the four classic Western Doctors of the Church, and he is sometimes shown holding a whip of cords (see below).

The Cistercian abbot St. Bernard of Clairvaux, who is known as the "Mellifluous Doctor," is sometimes shown with a beehive on account of the sweetness of his preaching and writing. In particular, Saint Bernard wrote an extensive commentary on the Song of Songs, and the beautiful hymn "Iesu Dulcis Memoria," which tells of the sweetness of Christ's Name, is attributed to him.

Bell

As mentioned in chapter 22, the bell is sometimes associated with Saint Anthony or at least the pigs of the Antonine Order.

A bell is also sometimes found on the heraldry of Saint Kentigern (see chapter 22) alongside the fish, the robin, and a tree.

Saint Agatha, the virgin martyr of Sicily who

was executed between AD 250 and 253 is also symbolized by a bell because, as part of her tortures, she had her breasts removed by her tormenters. The bell is a euphemistic reference to this terrible act, but Saint Agatha is thus the patron saint of bell founders and breast cancer patients. Her feast is on February 5, and she is one of the five virgin martyrs mentioned in the Roman Canon.

Book

Many saints are shown holding a book, usually the Gospels or their own theological writings. Saints who were scholarly or who were teachers, preachers, or writers are often shown with a book. Unless the title of the book is given, one usually needs to look for another attribute to close in on the identity of the saint.

Saint Anne, the mother of Our Lady, is often

ST. ALPHONSUS. LIGORI.

guori, founder of the Redemptorists and patron saint of moral theologians, is dressed as a bishop and shown meditating with an open book or teaching from it. He is recognizable from his portrait, which has been quite consistent: a prominent hooked nose and a pronounced stoop because of rheumatic pains that assailed him from the age of seventy-one.

Bread

A finely dressed laywoman, crowned, with a basket of bread is likely to be St. Elizabeth of Hungary, who was landgravine of Thuringia (Germany) and a Third Order Franciscan. She had a happy marriage but was widowed early, and she devoted the rest of her short life (1207-31) to serving the poor and the sick and to building a hospital for them. The basket of bread is a sign of her care for the hungry and the homeless. On one occasion, she was challenged by her relatives who opposed her charitable works and demanded to see what was in her basket, but when she uncovered it, they saw only roses. So sometimes, St. Elizabeth of Hungary is shown holding a basket out of which roses are shown spilling over.

St. Martin de Porres, the Dominican brother of Lima, Peru, is also sometimes shown holding a basket of bread with which he would feed the poor as well as the rats in his garden (see chapter 22)!

St. Juan Macias, another Dominican lay brother who lived in Lima, in the Convent of St. Mary Magdalene, is shown with a basket of bread because he is known for having multiplied bread. Once, during a famine, he prayed over a basket with a few loaves and had enough bread to feed the friars in the priory and more than two hundred people who came to the door.

shown teaching Mary to read from an open book of the Scriptures; the young Mary would be Saint Anne's attribute in this case, and Our Lady is identifiable perhaps by a crown of stars.

The Franciscan St. Anthony of Padua is often shown holding a closed book with the infant Jesus standing on it because he was such an eloquent preacher of the Incarnate Word of God, and also because some say that he had a vision of the baby Jesus who would visit him when he prayed at night.

The Doctor of the Church St. Alphonsus Li-

Saint Anthony may also be shown with bread, which he gave to the poor and the homeless of Padua.

Broom

St. Martin de Porres's third attribute (apart from the rat and the bread mentioned above) is a broom. It is often asserted that this is because of the menial tasks assigned to him, although the historical records show that, in fact, as a *donado*, St. Martin was assigned the work of the "infirmarian, barber, and surgeon" of his convent, which means he exercised medical duties. Indeed, he was famed as a healer and for working healing miracles. The broom, therefore, is a reference to his humility, for he had reputedly said: "I wish to be as useful as a

broom — taken out and put to use as needed, and then hidden away out of sight when not!"

Candles

The traditional blessing of throats on the feast of the martyr and bishop Saint Blaise (February 3) is usually done while the priest holds two crossed candles against the throat of the person being blessed. Saint Blaise had prayed and saved a boy who was choking on a fish bone. The crossed candles are thus one of the attributes of Saint Blaise, alongside the somewhat more unpleasant metal wool comb with which he was tortured.

Chalice, Cracked (or with a Snake)

We saw in chapter 18 that a snake (or a dragon) emerging from a chalice is a symbol of a poisoned chalice of wine, rendered ineffectual by the prayer of a saint, such as Saint John.

Sometimes, though, the neutralizing of the assassin's poison is symbolized by a crack in the chalice. The enemies of the abbot Saint Benedict failed to poison his bread (see above), so they tried to poison his wine, but the saint blessed the wine with the Sign of the Cross, and the chalice cracked, and so the saint was saved. Incidentally, Saint Benedict's would-be assassins were fellow monks, so this should serve as a warning to anyone who thinks that religious life is a bowl of roses. Indeed, the stories of many saints who desired to preach the Gospel and live it out with integrity show us that holy reformers are consistently resisted and even violently opposed or killed. But Jesus has warned: "A servant is not greater than his master. If they persecuted me, they will persecute you" (Jn 15:20).

Cloak

I mentioned briefly in chapter 21 that the cloak is a symbol of the fourth-century saint Martin of Tours. His story is recounted by his contemporary Sulpitius Severus. Martin was a catechumen when

> at a certain period, when he had nothing except his arms and his simple military dress, in the middle of winter, a winter which had shown itself more severe than ordinary, so that the extreme cold was proving fatal to many, Martin happened to meet at the gate of the city of Amiens a poor man destitute of clothing. He was entreating those that passed by to have compassion upon him, but all passed the wretched man without notice, when Martin, that man full of God, recognized that a being to whom others showed no pity, was, in that respect, left to him. Yet, what should he do? He had nothing except the cloak in which he was clad, for he had already parted with the rest of his garments for similar purposes. Taking, therefore, his sword with which he was girt, he divided his cloak into two equal parts, and gave one part to the poor man, while he again clothed himself with the remainder. Upon this, some of the by-standers laughed, because he was now

an unsightly object, and stood out as but partly dressed.

The following night, "he had a vision of Christ arrayed in that part of his cloak with which he had clothed the poor man." Martin then got himself baptized, left military service, and decided to become a "soldier of Christ" instead.

The remaining half of Saint Martin's cloak became a precious relic that was carried by the French kings into battle. The cloak was housed in a building called the *capella* (meaning "little cloak"), and the priest who had the care of the cloak was called the *capellanus*. From these two terms we derive, by way of the French language, the words *chapel* and *chaplain*.

In an equally dramatic way, St. Raymond of Penyafort, the Dominican confessor of King James I of Aragon, had a confrontation with the king when the king insisted on bringing his mistress with him to the island of Majorca. Saint Raymond would not tolerate this blatant act of adultery, and the king would not repent, so the saint attached his black cloak to a traveling staff and "windsurfed" from Majorca to Barcelona on the mainland of Spain, a distance of at least 160 kilometers. Several witnesses saw him step onto the beach. Saint Raymond is buried in Barcelona Cathedral, and he is the patron of confessors and canon lawyers. In this regard, he is sometimes shown with the crossed keys, which, as mentioned above, is a symbol of the Sacrament of Penance.

Cross

Apart from the apostles mentioned in chapter 19 who are shown with the cross on which they died, and those saints and mystical writers on Christ's passion who are shown holding a cross or a crucifix, the most notable saint who holds a large wooden cross

is Saint Helena. She was the mother of the emperor Constantine, and around AD 326 to 328, she made a pilgrimage to Jerusalem. She found the relics of the true Cross and of the Lord's passion and brought these back to Rome, where most of them are now enshrined in the basilica built on the site of her palace. The feast of the Triumph of the Holy Cross (September 14) commemorates Saint Helena's finding of the cross.

The cross of St. Brigid of Kildare, fashioned of green reeds, is a distinctive symbol of the saint, who was an abbess and is one of the patron saints of Ireland.

Crown of Thorns

Several saints are shown holding or wearing a crown of thorns. St. Louis IX, king of France, as mentioned in chapter 10, is often shown in the royal robes of France (with gold fleurs-de-lis on a blue field) with the relic of the Lord's crown of thorns.

Other saints, who were mystical sharers in the Lord's passion, are often shown wearing the crown of thorns and holding a crucifix. Below are some of the most well-known and thus frequently seen in church art:

The thirteenth-century Mercedarian martyr St. Raymond Nonnatus, dressed in a white habit similar to the Dominicans' but with the yellow and red striped coat of arms of the Mercedarian Order on the scapular, is shown sometimes wearing a crown of thorns.

The fourteenth-century Dominican St. Catherine of Siena, who received the sacred stigmata

(the wounds of the Crucified Christ — see below), was told by Our Lord: "Know my dear daughter that you must of necessity be crowned some time or other, with one of these two crowns. Therefore take your choice; either the Crown of Thorns in this transitory life, and have the other reserved for your everlasting glory; or take the crown of gold at present and hereafter that of thorns."

St. Rita of Cascia, who was widowed and became an Augustinian nun in 1413, is depicted with a crown of thorns or frequently shown with just one of the thorns piercing her forehead.

St. Catherine de Ricci, a Dominican nun, experienced the sufferings of Christ's passion from 1541 to 1553, suffering with him every week from noon on Thursday until late afternoon on Friday. A stigmatist (see below), she is often shown holding the crown of thorns and the nails of the Lord's passion.

St. Veronica Giuliani, a seventeenth-century Poor Clare (Franciscan), offered her sufferings for the missions. She was a stigmatist and is shown wearing a crown of thorns.

St. Gemma Galgani, a twentieth-century young woman, often shown in modest black clothing but unveiled, was associated with the Passionist Order. She was also a stigmatist and is sometimes shown holding a crown of thorns.

Dalmatic

The distinctive vestment of a deacon (which came from the region known as Dalmatia), as described in chapter 21, is worn by some of the most significant martyrs in the Church who are often depicted in art, including the protomartyr, Saint Stephen; one of the patron saints of Rome, Saint Lawrence; and the protomartyr of Spain, Saint Vincent. As

we saw in chapter 22, Saint Vincent is sometimes distinguished by the additional attribute of ravens, and each of the other deacons has other symbols to set him apart.

Eyes on a Dish

Saint Lucy, another of the five virgin martyrs included in the Roman Canon, was killed in the third century in Syracuse. She had been to Catania in Sicily to seek the intercession of Saint Agatha, and when she returned with her mother to Syracuse, the Roman prefect tried to get her to renounce the Faith. He put her in a brothel, but she replied: "The chaste are the temple of God, and the Holy Spirit dwells in them." In the end, the Romans tortured and beheaded her. Among the tortures she

endured was having her eyes removed; thus they might be shown on a dish as one of her attributes. Fittingly, she is the patron of the blind, and her feast is on December 13, which had been the winter solstice.

Gridiron

A large metal grill is the attribute of the deacon St. Lawrence of Rome, patron of cooks and comedians. When he was being grilled alive on the gridiron, he reputedly quipped: "Turn me over:

I'm done on this side!" Sometimes the gridiron he holds is quite small, looking more like a fly swatter.

Heart

A heart ablaze is held by several mystic saints and promoters of devotion to the Sacred Heart of Jesus (see chapter 13), but, surprisingly, it is not common to see it used as an attribute of St. Philip Neri, whose heart was physically enlarged by the Holy Spirit. Those saints who are commonly shown holding a heart, typically with flames emerging

Objects, Body Parts, and Instruments **239**

from it, include the following:

St. Augustine of Hippo, the fourth of the great Western Doctors of the Church, is often shown holding a flaming heart. In the official insignia of the Augustinian friars, this heart is pierced with an arrow, a symbol of being wounded by God's love. As Saint Augustine wrote in his *Confessions*: "With the arrows of your charity you had pierced our hearts, and we bore your words within us like a sword penetrating us to the core."

St. Gertrude the Great, a thirteenth-century Benedictine nun from Germany, had mystical visions of Christ and St. John the Evangelist, and she is often shown holding the Sacred Heart of Jesus, as he had said to her: "Behold, I manifest to the gaze of thy soul my deified Heart, the harmonious instrument whose sweet tones ravish the Most Adorable Trinity." She is one of the earliest promoters of devotion to the Sacred Heart of Our Lord.

St. Catherine of Siena is sometimes shown with a white veil because she wasn't a Dominican nun but rather a member of a group of penitential women known as the "Mantellate," who shared certain elements of the Dominican habit. We can tell it is Saint Catherine, however, by at least one of three symbols: the stigmata, the crown of thorns (see above), and

the flaming heart. In one of her mystical visions, Jesus gave his heart to her: "Suddenly she saw herself surrounded by a light from heaven, and amid this light, the Savior appeared to her, bearing in his sacred hands a heart of vermilion hue and radiating fire. Deeply affected with this presence and this splendor, she prostrated herself on the ground. Our Lord approached, opened anew her left side, and placed in it the heart which he bore."

St. John Houghton, the Carthusian monk who in 1535 became the first martyr of the English Protestant Reformation, is sometimes shown holding his heart because as he was being hanged, drawn, and quartered — a most gruesome form of execution, reserved for traitors to the English Crown — he prayed: "O Jesus, what wouldst thou do with my heart?"

St. Teresa of Ávila, the Carmelite mystic and reformer, wrote that her heart was pierced with a dart of love. She is thus shown in art with a pierced heart or by images of an angel piercing her heart with a spear: "In his hands I saw a great golden spear, and at the iron tip there appeared to be a point of fire. This he plunged into my heart several times so that it penetrated to my entrails. When he pulled it out, I felt that he took them with it, and left me utterly consumed by the great love of God."

St. Margaret Mary Alacoque, in seventeenth-century France, was a Visitation sister who had visions of the Sacred Heart of Jesus and is the foremost promoter of devotion to Our Lord's Eucharistic Heart, particularly through the First Friday devotion. She once said: "It seems to me that I can breathe only to increase devotion to the Heart of Jesus."

Heraldry

The ancient art of using symbols to represent an

institution or a family or an individual is still with us today: We recognize corporations and brands by their logos. This visual language goes back to the Middle Ages and is called heraldry, because it was the job of professional heralds to identify personages by their coats of arms and to announce their arrival at court. We may be familiar with ecclesiastical heraldry because popes and bishops and our dioceses will typically display their coats of arms on a shield. We have seen some examples so far, so we know that heraldry is an important way to identify the saints we see in church art. Unfortunately, it

would take another book to cover this symbolic art form adequately, but we can look out for heraldic emblems and learn to recognize the more common ones.

Most religious orders and congregations will adopt a coat of arms that relates to their order and their history, and this may be displayed in addition to the religious habit as a means of identifying the saint. For example, the Dominican coat of arms (of which there are three major forms over the ages) might be a black and white cross on a black and white alternating background, as shown here. The Franciscan coat of arms has the crossed arms of Christ and Saint Francis, each bearing wounds in their palms, and with a Tau cross between them.

Several saints, especially those who were from noble European families, are portrayed with their coats of arms. St. Ignatius of Loyola, the founder of the Society of Jesus (the Jesuits), for example, was the son of a Basque noble family. The Jesuit logo is the IHS Christogram surrounded by the rays of the sun, but one is equally likely to see Saint Ignatius portrayed with the shield of the Oñaz-Loyola family, with maroon and gold diagonal stripes, alternating with an image of two rampant wolves flanking a cooking pot.

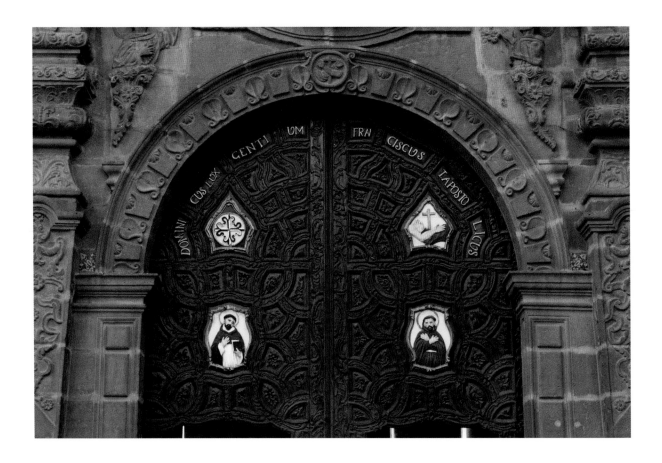

Papal coats of arms or heraldic emblems are also helpful if you're looking at an image of a pope but need to identify *which* pope it is; every pope since the fourteenth century has had a heraldic device, and one can find a list online and become familiar with them. Pope St. John Paul II's, for example, is quite distinctive with a gold letter *M* under a gold cross on a blue field.

IHS Banner

As mentioned earlier, the Jesuits have as their emblem the Christogram IHS (see chapter 12 in the section on the Holy Name of Jesus). This is usually drawn with three nails under the name, a cross above it, and the whole device surrounded by the rays of the sun. St. Ignatius of Loyola is often shown with this emblem, and in the main Jesuit church in Rome, there is a portrait of the saint being given a banner emblazoned with this emblem by the Risen Christ. Saint Ignatius is also recognizable because depictions of his face, drawn from life, have been fairly consistent from the beginning.

Jar of Ointment

St. Mary Magdalene is often shown holding a lidded jar containing spices, which she had intended for the anointing of the dead body of Jesus. As Saint Mark says: "When the sabbath was past, Mary Magdalene, and Mary the mother of James, and Salome, bought spices, so that they might go and anoint him" (16:1). Traditionally, however, Mary Magdalene was believed to be the same Mary — the sister of Lazarus and Martha — who anointed Jesus' feet with nard and wiped his feet with her hair (see Jn 12:3), and this was conflated with the unnamed woman who went to Simon's house and "wet [Jesus'] feet with her tears, and wiped them with the hair

of her head, and kissed his feet, and anointed them with the ointment" (Lk 7:38). Hence St. Mary Magdalene is frequently shown with her hair unbound and uncovered, and with a covered jar (or box) of ointment. Mary Magdalene, of course, is the first person recorded in the Gospels to have seen the Risen Christ, and it is she who is sent by the Lord to tell the apostles of his resurrection. The Vatican Dicastery for Divine Worship and the Discipline of the Sacraments has said, citing St. Thomas Aquinas: "She becomes the '*apostolorum apostola*' because she announces to the apostles what in turn they will announce to the whole world." One of the more common depictions of St. Mary Magdalene has her at the empty tomb, reaching out to the risen Lord (who is sometimes portrayed as a gardener with a hoe and

a sun hat), and with her jar of ointment nearby.

Sometimes, the twin saints Cosmas and Damian, who were physicians, may be shown with a jar of ointment too.

Keys

As mentioned in chapter 19, the keys are entrusted to Saint Peter, and he is almost invariably shown holding them. Sometimes other saints who have sat on the Chair of Saint Peter are shown holding a set of crossed keys, usually one in silver and one in gold to represent earth and heaven. These keys are the preeminent sign of papal authority, and typically, as a symbol of the Holy See, they are surmounted by a papal crown. Sometimes they are surmounted by a striped umbrella, which is one of the symbols of a papal basilica (see part 1), but when the keys and the umbrella are combined, with the umbrella closed, this is usually a sign that the Holy See is vacant—that is, the pope is dead and a new one has yet to be elected.

Saints who are especially linked to the ministry of hearing confessions are also sometimes shown with crossed keys because, as I said in the section on the sacraments, the "power of the keys" entrusted to Saint Peter and the apostles can refer to the power to absolve from sins in the Sacrament of Penance. The keys also symbolize the absolute secrecy of the sacrament — called the "seal of the confessional" — such that anything that is told to a priest in confession cannot be divulged to anybody at all under any circumstances whatsoever.

Following are two of the saints shown with the keys:

St. Raymond of Penyafort, the patron saint of canon lawyers, contributed greatly to the compilation of the Church's laws, called the *Decretals of Gregory IX*, which remained the basic collection of canon law for some seven hundred years.

St. John Nepomucene (or Nepomuk), who was martyred for refusing to violate the seal of the con-

Monstrance

As I have noted, a monstrance, from the Latin word for "to show," is a golden vessel, often shaped like a sunburst or a Gothic tower, that displays the Eucharist for adoration. As such, it is itself a symbol of the Eucharist. Saints who have protected the doctrine of Christ's Real Presence in the Eucharist, or who have died protecting the Blessed Sacrament from desecration, or who have had a particularly strong faith in the power of the Eucharistic Lord are shown with a monstrance, such as Saint Anthony in his miracle of the donkey (see chapter 22). Other saints depicted with the monstrance include these:

St. Norbert of Xanten, twelfth-century abbot and founder of the Premonstratensians, is frequently shown with a monstrance and repelling the heretic Tanchelm, who did not believe that the sacraments are efficacious. Because of his doctrinal defense of the Eucharist, Saint Norbert is venerated as the "Apostle of the Eucharist." The Norbertines wear a white habit with a white scapular, a white shoulder cape with a small hood, a white sash, a rochet, and a white cape; sometimes Saint Norbert wears a pallium or a white boxlike hat called a biretta. He might also be shown holding a chalice (with a spider in it), as mentioned in chapter 22.

St. Clare of Assisi, foundress of the Franciscan nuns, is credited with having repelled the Saracen invaders who stormed her convent in 1240, armed only with the monstrance and her faith in the Eucharist. Tommaso da Celano writes that Saint Clare had gone in prayer before the tabernacle, pleading with the Lord for mercy and protection, and "she suddenly heard a voice from the tabernacle, 'I will always protect you.'" So she rushed out with the Eucharist, and the attackers, seeing her

fessional, is also often shown wearing a surplice and a stole (see chapter 21), vested for confession, with his finger over his lips, and holding the palm of martyrdom.

Lamp

Saint Lucy, whose name means "light," is sometimes shown carrying a lamp, which is less graphic than her eyes on a dish (see above)! This helps us to distinguish her from the other virgin martyrs of the Roman Canon.

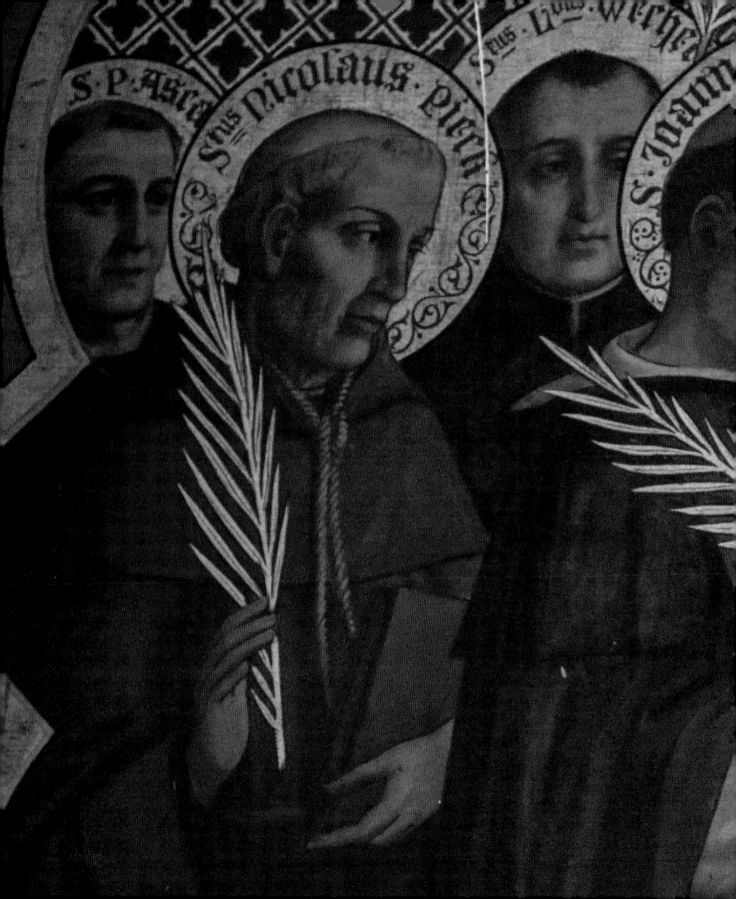

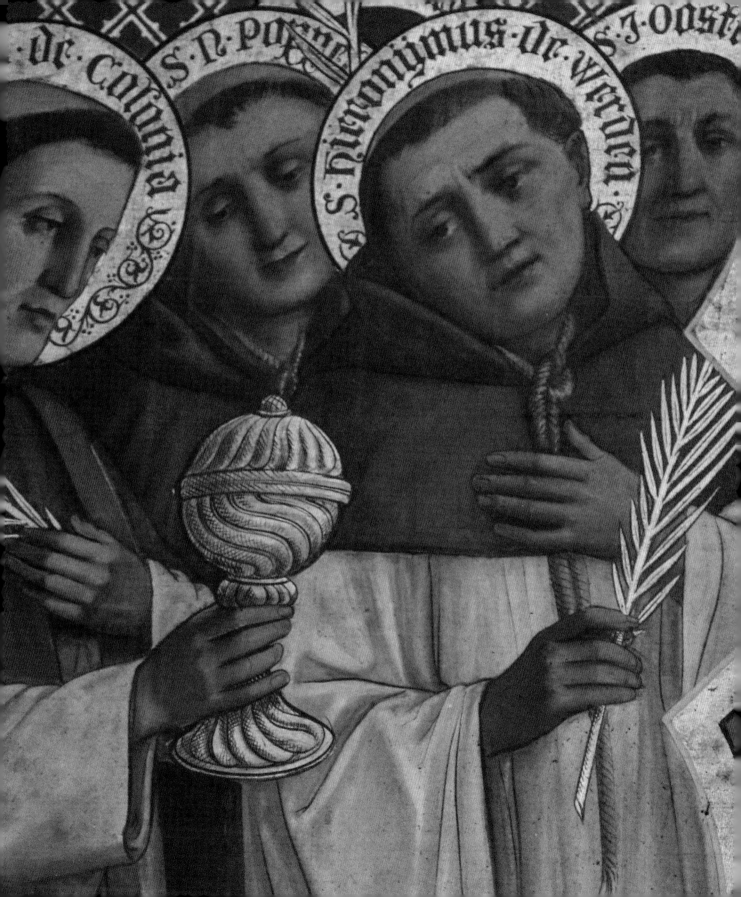

he was hanged, Saint John refused to renounce his Faith in the Eucharist, confession, and the primacy of the pope. He is often depicted with a noose, the instrument of his martyrdom, and with a monstrance, a sign of his Eucharistic faith.

Bl. Carlo Acutis is probably the first saint to be depicted in modern clothing and sometimes with a computer, but he is also shown with the ancient attribute of the monstrance because of his Eucharistic devotion. Blessed Carlo set up a website documenting all the Eucharistic miracles he could find, and he said: "The more Eucharist we receive, the more we will become like Jesus, so that on earth we will have a foretaste of heaven."

Noose

As mentioned above, St. John of Cologne, martyred by hanging, is depicted with a noose around his neck; likewise the Carthusian abbot St. John Houghton, protomartyr of the martyrs of England and Wales under Henry VIII, and St. John Ogilvie, the Jesuit martyr of the Scottish Reformation.

Unusually, St. Charles Borromeo, a cardinal and archbishop of Milan in the sixteenth century, is also shown with a noose around his neck, even though he is not a martyr. This recalls that during a time of plague in Milan, Saint Charles organized penitential processions and acts of Eucharistic devotion, and he himself walked with a noose around his neck like a condemned criminal. He also personally attended to the sick, fed those who were abandoned, and tried to get the civil authorities to help those in need. People were so moved by his humility and devotion that many repented of their sins, were converted, and were saved from eternal death, even in a time of great pestilence. Indeed, in times of illness and pan-

boldness and courage, retreated from the convent.

St. Hyacinth of Poland, a Dominican friar, had his convent in Kiev come under attack from invading Tartars in the same year, 1240. With the church in flames, Saint Hyacinth ran inside to retrieve the Blessed Sacrament from the tabernacle and also a sizable statue of Our Lady. He was given the strength and grace to carry both to safety.

St. John of Cologne was a Dominican friar and one of nineteen Dutch clerics who were martyred by Calvinists in Brielle in 1572. Until the end, when

demics and dangers, should we not be even more fervent in penance and prayer? Saint Charles certainly practiced this and led his flock to imitate his humility and penitence. So, from 1576 to 1578, it was observed that even

> when the plague began to grow, this practice [of singing the litanies in public] was interrupted, so as not to allow the congregations to provide it more fuel. The orations did not stop, however, because each person stood in his house at the window

or door and made them from there. Just think, in walking around Milan, one heard nothing but song, veneration of God, and supplication to the saints, such that one almost wished for these tribulations to last longer.

Organ

Saint Cecilia, one of the five virgin martyrs named in the Roman Canon, was said to have sung to God in her heart as she was martyred in her house in Rome. The traditional antiphon for Morning

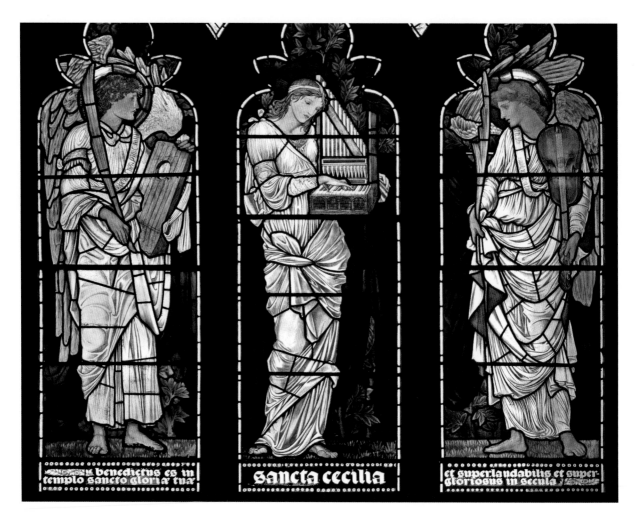

benedictus es in templo sancto gloriæ tuæ

sancta cecilia

et superlaudabilis et super-gloriosus in secula

Prayer on her feast, in fact, reads: "While the organ was playing, Cecilia sang to the Lord saying: 'Let my heart be spotless so that I may not be confounded.'" Consequently, the pipe organ is Saint Cecilia's attribute, and she is also the patron saint of church music.

Incidentally, the Second Vatican Council reminds us in the Western Church that the pipe organ "is to be held in high esteem, for it is the traditional musical instrument which adds a wonderful splendor to the Church's ceremonies and powerfully lifts up man's mind to God and to higher things" (*Sacrosanctum concilium*, par. 120). The Church from antiquity generally favored unaccompanied singing in church, but the organ was permitted because it works like the human voice, with "breath" channeled through pipes. Moreover, with its many pipes united as one instrument, the organ was seen by Saint Augustine and others as a symbol that should inspire civic leaders and the Church to seek

harmonious unity. For, in the pipe organ, as Pope St. John XXIII said, "the giving of a proper and ordered harmony to different musical sounds is an image of the well-governed city, where peace and order reign, thanks to the harmonious union of the different elements."

Pistol

The sixteenth-century Dominican St. Louis Bertrand is sometimes portrayed holding an unusual attribute for a saint: a pistol — to be precise, only the handle and the trigger remain of this gun, but the barrel has morphed into a crucifix. Apparently, he had been preaching against the corruption of the nobility of Spain, and someone tried to assassinate him. But Saint Louis blessed the pistol, and it turned into a crucifix! He is also sometimes shown with a chalice filled with snakes, which, as I

noted in chapter 22, is a symbol of a poisoned chalice. This alludes to an incident in South America, where he had been a missionary, and again he made the Sign of the Cross over a chalice and the poison in it was neutralized.

Ring

St. Edward the Confessor, king and protector of the realm of England, is often shown in royal robes, crowned, and holding a sapphire ring. Apparently, he had given it to a beggar who was seeking alms at the door of Westminster Abbey. Years later, some English pilgrims to the Holy Land met the same beggar, who told them he was St. John the Evangelist, and they were told to return the ring to Saint Edward, which they did. This ring was buried with the saint in Westminster Abbey, but the sapphire was recovered. It is believed to be embedded in the Imperial State Crown, which is still worn by the reigning monarch of England.

Rosary

Our Lady (with the child Jesus) is frequently depicted giving rosary beads to Saint Dominic and sometimes also to St. Catherine of Siena because the Rosary is the "sacred inheritance" of the Dominican Order, given by Our Lady to the order. Apart from Dominicans, though, there are other saints shown holding images of this beloved and vital prayer of the Church, a gift from Mary to the whole world through the sons and daughters of Saint Dominic. These saints include the two visionaries of Fátima, St. Jacinta Marto and St. Francisco Marto, who (with their cousin Lúcia dos Santos) saw Our Lady of the Rosary in six apparitions in 1917.

Ship

Saint Nicholas, whose body is enshrined in Bari, on the east coast of Italy, is regarded as the patron saint of sailors and is sometimes shown with a ship because he miraculously rescued sailors caught in turbulent waters.

Skull

The skull is a *memento mori* — a reminder of our human mortality — and a symbol of penitence. As such, it is associated with many holy men and women, such as St. Mary Magdalene, St. Francis of Assisi, Saint Jerome, and Saint Bruno, founder of the Carthusians. A skull is sometimes seen at the foot of the cross because, as Scripture says, Christ was crucified at "a place called Golgotha (which means the place of a skull)" (Mt 27:33). Tradition holds that this was, in fact, the skull of Adam, such that the precious blood of Christ, the second Adam, should flow from the cross and soak into the ground where the skull of Adam was buried, thus redeeming him and all humanity.

Spear

Saint Longinus, the Roman soldier who pierced the side of Christ (see Jn 19:34), is shown holding a spear. Most notably, in St. Peter's Basilica in Rome, a monumental statue of this saint stands beneath a hidden chapel where the relic of his spear is kept. It is displayed for veneration once a year on the eve of the Second Sunday of Lent.

Certain military saints, such as Saint George and Saint Michael, are also shown holding spears with which they overcome the dragon (see above).

As mentioned above, St. Teresa of Ávila is sometimes depicted alongside an angel who holds a golden spear of divine love with which to pierce her heart.

Staff

We have observed in iconography the prominence of the traveler's staff, a sign of the pilgrim, of one who is on a journey. The traditional patron saint of travelers was a giant of a man known as Saint Christopher, who is shown with a traveling staff to match his dimensions: a tree! His name means "carrier of Christ," so he is almost always shown bearing the child Jesus on his shoulders as they traverse the land or cross a river.

Star

At Saint Dominic's baptism, his godmother saw a bright light shining from his forehead, so he is often depicted with a star in his halo or above his head. Saint Dominic is thus the patron saint of astronomers.

St. John of Nepomuk, the fourteenth-century Czech martyr of the confessional, is also shown with five stars around his halo. After he was tortured and thrown into a river by order of King Wenceslaus IV, stars appeared above the waters to indicate the location of his body.

Stigmata

The stigmata are the five wounds of Christ Crucified that have mystically appeared on the bodies of some saints, although these were not always visible until after death. The most well-known stigmatist saints are these:

- St. Francis of Assisi, who was imprinted with the stigmata by a vision of a burning seraphim in 1224
- St. Catherine of Siena, who begged Our Lord to keep the stigmata invisible, and he did
- St. Rita of Cascia, patron saint of

Stones

The Acts of the Apostles recounts that the people of Jerusalem "cast [Saint Stephen] out of the city and stoned him; and the witnesses laid down their garments at the feet of a young man named Saul. And as they were stoning Stephen, he prayed, 'Lord Jesus, receive my spirit'" (7:58–59). Saint Stephen is regarded as the first martyr of the Church, and he is depicted in a deacon's dalmatic and holding a stone or with a stone embedded in his head.

St. Margaret Clitherow, an English laywoman, wife, and mother, was condemned to death for harboring Catholic priests. This was in 1586, when she was just twenty-nine and might also have been pregnant. But this did not prevent the English authorities, who had outlawed Catholicism and Catholic priests, from carrying out her death sentence. She was taken to the city gate on Ouse Bridge in York on Annunciation Day and was "pressed under seven or eight hundredweight [approximately eight hundred to nine hundred pounds in weight] until she died roughly 15 minutes later." Her son later became a Catholic priest and returned to England as a missionary.

Sun

St. Thomas Aquinas, the great Dominican theologian, is frequently depicted with a blazing sun over his heart. Pope Pius XI said that the sun is Saint Thomas's symbol because "he both brings the light of learning into the minds of men and fires their hearts and wills with the virtues." Even earlier, Pope John XXII had said that "he alone enlightened the Church more than all other doctors." Yet it is important to recall that the brilliance of Saint Thomas's teaching comes from Christ, the light of the world, who is the source of all wisdom. As

impossible cases, who became an Augustinian nun

- St. Catherine de Ricci, Dominican nun and mystic
- St. Gemma Galgani, Passionist affiliate
- St. Pio of Pietrelcina, more commonly known as Padre Pio, a Capuchin friar who lived in Italy from 1887 to 1968. He covered the wounds on his hands with thick woolen gloves, as often seen in photos and in art.

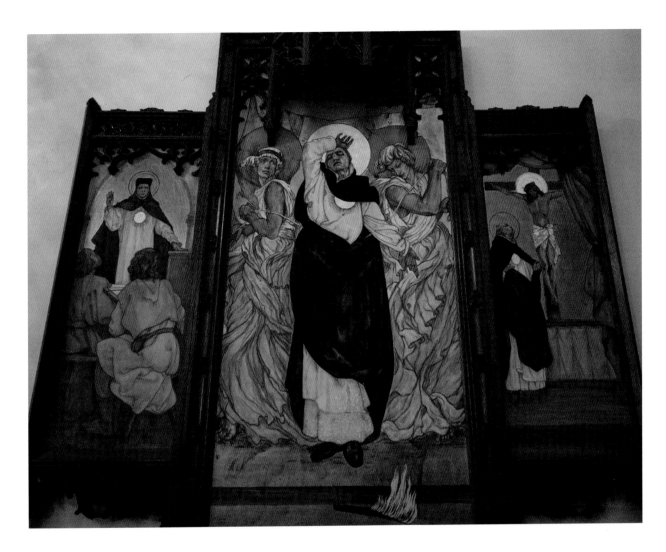

Saint Thomas himself said in 1256 at his inaugural lecture in Paris: "The minds of teachers ... are watered by the things that are above in the wisdom of God, and by their ministry the light of divine wisdom flows down into the minds of students."

Sword

As mentioned in chapter 19, the sword is the symbol of Saint Paul, who was martyred by the sword. So, too, other saints who suffered death by the sword might be shown with this attribute, such as the following:

St. Catherine of Alexandria, martyred around AD 305, was reputed to have been a princess and debated the truths of Christianity against pagan Greek philosophers. She is often shown with a crown and her typical symbol, a wheel (see below), on which she was tortured. However, she was finally beheaded, so she is also shown holding a sword.

Saint Boniface, an English Benedictine monk who became a missionary to Germanic tribes in the eighth century and was the first archbishop of Mainz, was killed by pagan bandits. As he was reading from the Gospels, they slew him with a sword. Hence he is often shown holding a book pierced with a sword.

Saint Thomas, archbishop of Canterbury, was struck on his head by a sword, martyred in his own cathedral on December 29 in 1170 by knights of the English realm who were eager to please their king, Henry II, who was in a bitter dispute with the archbishop over the liberty and rights of the Church. Many saints have been killed while defending the Church's freedom from the interference of the political and civil regimes of their day. St. Thomas Becket, as he is also known, is often shown with the sword going through his miter.

St. Peter of Verona, the protomartyr of the Dominican Order, is also shown with the instrument of his death but, more gorily, slicing across his head or embedded in his chest. He was killed not with a sword, however, but with a machete. He is also identified by

as punishment for her Christian faith, and although he eventually killed her, he himself was killed when he was struck by lightning. Saint Barbara was especially popular in the Middle Ages because she was invoked against lightning strikes and violent death and is the patroness of those who work with explosives, such as miners and the artillery corps.

Trumpet

The fifteenth-century Dominican saint Vincent Ferrer is often symbolized by a trumpet on account of his preaching, which is said to have reached far and wide, converting tens of thousands of people to Christianity. His preaching was so renowned and so fiery, however, that Pope Pius II referred to him as "the Angel of the Apocalypse, flying through the heavens to announce the day of the Last Judgment, to evangelize the inhabitants of the earth." For this reason, too, he is shown with the trumpet (associated with the angels in the Book of Revelation) and is sometimes shown with wings like an angel. Saint Vincent is also shown holding a rosary because he attributed the conversion of souls to the praying of the Rosary.

Wheel

The wheel is so closely associated with St. Catherine of Alexandria that a wheel used for torturing people in the Middle Ages has been named after her. The wheel is usually shown with spikes, and Saint Catherine is depicted with it and holding a palm. Because she was seen in visions of the early Dominicans in the company of the Blessed Virgin Mary, Saint Catherine is regarded as one of the patrons of the Dominican Order. She is also patroness of philosophers, and her eloquence is said to have converted thousands.

the word *Credo*, "I believe," in red letters, because he wrote the opening words of the Creed with his blood on the ground as he died in 1252, thus confessing in his final moments his belief in one God.

Tower

Saint Barbara, whose name adorns a seaside town on the Californian coast, was thought to have been a third-century virgin martyr, and the story of her life is largely regarded as fanciful. Nevertheless, she is seen in many churches. She is often depicted with a crown and holding a palm and either holding a small tower or standing near one. According to tradition, her pagan father had her locked in a tower

Milan and reduced their influence by stirring up devotion to the martyrs of Milan, Saint Gervase and Saint Protase, who he said had been given to Milan by the Lord to defend his divinity and the true Catholic Faith: "Thanks be to You, Lord Jesus, for having roused the spirit of the martyrs at a time such as this when your church needs greater protection. Let everyone know that I require such defenders who are not accustomed to attack but are able to defend. These I have acquired for you, holy people; they who provide aid, and harm no one." After this date, there were no further troubles from the Arians. The whip, therefore, is a symbol of Saint Ambrose, who successfully whipped up the people against heresy.

Occasionally other saints are shown with a whip as a sign of their bodily penance and compassion for sinners.

Wreaths

As noted in chapter 8, wreaths and crowns are symbols of victory and are sometimes worn by martyrs or the great company of saints in heaven. A wreath or garland of roses might also be seen on St. Rose of Lima or as a symbol of the Rosary.

Whip

Saint Ambrose, archbishop of Milan and Doctor of the Church, is often shown holding a whip with three knots in honor of the Trinity. But Saint Ambrose did not need to use physical force to expel from Milan the Arians, who denied the divinity of Christ. Despite the fact that the emperor favored the Arians, Saint Ambrose whipped up the fervor and devotion of the people who supported him and were persuaded by his teaching and his eloquence. In 386–387, he managed to drive the Arians out of

A closing thought: This list of saintly attributes is fittingly incomplete because God's saints are beyond our ability to count, for his grace is so bountiful and his loving mercy, limitless. And most importantly, you and I are still in the process of being numbered among them, please God! The aim of this book and this list, then, have been to help equip you to identify the saints in church art; to encourage you to discover and to imitate the holy men

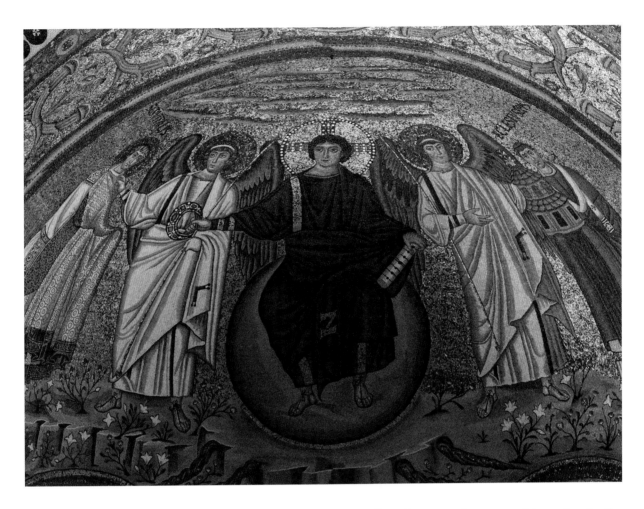

and women who are portrayed on the surfaces, windows, and altars of our churches; and, hopefully, to excite you to find out more about them, especially when the depictions are obscure, and they are less easily identifiable. If you find someone unknown to me, please let me know!

Returning to the laurel wreaths that crown our saints, let me end this final section with these words from Saint Paul to spur you and me on in our Christian journey here on earth, looking ahead to joining the company of the saints in heaven: "The time of my departure has come. I have fought the good fight, I have finished the race, I have kept the faith. From now on there is laid up for me the crown of righteousness, which the Lord, the righteous judge, will award to me on that Day, and not only to me but also to all who have loved his appearing" (2 Tm 4:6–8).

Epilogue

We end as we began, with our focus on heaven, the abode of the saints and, as Saint Paul says, our "commonwealth" (Phil 3:20), our true "homeland," which God has prepared for us (see Heb 11:14-16). The church building and the liturgy we celebrate now on earth as a communion of saints is but a preparation for the heavenly Jerusalem, where we shall be gathered with the whole host of heaven for the eternal liturgy. So if the church points to the coming of heaven to earth, then, at the same time, its goal is to bring earth to heaven. For this, too, is why God became man: So that man might become God (see CCC 460).

The architect Sir Ninian Comper rightly says that "the note of a church should be, not that of novelty, but of eternity. Like the Liturgy celebrated within it, the measure of its greatness will be the measure in which it succeeds in eliminating time and producing the atmosphere of heavenly worship." I would go further than this and suggest that the greatness of a church building and the liturgy within it is measured not only by the external forms that Comper rightly points to but by whether it succeeds in increasing devotion — that is to say, love for God; whether it is conducive to holiness and the virtues demonstrated by some of the saints we have considered; and whether it thus prepares us for the worship of the heavenly Temple. For, as Saint Paul says, "We have a building from God, a house not made with hands, eternal in the heavens" (2 Cor 5:1).

Permit me to leave us all with a challenge and a stimulus for thought and for the examination of our consciences. These words come from one of the finest Christian thinkers in recent decades — someone whom God used as a catalyst for my becoming a Catholic. He helped me in my formative years to discover the beauty of the Church, the vitality of Tradition and humble theological discourse, and the power of authentic liturgy (being the graced action of Jesus Christ himself) to

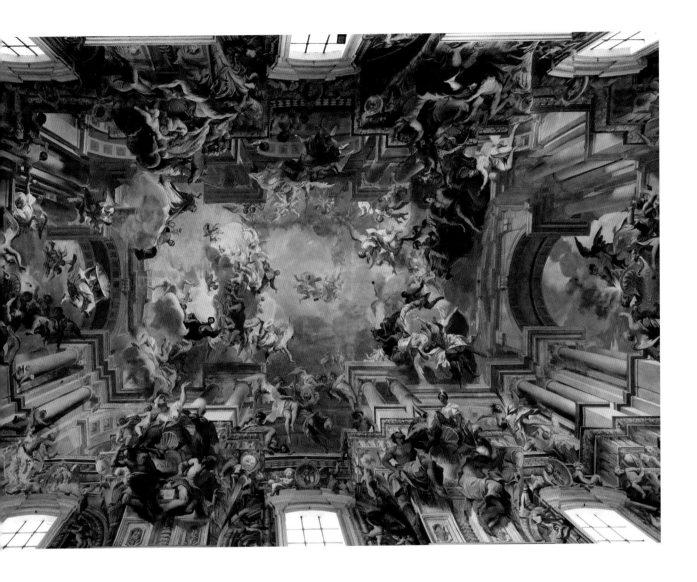

attract contemporary souls, who thirst for beauty, goodness, and truth and raise them up to partake in the life of the eternal God, who is love.

Joseph Ratzinger, Pope Benedict XVI, writes:

What is the relationship between the stone building and the building of living stones?

... The spirit builds the stones, not vice versa. The spirit cannot be replaced with money or with history. Where the spirit does not build, the stones become silent. Where the spirit is not alive, where it is not effective and does not reign, cathedrals become museums, memorials to the

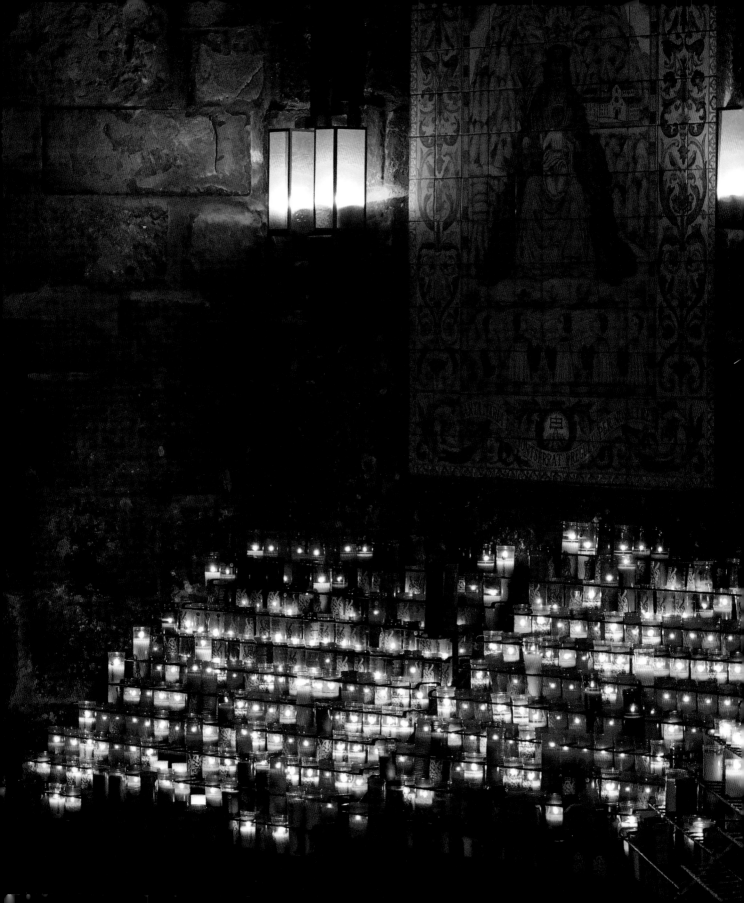

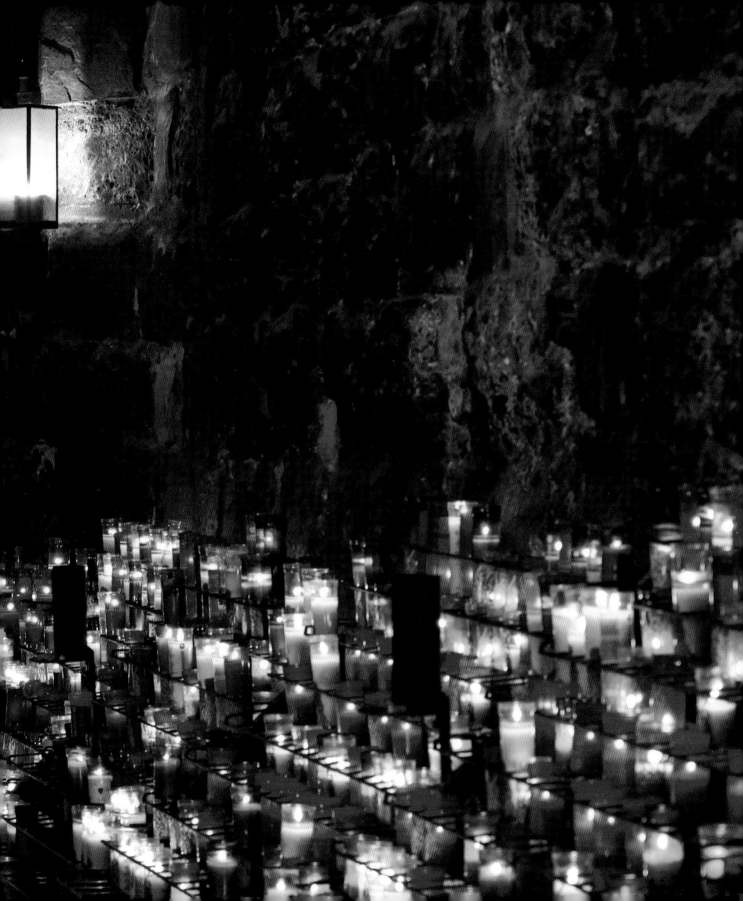

past whose beauty makes you sad because it is dead. ... If the spirit does not build, money builds in vain. Faith alone can keep cathedrals alive, and the question the one-thousand-year-old cathedral is asking us is whether we have the strength of faith to give it a present and a future. ... [Finally,] God builds his house; that is, it does not take shape where people only want to plan, achieve, and produce by themselves. ... It does not materialize where people are not prepared to make space and time in their lives for him; it does not get constructed where people only build by themselves and for themselves. But where people let themselves be claimed for God, there they have time for him and there space is available for him. There they can dare to represent in the present what is to come: the dwelling of God with us and our gathering together through him, which make us sisters and brothers of one house. Being open to simplicity is just as natural here as recognizing the right to beauty, to the beautiful. ... The beauty of the cathedral does not stand in opposition to the theology of the Cross but is its fruit: it was born from the willingness not to build one's city by oneself and for oneself.

The cathedral, these church buildings, call upon us Christians to become a living sacrifice in Christ, offered up in love for God and for one another; to become, as Ratzinger says, "the living cathedral so that the cathedral of stone remains a present reali-ty and heralds the future." Within these walls, God calls us to that "sacred banquet, in which Christ is received, the memory of his passion is renewed, the mind is filled with grace, and a pledge of future glo-ry is given us." Alleluia!

cknowledgments

The thought of writing and illustrating a book like this remained a velleity for many years, something that had occasionally been suggested to me by friends and acquaintances but which I had never had the confidence to undertake — I just did not feel adequate to the task. So my thanks goes first of all to those who encouraged me to attempt this work, beginning with my editor, Rebecca Martin; and I am grateful to the good people at OSV, especially Fr. Patrick Briscoe, OP, who first reached out to me and enthusiastically helped and supported me in bringing this book to fruition.

Over the years, many people have helped me to see the beauty of the churches around us and to photograph them attentively. Among these are my Flickr friends from my Oxfordshire "church crawl" group and particularly Martin Beek, who took me to many churches and taught me to use my camera and inspired me to acquire a photographer's eye. My thanks, too, to those who have made it possible for me, a mendicant friar, to get to as many churches as possible, whether through organized pilgrimages — especially those arranged by Milanka Lachman and her company, 206 Tours — or through friends and brethren who have taken me on journeys with them and waited as I photographed every inch of a building. In particular, I remember the kindness and patience of Sr. Valery Walker, OP; Sr. Jadwiga Swiatecka, OP; my novice master, Fr. John Patrick Kenrick, OP; my fellow novice Paul Mills; Quentin Gelder; Allan Barton; Rory Lamb; Alexander Cooper; Fr. James Bradley; and countless others who have opened their churches for me, shared their favorite churches and discoveries with me, and taken me to visit some very special holy places.

All the photographs in this book have been taken and processed with cameras and lenses and on computers given to me by my father, Charles Lew. My father, in his generosity and benevolence and goodness to me from the day of my birth, has given me a glimpse of the love

of the heavenly Father for each of us. Words cannot contain the gratitude I have for him. Likewise, my endless thanks to my mother, Sonia Becker, from whom I inherited my aesthetic eye. She remains one of the most creative, artistic, and imaginative people I know, and she frequently gifts her creations to her friends and loved ones, but the greatest gift she has given me, apart from this life itself, is a love for beauty and a care for the beautiful things around us, something we both inherited from her mother, Esther, to whom I dedicate this book.

Finally, I wish to thank my Dominican confreres and my superiors, who have allowed me to develop my interests and love for photography, architecture, and art, and I am grateful to have been given the time and space to complete this book, especially after I was released from my pastoral responsibilities in London. Many of the brethren here in Great Britain, and also in the United States and in Rome, have educated me and nourished my intellectual and Christian life, both through formal study and through our common life as brothers. I am grateful to them and to God for the Dominican vocation he has given me. Indeed, to the First goes my last and deepest thanks: to God, for all that is, and also to his blessed mother, "Mama Mary," most beautiful of all God's creatures.

hotography Credits

Cover, front
Left: Nave and high altar of Rosary Shrine, London, England
Top right: Detail of a fresco by Fra Angelico in the San Brizio chapel, Orvieto Cathedral, Italy
Middle right: Priory church of the Priory of the Holy Spirit (Blackfriars), Oxford, UK
Bottom right: Detail of rose window in north transept, Chartres Cathedral, France
Cover, back
Left: Cathedral of the Assumption, Salamanca, Spain
Right: Detail from the Priory church of the Priory of the Immaculate Conception (Dominican House of Studies), Washington, D.C., USA

PART I

6 — Grotto of the Annunciation, Nazareth, Israel
7 — Most Holy Redeemer Church, Detroit, MI, USA
8-9 — Santa Sabina Basilica, Rome, Italy
11 — Eucharist celebrated in St. Cuthbert's church, Durham, UK
12 — Priory church of the Priory of the Holy Spirit (Blackfriars), Oxford, UK
13 — Priory church of the Priory of the Immaculate Conception (Dominican House of Studies), Washington D.C., USA
14 — St. Vincent Ferrer church, New York City, NY, USA
15 — Adoration in St. Jean Baptiste Church, New York City NY, USA
16-17 — Dominican Sisters kneel before the shrine of St. Cecilia in St. Cecilia's Basilica, Rome, Italy
19 — The rotunda of the church of the Holy Sepulcher, Jerusalem, Israel
20 — St. Louis Cathedral, New Orleans, LA, USA
21 — Collegiate church of St. Nicolas, Fribourg, Switzerland
22 — Santa Sabina Basilica, Rome, Italy
25, left — St. James's church, Rothenburg ob der Tauber, Germany
25, top right — Basilica of St. Paul outside the Walls, Rome, Italy
25, bottom right — Detail of a fresco by Fra Angelico in the San Brizio chapel, Orvieto Cathedral, Italy
26 — Eucharist celebrated in the Cathedral of the Precious Blood, (Westminster Cathedral), London, UK
27 — East doors of the upper church, Sainte Chapelle, Paris, France
28 — Notre Dame Cathedral, Paris, France
29 — Arch of Constantine, Rome, Italy
30 — Colonnade by Gian Lorenzo Bernini, St. Peter's Square, Rome, Italy
31 — Side door in the south transept, Church of the Holy Sepulcher, Jerusalem, Israel
32 — Baptistery of the Lateran Basilica, Rome, Italy
33 — Paschal candle in the Rosary Shrine (St. Dominic's Priory), London, UK
34 — St. Patrick's Church, Columbus, OH, USA
37 — St. Nicholas Orthodox Cathedral, Washington D.C., USA
38 — Gold leaf being applied to the walls of St. Dominic's Priory church (the Rosary Shrine) in London, UK
39, Red — Fresco in the ceiling of the Rosary chapel of the Basilica of Santa Maria sopra Minerva, Rome, Italy
39, Black — Requiem Mass celebrated in the Priory church of the Priory of the Immaculate Conception (Dominican House of Studies), Washington D.C., USA
40 — The Harrowing of Hell, fresco by Fra Angelico in San Marco, Florence, Italy
41 — Madonna and Child by Filippo Lippi, Metropolitan Museum of Art. Credit: The Jules Bache Collection, 1949.
42 — Seventh-century mosaic of Our Lady from the apse of the chapel of St. Venantius, in the Lateran Baptistery, Rome, Italy.
43 — National Shrine of St. Joseph, De Pere, WI, USA
45 — Basilica of the National Shrine of the

Immaculate Conception, Washington D.C., USA
46 — St. James the Greater Catholic Church, Charles Town, WV, USA
47 — Cathedral of the Assumption, Orvieto, Italy
48 — Statue of an apostle in the upper church, Sainte Chapelle, Paris, France
49 — St. Francis Xavier church, Newtowne, MD, USA, which is the oldest Catholic church in the original 13 Colonies.
50-51 — Priory church of the Priory of San Esteban, Salamanca, Spain
53 — The Baptistery of Neon, Ravenna, Italy
54 — Basilica of San Clemente, Rome, Italy
55 — Chapel of St. Nicholas, St. Anthony's Monastery, Florence, AZ, USA
56 — Oratory church of St. Philip Neri, Birmingham, UK
57 — St. Dominic Church, Washington D.C., USA
58 — Cathedral of the Precious Blood, (Westminster Cathedral), London, UK
59 — Apse of Santa Sabina Basilica, Rome, Italy.
61 — Basilica of St. Paul outside the Walls, Rome, Italy
62 — St. John the Beloved Church, McLean, VA, USA
63 — Two religious sisters engaged in conversation with a beggar at the gates of the Basilica of Santa Maria Maggiore, Rome, Italy.
64-65 — Pilgrims facing the Grotto of Massabielle at the Shrine of Our Lady of Lourdes, France
66 — Oratory church of St. Aloysius, Oxford, UK
67 — Detail from Communion of the Apostles, fresco by Fra Angelico, Convent of San Marco, Florence, Italy

PART II

68-69 — Grotto of the Annunciation, Nazareth, Israel
71, left — Statue of the Immaculate Virgin in the forecourt of the Basilica of the Annunciation, Nazareth, Israel
71, right — Durham Cathedral, Durham, UK
73 — Chapel of the Throne in the Abbey church of Our Lady of Montserrat, Spain
74 — Stained-glass window in the former St. Thomas Aquinas priory at River Forest,

IL, USA
75 — Climbing the Calvary at Banská Štiavnica in Slovakia.
76 — Carved detail from the east portal of the upper church, Sainte Chapelle, Paris, France
77 — High Altar of the Rosary Shrine (St. Dominic's Priory), London, UK
78 — Stained-glass window in the cloister of Saint-Étienne-du-Mont, Paris, France
79, left — Choir stall in the priory church of St. Vincent Ferrer, New York City, NY, USA
79, right — Carved detail from the choir stalls of Winchester Cathedral, Winchester, UK
81 — Stained-glass window from the Basilica of the Sacred Heart, Paray-le-Monial, France
82-83 — Cathedral of the Assumption, Salamanca, Spain
85 — Stained-glass window by John Piper in St. Mary's church, Iffley, UK
86 — Enamel detail from a tabernacle door in the Rosary Basilica, Lourdes, France
87 — Stained-glass detail from St. Alban's church, London, UK
88 — Detail from the 12th-century apse mosaic of the apse of San Clemente, Rome, Italy
89 — Detail from the apse windows of the Rosary Shrine (St. Dominic's Priory), London, UK
90 — Sixth-century mosaic from the Basilica of San Vitale in Ravenna, Italy
91 — Twenty-first-century mosaic from the Cathedral of the Precious Blood, (Westminster Cathedral), London, UK
92 — Encaustic tiles on the floor of the Lady Chapel, St. Mary's College (Oscott College), Birmingham, UK
93, left — Stained-glass window in the Percy chapel of Tynemouth Priory, North Shields, UK
93, right — Tabernacle in a side chapel of St. Patrick's Cathedral, New York City, NY, USA
94 — Statue of Our Lady of Cana by Cody Swanson, in the Luminous Mysteries garden of the Rosary Shrine (St. Dominic's Priory), London, UK
95 — Sixth-century mosaic from the Basilica of San Vitale in Ravenna, Italy
96 — Statue from the facade of the Cathedral Basilica of Santiago de Compostela, Spain
97 — Detail from the memorial window of the Wesley Memorial Church, Oxford, UK
98, top — Tapestry in Wartburg Castle, Eisenach, Germany
98, bottom — Carved foot of the font at

Orvieto Cathedral, Orvieto, Italy
99 — Detail from a medieval window in York Minster, York, UK
100, left — Detail from the rails around the *confessio* in the Basilica of St. Cecilia, Rome, Italy.
100, right — Detail from a stained-glass window by Jozef Mehoffer in St. Nicolas Cathedral, Fribourg, Switzerland
101 — Detail from the sixth-century apse mosaics of the Basilica of Saints Cosmas and Damian, Rome, Italy
102 — Apse mosaic, installed c.1130s of the Basilica of San Clemente, Rome, Italy
103, top — Carved detail from the choir stalls of King's College Chapel, Cambridge, UK
103, bottom — Stained-glass window from St. Mary's Church, Peru, IL, USA
104 — Stained-glass window from St. Francis Xavier Cathedral, Green Bay, WI, USA
105 — Mosaic detail from the High Altar of St. Joseph's church, Lancaster, UK
106, top — Sixth-century apse mosaic in the Basilica of Sant'Apollinare in Classe, near Ravenna, Italy.
106, bottom — Detail from the Co-Cathedral of St. John the Baptist in Valletta, Malta
107 — Fragment from an early Christian sarcophagus in the catacombs of St. Sebastian in Rome, Italy
108 — Detail from the apse of the Basilica of San Clemente, Rome, Italy
109 — Stained-glass window in the chapel of St. Mary's Seminary, Houston, TX, USA
110 — St. Mary's Basilica, Krakow, Poland
111 — Medieval stained-glass window in Chartres Cathedral, Chartres, France
112-113 — Painting by Jan Henryk de Rosen in the USCCB building, Washington D.C., USA

PART III

114-115 — Apse of Most Holy Redeemer Church, Detroit, MI, USA
117 — Priory church of the Priory of the Holy Spirit (Blackfriars), Oxford, UK
118 — Dominican Sisters enjoying the view of the Pyrénées near Lourdes, France
119 — Our Lady giving the Rosary to St. Dominic, in the Dominican priory of Guatemala City, Guatemala
121 — Detail from the altarpiece in the Lady Chapel of Winchester Cathedral, Winchester, UK

PART IV

Chapter House of Santa Maria Novella, Florence, Italy

209, bottom — Stained-glass window in the Basilica of Santa Croce in Gerusalemme, Rome, Italy

210, top — St. Dominic's Altar in the Rosary Shrine (St. Dominic's Priory), London, UK

210, bottom — Our Lady of Solitude Monastery in Tonopah, AZ, USA

211, left — Chapel of the birthplace of St. Teresa of Ávila, in the convent church named after her in Ávila, Spain

211, right — Museum of San Agustin church in Intramuros, Manila, the Philippines

212 — Mosaics from the Basilica of the Sacred Heart, Paris, France

213 — Painting from St. Casimir Church in Baltimore, MD, USA

214, left — Canterbury Cathedral, Canterbury, UK

214, right — Detail of a fresco in the Chapel of the Corporal, Orvieto Cathedral, Italy

215 — Detail from the vault of the San Brizio chapel, Orvieto Cathedral, Italy

217, left — St. Martin's Cathedral, Leicester, UK

217, right — St. John's Church, Fribourg, Switzerland

218 — St. Giles Church, Houghton St. Giles, UK

219 — Detail from a window in the Lady Chapel of St. Patrick's Cathedral, New York City, NY, USA

220 — Cathedral of the Assumption, Orvieto, Italy

221 — Cathedral of the Precious Blood, (Westminster Cathedral), London, UK

222 — Geese in the cloister of St. Eulalia Cathedral, Barcelona, Spain

223, left — Church of St. Anne, Krakow, Poland

223, right — Cathedral of the town of San Cristóbal de La Laguna, Tenerife, Canary Islands, Spain

224 — Chapel of Aquinas House, the Newman Center of Dartmouth College, Hanover, NH, USA

225 — Statue of St. Martin de Porres carved by Fr. Thomas McGlynn OP for the Rosary Shrine (St. Dominic's Priory), London, UK

226 — Entrance facade of St. Martin's Monastery, Santiago de Compostela, Spain

227 — Detail from the Guadalupe chapel in the Basilica of the National Shrine of the Immaculate Conception, Washington D.C., USA

228, left — The Basilica of St. Gregory the Great, Abbey church of Downside Abbey in Stratton-on-the-Fosse, UK

228, right — Detail of an oil painting in the museum of the Dominican priory of the Holy Trinity in Krakow, Poland

229 — St. John Nepumocene Church, New York City, NY, USA

231 — Sacristy of the Arch-basilica of the Lateran, Rome, Italy

232 — Crypt of the Basilica of the National Shrine of the Immaculate Conception, Washington D.C., USA

233 — St. Patrick's Cathedral, New York City, NY, USA

234, left — Statue by Fr. Thomas McGlynn OP on the campus of Providence College, Providence, RI, USA

234, right — Old St. Patrick's Church, New Orleans, LA, USA

235 — St. Martin's chapel in the Abbey church of Our Lady of Montserrat, Spain

236 — Chapel of St. Helen in the Basilica of Santa Croce in Gerusalemme, Rome, Italy

237, left — St. Louis in the chapel of the Pontifical French Seminary in Rome, Italy

237, right — Fresco in the House of St. Catherine in Siena, Italy

238 — Detail of St. Catherine de Ricci from a monumental oil painting in the church of St. Dominic in the town of San Cristóbal de La Laguna, Tenerife, Canary Islands, Spain

239, left — St. Paul Chapel, Catholic University of America, Washington D.C., USA

239, right — St. Paul Chapel, on the campus of the Catholic University of America, Washington D.C., USA

240 — Mosaic detail from the High Altar of the Rosary Shrine (St. Dominic's Priory), London, UK

241 — Detail from a window in the Lady Chapel of St. Patrick's Cathedral, New York City, NY, USA

242 — Main doors of the church of Santo Domingo in Mexico City, Mexico

243 — Medieval altarpiece in the museum of the Cathedral of Orvieto, Orvieto, Italy

244 — Carved detail from the facade of the Arch-basilica of the Lateran, Rome, Italy

245 — Detail from the Priory church of the Priory of the Immaculate Conception (Dominican House of Studies), Washington D.C., USA

246-247 — Detail from the Priory church of the Priory of the Immaculate Conception (Dominican House of Studies), Washington D.C., USA

248 — From the High Altar of the Priory church of the Holy Trinity in Krakow, Poland

249 — St. Michael and St. Gudula Cathedral, Brussels, Belgium

250 — Christ Church Cathedral, Oxford, UK

251 — St. Nicholas's Cathedral, Newcastle-upon-Tyne, UK

252 — Cathedral of the Blessed Virgin Mary, Salisbury, UK

253 — Statue of St. Christopher in the Cathedral of the town of San Cristóbal de La Laguna, Tenerife, Canary Islands, Spain

254 — Lille Cathedral, Lille, France

255 — Altarpiece by Jan Henryk de Rosen in St. Dominic's church, Los Angeles, CA, USA

256, left — St. Cuthbert's Seminary chapel, Ushaw College near Durham, UK

256, right — Stature of St. Peter Martyr in the Basilica of Our Lady of the Rosary, Guatemala City, Guatemala

257 — Stained-glass window in St. Dominic church, Washington D.C., USA

258 — Stained-glass detail of St. Ambrose from the chapel of St. Joseph's Seminary, Yonkers, NY, USA

259 — 6th-century mosaic from the Basilica of San Vitale in Ravenna, Italy

261 — Ceiling of Sant Ignazio in Rome, Italy, painted by the Jesuit brother Andrea Pozzo

262-263 — The votive candles burning at the Abbey of Montserrat in Spain; Our Lady of Montserrat is the principal patroness of the Catalan people

264 — Antonio Gaudí's expiatory Basilica of Sagrada Familia in Barcelona, Spain

265 — Ceiling fresco in the sacristy of the Abbey of Montserrat, Spain

About the Author

Fr. Lawrence Lew, OP, was born in Kuala Lumpur, Malaysia. His family are Evangelical and Pentecostalist Christians, and he grew up in a Plymouth Brethren household before converting to the fullness of the Catholic Faith in his teenage years in Singapore. Father Lawrence earned a degree in English civil law before joining the English Dominicans. He has studied theology at Blackfriars, Oxford, and at the Dominican House of Studies, Washington, D.C. Since his ordination in 2011, Father Lawrence has served as a university chaplain in Edinburgh, as national religious adviser to the Scouts and Guides of Europe, as chaplain to the Legion of Mary in Westminster, and as editor of the English Dominicans' newsletter as well as their online preaching site, Torch. He served until 2023 as prior and parish priest of St. Dominic's in London and rector of the Rosary Shrine in London. Father Lawrence is currently based at the Dominican priory in Oxford, where he serves the international Dominican Order as its global Promoter General of the Holy Rosary. He loves going on pilgrimages, especially to Marian sanctuaries, and he regularly travels, giving talks, retreats, and parish missions worldwide on Our Lady, the Rosary, and sacred art and beauty as instruments of evangelization. His photos are updated daily on flickr.com/photos/paullew, and he actively promotes beauty and the Gospel on social media through Instagram, X, and Facebook. This work is his third book, and his first with OSV.